BRITISH FASHION DESIGN

Rag trade or image industry?

Angela McRobbie

London and New York

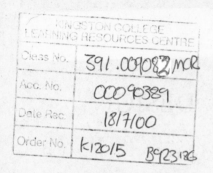

First published 1998
by Routledge
11 New Fetter Lane, London EC4P 4EE

Simultaneously published in the USA and Canada
by Routledge
29 West 35th Street, New York, NY 10001

© 1998 Angela McRobbie

Typeset in Joanna and Bembo by
M Rules
Printed and bound in Great Britain by
Butler & Tanner Ltd, Frome and London

British Library Cataloguing in Publication Data
A catalogue record for this book is available from the British Library.

Library of Congress Cataloguing in Publication Data
A catalogue record for this book has been requested.

ISBN 0 415 05780 9 (hbk)
ISBN 0 415 05781 7 (pbk)

CONTENTS

ACKNOWLEDGEMENTS

This study of the careers of young British fashion designers could not have happened without the co-operation and help of a substantial number of people in the industry, in fashion education and in fashion journalism. I would particularly like to thank Darlajane Gilroy, Pam Hogg, Barbara Sonnentag and Tracy Mulligan for their time and for the way they each seemed to know instinctively the kind of issues I was interested in talking to them about. In fashion education I would like especially to thank Jane Rapley and John Miles. Once again, what they said seemed to strike a chord which helped me formulate the project as a whole. From the fashion media I would also like to express my gratitude to Glenda Bailey, Sheryl Garrett and Edward Enninful, all three also seemed to have their finger on the pulse I was keen to find. Thanks also to Anna Cockburn for her time, to Paul Davies for bringing to bear all his contacts and networks in helping me to pursue this study, to my other Thames Valley University ex-students including Jasarat Rana and Alev Adil, and to the library staff at Central St Martins for allowing me to work in their library, a crowded place which never fails however to produce what Raymond Williams described as 'delight in work'. This effect of enjoyment has also been produced with the background input of the writing and ideas of, amongst others, Judith Butler, Dick Hebdige, Pierre Bourdieu and James Kelman — so, indirectly, thanks also to them.

I should also explain that to ensure anonymity I have given all the designers whom I interviewed pseudonyms and I have described the fashion academics alphabetically. In the section on the fashion media, however, I have retained the proper names of the journalists, stylists and publicists interviewed since the subject matter in that particular chapter involves neither the question of livelihoods and financial survival, nor does it describe institutional practices and policies.

As ever there are many people who have contributed to this book, in many different ways. Although for some this has involved the arduous task of reading drafts, for which I am extremely grateful, inevitably it is for their company and friendship, for inviting me to dinner or for joining me in my kitchen, for coming shopping, for talking on the phone, for club nights and for inviting me to conferences in a range of great places, that I would like to thank the following people; Mick Billig, Lucy Bland, Charlotte Brunsdon, Martin Chalmers, Shelley

Charlesworth, Phil Cohen, Lidia Curti and Iain Chambers, Erica Carter, Paul Du Gay, Paul Gilroy, Peter Golding, Larry Grossberg, Marcella Evaristi, Mike Fitzgerald, Simon Frith, Mariam Fraser, Natalie Fenton, Stuart Hall and Catherine Hall, Terry Halbert, Ruth Lister, Frank Mort, Dave Morley, Graham Murdock (special thanks), Mica Nava, Sean Nixon, Ann Phoenix, Sylvia Paskin, Maria Pini, Sarah Thornton and Jeremy Silver, Roger and Jennifer Silverstone, Denise Riley, Andrew Ross, Vron Ware, Lola Young, Lesley Woods and finally my daughter Hanna Chalmers and her friends, including Catherine Dempsey, Rosie Woodward and Hannah Clements who have all brought their taste and style to bear on this book.

1

FASHION DESIGN AND CULTURAL PRODUCTION

DESIGNER TIMES

The seeds for this study were first sown in 1989, at the end of the so-called 'designer decade' when a collection of articles, many of which had appeared throughout that decade in the political magazine *Marxism Today*, were published in a volume entitled *New Times: The Changing Face of Politics in the 1990s*, edited by Stuart Hall and Martin Jacques (Hall and Jacques 1989). I was immediately interested in a short comment made by Robin Murray, 'There are now 29,000 people working in design consultancies in the United Kingdom, which have sales of £1,600 million per annum. They are the engineers of designer capitalism' (Murray 1989: 44). It struck me at the time that very little, if anything, was known about the working lives or careers of this kind of worker. In addition, I was slightly puzzled by the immediate equation Murray made between being a designer and designing for capitalism. The designers I knew personally, including the fashion designers, rarely saw themselves in this way. The extent to which notions of art, creativity and culture intruded upon and defined their practices as designers produced, at the very least, a sense of tension between themselves and the world of business. Clearly there are many different types of 'designer', from the art directors of the big advertising agencies for whom designing is indeed about selling commodities, to the small scale fashion designer for whom design work often seems to be at odds with what the market wants, to people like the graphic designer, Neville Brody, whose work throughout the 1980s could be seen in magazines like *The Face* and the left wing *New Socialist*. Figures like Brody and designers like, for example, Pam Hogg, seemed to me to be more ambivalently poised in relation to working for capitalism and it was this tension which I wanted to explore in greater depth.

There was also an underlying political motive in pursuing a study of fashion designers, as a case study of the 'new cultural worker'. Left-wing thinking at the time was only able to interpret this kind of work in one of two ways. The first argued that these were 'Thatcher's children', prime examples of the 'enterprise culture', who would fufil the Tory dreams of rebuilding British society along highly individualist lines. These would be self-reliant young men and women

who would literally embody the virtues of 'going it alone' and 'fending for yourself' without the support of the 'Nanny State'. For the left, people like these could only be seen as Tory supporters, new anti-union 'Yuppies', deeply intertwined and committed to the consumer culture for whom they provided the fancy wrapping paper. In contrast, the second approach suggested instead that they were simply fodder. They had been fed the jargon of enterprise and the joys of 'being your own boss' and then shoved into the cold and left to fend for themselves and, as a result, were working longer hours than even a nineteenth century employer could expect of his workforce. More fool them! These would be the middle class or professional equivalent of the newly casual and flexible workers described by Anna Pollert as being encouraged repeatedly during this period to 'live with insecurity and learn to love it' (Pollert 1988: 72). Neither of these characterisations seemed to me to be convincing or adequate as accounts of the 'cultural intermediaries' who were entering, or rather, creating their own labour market throughout this decade.

My interest in providing a fuller account of these kinds of careers was motivated by both a sociological and a political concern. The absence of documentation of this kind of work in sociology or in cultural studies meant that political commentary was inevitably speculative. My reservations about consigning such workers to the camp of the new right, and thus ignoring them as potential allies, were based on a commitment on my part to attempting to build political bridges and draw different kinds of workers into the political processes, something that seemed all the more urgent in the face of the strong right wing government of the time, and the dwindling impact of the left (McRobbie 1996a). But the experience of teaching students who would become part of this creative workforce also led me to rather different conclusions from the mainstream left. In practice they showed few signs of embracing the language of Thatcherism (McRobbie 1996b). Although their education and social identities did, by and large, give them a more individualist outlook (not unusual for arts or media students) than their 1960s or 1970s counterparts who were more thoroughly 'subjectivised' by the statist discourses of 'the social' and by the prospect of careers in the public sector, this did not turn them into rampant Thatcherites. Many came from disadvantaged social backgrounds, some were gay or lesbian. There was also an increasing flow of young people from different ethnic backgrounds into higher education, particularly into the new universities and the art colleges throughout the 1980s.

All the experiences we now associate with the social dislocation of Britain in the late 1970s and 1980s had also made some impact upon these young people. They grew up in different types of families, and were certainly not going to be party to the demonisation of single mothers conducted by the Tory press during this time. Many had parents who were unemployed and were unlikely to work again, others were struggling with the difficulties of coming out as gay or lesbian. In every respect, the old structures of support which in the past determined many of the patterns of people's lives had faded away and so self-reliance was more of

a survival strategy than a political statement. Most significant, in retrospect, was the sheer determination on the part of the young women whom I taught during this period to make careers for themselves and find ways of being economically independent, without having to depend in the future upon a male breadwinner. Indeed, many of the careers charted in this book are the fruits of this kind of effort, and are indicative of a labour market being produced from virtually nothing by young women designers who were part of a first generation of full-time female workers for whom a career of whatever sort would now be for life. The great irony is that just as this process comes underway, jobs for life are becoming a thing of the past. The various attempts at self-employment on the part of the designers I interviewed were therefore doubly significant in so far as they brought together these changing dynamics of both gender and employment.

Even amongst my own generation of women, educated in the 1960s, the idea of working and earning a living becoming an absolute necessity did not exist (but now in the 1990s, with so many marriages ending in divorce with dire financial consequences for women, I am regularly surprised to discover how many of my old schoolmates are, in fact, full-time housewives, and this idea now seems like such an anachronism). So, in debate with some of the old Marxist Left, for whom the dreams and aspirations of their design and media studies students to be successful and to have rewarding careers were so much self-illusion, I wanted to introduce a gender dimension as well as a note of political realism.

'We are just sending out cannon fodder', said one academic, 'it's like the battle of the Somme. They leave with big ideas of being film directors, or fashion designers, and they get mown down within a couple of years!'. This, of course, emphasises the old notion of 'false consciousness', that students are seduced in this case, by the ideological offensive of Thatcherism, have no real understanding of their position as workers, eschew trade unionism, and then come to grief. This kind of comment poured scorn upon the enthusiasm and hard work of the ex-students I knew who were struggling to make a living for themselves in a way in which they found rewarding. And, if this was laced by glamour or fantasy, I wanted to argue with the old, puritan Left that these were hardly crimes, nor did they make these young workers automatically enemies of the Left. Much of the work in this book is aimed at producing a more complex and informed account of the new creative workforce.

The New Times collection was refreshing in its suggestion of moving beyond these old positions. It asked how the Left should respond to the enormous changes which had taken place in British society over the previous decade and under the political leadership of Mrs Thatcher. There was a clear sense that familiar theories needed to be revised. The Left had to shake itself up and plug in more successfully to what people wanted and to what it was that made Mrs Thatcher so popular. More specifically, there was the recognition that Britain had become a more fluid society. It seemed as if various different social groups had become unanchored from their traditional moorings in the class structure. Class still provided an overall map of opportunities, expectations and outcomes, it still worked

as a macro-structure of lifechances, but it was also a moving macro-structure, as were the other positionings of gender, generation, ethnicity and sexuality. These shifts were most vividly charted in changes in the economy and in work and patterns of employment, and the writers of the *New Times* acknowledged how these changes 'collided' with the growth of popular consumption and the rise of the service sector as a place of work.

The 1980s saw the retail revolution transform the British high street. This was symbolised, as several writers since then have noted, by the success of the Next chain, which brought fashion with a higher design input within the reach of average income consumers, male and female (Mort 1996, Nixon 1996). The availability of more differentiated goods, together with what appeared to be a more carefully designed appearance, reinforced the process of social fragmentation as tastes proliferated, and people strove to be different through the access they appeared to have to a wider range of goods. Even low income groups began participating more noticeably in this leisure field where individuals were invited or prevailed upon to 'invent themselves' in different ways as a mark of individuality, a sign of identity. As Stuart Hall very recently noted, young black people, 'with hardly a penny in their pockets', paraded the streets in demonstrations of spectacular consumption (Hall 1997). As Baudrillard argued, consumption had achieved a new prominence simultaneously with the way that culture and the media were now focal points in people's lives (Baudrillard 1988). Suddenly everything seemed to become more cultural. This was as true for the single mum who would deprive herself in order to be able to buy some of the goods seen by her children on television, as it was for the more affluent working classes. For young people themselves, in the poorest areas, consumption was often accomplished through illicit means. The 1980s gave rise to new forms of hidden economy, from weekend street markets, to working 'off the cards', to handling stolen goods, drug dealing and, increasingly, working in and around the emergent club scene.

The *New Times*' writers attributed the availability of designer goods to the growth of Post-Fordism (in response to global competition and saturated markets) and the application of new technology to the production of more differentiated goods. Flexible specialisation in production boosted flagging consumption by bringing niche marketed goods made in short runs to more discerning consumers. The people who were responsible for the higher input of quality and symbolic content in the new products were the designers and, while the traditional manufacturing workforce was slimmed down, there was a growth in this new branch of the service sector, the creative professionals. This, in turn, fed directly into the new kind of society in which we now live, where we are more likely to consume images of things than the actual objects or products to which they refer. The expanded market for images has created the need for a new workforce of image makers and, once again, the cultural intermediaries step in to play this role. The *New Times*, however, stops short of asking the question of who the cultural intermediaries actually are, what precisely they do, and what the conditions of their labour are?

4

By taking fashion designers as a case study, this book goes some way towards answering these questions but it also, in two respects, follows the lead set by Nixon (Nixon 1993, 1996). In his account of the growth of the market for male products during this same period he comments upon the ambivalent position occupied by the editor and founder of The Face magazine, Nick Logan. He is, argues Nixon, a 'committed entrepreneur', not the kind of 'gung-ho' capitalist championed by Mrs Thatcher but rather a product of the British working-class youth cultures of the late 1960s for whom values, other than simply profit and the market, influenced how he set himself up in the magazine business (Nixon 1993). In the case of The Face magazine, now very successful but still run on a shoestring, as we will see in chapter 10, this meant spurning the revenue from advertising in favour of retaining editorial independence and freedom in order to develop a new kind of magazine. Nixon does not pursue further the particular qualities of being a 'committed entrepreneur' though the term does suggest some social, cultural or even ethical dimension.

The socio-cultural dynamics of the particular brand of enterprise culture pursued by the fashion designers forms one strand in the current study, though it does remain uncertain how exactly they are positioned in relation to labour and capital. There is a sense in which they represent both and neither of these poles, so fluid and precarious are their careers in the enterprise culture. They share with Nick Logan a commitment to artistic or cultural integrity over the values of the market-place but, trained in the fine art tradition, they do not have the same entrepreneurial vision. Their enterprise comes more from necessity and the experience of unemployment. There were few 'proper' jobs in fashion design in the mid- and late 1980s and so the newly emerging fashion designers created their own jobs on the strength of dole payments, then the Enterprise Allowance Scheme (EAS), and with the help of a sewing machine, a few stretches of fabric and access to a stall or unit at Camden Lock or one of the other city centre markets. I was interested in how these small scale cultural entrepreneurs fitted into the occupational map of the Left (and indeed of contemporary sociology). How do we allocate them a class position? What does the future of work hold for them? I have already alluded to the role of youth culture and will return to it shortly, but a second feature of Nixon's work, his explorations of movements in the new economy of culture, also shapes the present inquiry (Nixon 1996). This was broached by Stuart Hall when he wrote 'Culture has ceased . . . to be a decorative addendum to the "hard world" of production and things, the icing on the cake of material culture . . . the material world of commodities and technologies is profoundly cultural' (Hall 1988: 128).

Hall's comment indicates a realignment of relations between the cultural and the economic. No longer can the economic be understood as existing in some pure state, untainted by the cultural and the symbolic and providing a kind of bottom line from which all cultural phenomena develop. Nixon argues that economic decisions are, in fact, increasingly rendered in cultural discourse, that cultural knowledge wielded by the creative professionals actively produces new

economies. The account of these realignments which are quite fundamental to contemporary society, is directed in Nixon's work ultimately towards the new products, the launching of the new man as a potential market and also as a dynamic feature of consumer culture. In this book, the emphasis is instead on the livelihoods of the cultural producers and the micro-economies they bring into being. As we will see, in the field of fashion design economic issues are continually subordinated to creative or cultural priorities, producing what Bourdieu has called a kind of 'anti-economy' (Bourdieu 1993b). But this does not mean that designers do not think about cash-flows and earning a living. Far from it, it is rather that they rationalise their own economic fragility by seeing their market failure as a sign of artistic success, or at least artistic integrity.

Bourdieu argues that this display of economic 'disinterest' is actually a strategy for longer term success as an artist which requires short term sacrifice in the name of 'no sell out' to commercial opportunities. But the model Bourdieu proposes depends upon the 'rarity of the producer'(Bourdieu 1993a). What happens, I ask, when so many young people are being trained in art schools and pursue artistic careers of some description after graduation? The designers whom I interviewed all perceived themselves as artists. But Bourdieu's model of artists spurning the market and disavowing the need to earn a living, as a kind of symbolic investment, a testimony to the purity of their motives, does not quite tally with the enormous expansion of the cultural economy which is full of 'struggling artists' who are becoming simply another part of the low pay, casual economy. This points to another, rather different, relation between culture and economy, one which I hope at least to unravel in the following pages.

Various other writers have called either for renewed emphasis to be paid to the complex economies of culture and to the 'interplay between the symbolic and the economic' (Murdock 1997a: 68) or they have commented on the way in which 'the connections among the political, the social and the cultural are in movement – both in society and in our heads' (Hartwig 1993: 4). This book provides a concrete example of some of these shifts and processes. In fact, its origin predates the 1989 appearance of the *New Times* and draws extensively upon what might be called the Hall tradition. By this I mean the particular convergence of themes and issues which have characterised the work of Stuart Hall, and the cultural studies tradition which has developed around these interests. Inevitably there is a lot more to Hall's work than those elements on which I choose to focus here. However, the general frame provided by Hall is characterised precisely by its continuing attempt to connect sociological and cultural analysis with the political transformation of British society in the post-war years. From the Gramscian-inspired analysis of working-class youth cultures in the mid-1970s, through the account of the ideological groundwork carried out by the popular press and media in the years running up to the Tory victory of 1979, there has been a persistent attempt in Hall's work to draw upon 'theory' with a view to making full use of it in political analysis, or as Grossberg puts it, to 'allow you

to re-describe the context that poses the political challenge' (Hall and Jefferson 1976, Hall et al. 1978, Grossberg 1997: 291).

The political challenge underlying this book was posed by Britain ten years after the election to power of the Tories in 1979, when there seemed to be no end in sight to the successes of Thatcherism. Writing about the emergence of a new occupational strata, in this case the young fashion designers who had graduated from art school in the mid-1980s, it was tempting to pursue a pathway which depicted these young workers as merely the product of the inexorable logic of capital, a version of the 'nation of shopkeepers' which Mrs Thatcher herself was keen to promote through her commitment to 'enterprise culture'. Hall's influence can be seen, I suggest, in the way I have argued that these 'disciplinary regimes' cannot completely dictate their own outcomes. The young workers who emerge from the other side of 'enterprise' are, in this book, as much positioned by other previous or accompanying formations such as that provided by virtue of their race, or sexuality or family background or even by their working class identities, as they are by the apparently dominant discourse of the 'enterprising self'. These jostle with each other, producing something other than a group of young cultural workers who could simply be described as 'Thatcher's children'. Yet the political challenge is that they do not fit, either in their occupational positioning as self-employed, or indeed as cultural entrepreneurs and small employers, with existing Left vocabularies. Hall's influence resides, I suggest, in the way he tends to stop short at fully endorsing the determinist version of history whereby all social and political phenomena are the outcome of the workings of the ideological apparatus or the products of the power of the 'subjectivising discourses'. As he puts it, the system is always more 'leaky' than these models permit. It produces its own failures as well as successes.

I have chosen to interpret this particular kind of workforce through the history and development of youth culture and popular culture in post-war Britain, not in isolation but rather as they intersect with education, in particular the art school, and with the commercial mass media, and also more dramatically with the growth of what Schwengell has called the *Kulturgesellschaft* – Culture Society (Schwengell 1991). Added to this, there is also in the focus on fashion a more specific attention to gender within these various intersections. The work I describe is broadly women's work and the young women who play a key role in the study hope to find the space to work independently by opting for self-employment. Although very few of them had children (none of the younger designers), there was a sense that this way of working could, at some point in the future, more easily accommodate family life. In fact, as we shall see, the work involved in being a one-woman business forces many women to postpone motherhood indefinitely.

But why does the youth culture tradition analysed at length by Hall and others in the mid-1970s offer a useful path towards considering the working practices of fashion designers in Britain in the 1980s and 1990s? I have already sketched out an answer to this question in two fairly recent articles. In the first, I argue that

whilst the youth culture work, best exemplified in the work of Cohen (reprinted 1997), Hall and Jefferson (1976), and Hebdige (1978) offered a rich analysis of the history and meaning of these formations and their symbolic worlds, it over-looked the fact that these phenomena also generated opportunities for young people to make a living. The clothes and other items of youth cultural style had to be purchased somewhere and, I argue, many of those who provided for this market were in fact recruited from within. They found ways of making a living for themselves by servicing the youth subcultures in the form of record stalls and small shops, fashion outlets and again market stalls. Later, the whole dance club scene saw an enormous rise in what at the time I called 'subcultural entrepreneurialism' (McRobbie 1989, reprinted 1994). This self-generated, self-employment demon-strated the existence of a sprawling network of micro-economies initially inside the youth cultures, and then extending far beyond them.

It was here in the street markets, where new fashion ideas mingled with the second-hand dresses, that a good deal of the groundwork in creating British fash-ion design was carried out. I also argued at the time that the subcultural field in which new styles were so rapidly displayed and then replaced with new ones, meant that the origins of these fashions could never really be attributed to any one individual. Even though Vivienne Westwood and Malcolm McLaren are recognised as the inventors of punk fashion, it is more the case that they provided a basic set of symbols, ideas and meanings (such as binliners, safety pins, bondage trousers). It was not so much the specific styles, more the combination of elements, the garish colours, the artificial fabrics, the aggressively do-it-yourself ethos which encouraged so many young people to create their own version. This, together with the idea of raiding the second-hand clothes shops, and poring through old magazines for a new 'old' look, is once again more reflective of British fashion than any straightforward history of its designers can demonstrate. It is also far removed from the *haute couture* tradition of European fashion design. Indeed, it is precisely because British fashion has followed this particular pop culture course, that no history of the designers can recount the whole story accurately.

It does not make sense to tell the story of British fashion by leaping from people such as Hardy Amies to Mary Quant to Ossie Clark, to the designers of the early 1980s, such as Bodymap, because these names alone tell us very little about fashion as a participative practice, a form of popular culture. This is recognised in most accounts, including the feminist accounts of British fashion, which all make connections with popular culture, women's magazines, shopping and consump-tion and youth cultures (Wilson 1985, Evans and Thornton 1989). But if fashion design as a highly creative practice appears to take shape in the youth subcultures, and if in the United Kingdom it is inextricably connected with the growth of pop music and popular culture, if it is a 'popular' thing, rather than an 'élite' thing, it does not stop there – indeed I will argue that this is, in fact, merely a starting point. Much of this book is concerned with the key role of British art schools in shaping fashion design. As large institutions they are 'legitimating agencies'. By the end of the 1980s, as a direct result of the expansion of this sector and as the

fashion departments in art schools gain confidence in promoting their own products, what emerged was a relatively new phenomenon, the fashion designer as *auteur*, as an artist in his or her own right. It is at this point that British fashion began to be associated with a series of names, from the 'genius' of John Galliano to those following in his footsteps, including Alexander McQueen and, more recently, Antonio Berardi. This still does not mean that British fashion is modelling itself on its European counterparts – far from it. It is more a matter of fashion finally gaining status as a kind of fine art practice in the way it has sought for so long. As long as the puzzled observer asks when a series of unlikely shapes and colours make their way down the catwalk, 'but is it art, and what does it mean?', then fashion has indeed fulfilled the conditions of its own existence.

I wish, however, to hold onto and signal strongly the earlier and more nebulous beginnings of British fashion which were inside the sweaty spaces of the raves and night clubs, and in the bedrooms of the groups of girls who designed and made their own outfits for these events, and then sometimes made them for their friends and ended up selling them at a market or to small shops. I want to stress the social context of this cultural activity because, in the conclusion to this book, I suggest the need for a return to a more socialised field of cultural production – the designers need to be able to collaborate and share their resources. The art ethos which they have been taught to embody is limited in its individualising focus. If art work is becoming more commonplace in the cultural economy of Britain in the late 1990s, this ethos needs to be revised and updated especially when, as we shall see in this book, it simply does not make economic sense for designers to work in isolation from each other and from the people who do their manufacturing. They can make a better living and produce cheaper clothes if they are able to pool their talents and abandon the ethos of working like an artist, alone in his or her studio.

The second and related theme I developed out of the youth culture studies was that subcultures could conceivably be seen as informal, unofficial job creation schemes, more popular and successful than the Youth Training Schemes set up by the Government at the time (McRobbie 1994). There was a degree of fluidity in the youth cultures where consumers often crossed over to be producers, and although this is more widely recognised in music, it has also been true for fashion. Being a participant in a youth culture could result in learning various skills, from poster production, to fanzine journalism, to mixing music and learning sound production, to designing and selling clothes. It is a fairly short route from these leisure activities into a BTEC or HND course at the local college and from there into art school. This kind of pathway was undreamt of by policy makers and government ministers when they expanded places in fashion design or sound production courses at and below degree level. But my research, as well as the history of British pop music, shows there to be an established link between youth culture as leisure activity, art school education, and then work in cultural production. However, as I will show in the first three chapters of this book, art school imposes its own disciplinary vocabulary upon its subjects and, perhaps not

9

surprisingly, this involves negating or at least dislodging the importance of these informal cultural practices associated with the street.

A final question which must be raised by my locating this work within the Hall tradition is the issue of Britishness and, connected with this, the value of such a localised study as the one I pursue here. In a world of global culture, it might seem strangely old-fashioned, indeed redundant, to document a local form of cultural activity and to dwell on its apparently national characteristics. Grossberg, for example, recently disputed the claims to political connectedness made by those who study the local on the grounds that it gives them some access to public representativeness, that is, by being local they are somehow in touch with real people in a way that those who do theory are not (Grossberg 1997: 6). My justification for the kind of study that I have undertaken here is not that it retreats to the easily recognisable contours of nation as a way of holding at bay the more threatening forces of globalisation, but rather that the history it documents also tells us something about the formation of nation, the 'peculiarities of the British'. This is a story of class and gender antagonism and the struggle over culture waged inside the art school. It is also a story about how women from different social backgrounds created a labour market for themselves in the field of fashion, and about how they modified 'government rationalities' as they developed in the 1980s to suit their own needs, in this case making use of enterprise culture to allow them to pursue their careers as creative fashion designers.

The question of the Britishness of these phenomena is more intractable. Are these various forms of cultural production (notably fashion, music and magazines) a kind of last ditch attempt at cultural imperialism, with Britfrocks following Britpop in the attempt to rule the waves, as they might put it in the tabloid press? Or am I merely avoiding the challenge posed by thinking through the role of fashion design as part of the new international division of labour, where the art work is done in the privileged post-industrial metropolitan centres, while the pre-industrial work of fashion manufacture and production is outsourced to wherever there is a regular supply of cheap female labour? It is true that I have drawn a series of boundaries around this investigation. It remains beyond the scope of this book to consider in more depth and in a way which is more deeply informed by recent questions about the nature of 'culture' itself by a number of authors including Stratton and Ang (1996) and Grossberg (1997), the extent to which it can be said that the fashion design I describe here is somehow the product of British post-war cultural history. However, if there is a close relation between fashion and 'pop', as I suggest, then fashion might also be seen as one of those features of symbolic disruption produced by the deep, indeed seismic ruptures of class, sex and ethnicity in British society which were first felt in the late 1950s.

Pop music bears the traces more evidently of the cultural journeys made by diasporic peoples and the way these have been adopted and commercialised for use by white audiences than does the field of fashion design, and for this reason it has been the subject of extensive analysis (Chambers 1987, Hebdige 1978, Gilroy 1987). The cleavages of class, race and sex can also be read in and through

the parades of fashion and style of the post-war years, but these particular narratives remain less thoroughly documented than the story of pop. Feminist scholars have made substantial contributions in this respect (Wilson 1985, Evans and Thornton 1989) but a good deal more work remains to be done. Fashion education, for example (and fashion designers themselves) sometimes display a remarkably imperialistic attitude in their uncritical plundering and exoticisation of other cultures in search of new fashion ideas. Geography is as rich a resource in this respect as history, and fashion photography as a genre is steeped in notions of 'exotic locations'. But the significance of fashion orientalism requires much more work than a simple reference can do justice to in this context.

To those who query the value of local studies, and dispute the claims to political relevance, I argue that, as Murdock (1997a) recently reminded us, the case study (in this case, geographically 'local') performs a knowledge-generating function. It allows us the opportunity to see how things actually work in practice and how more general social, and even global, trends like those described by social theorists including Beck, Giddens and Lash (1994) as well as Lash and Urry (also 1994) and also by cultural theorists like Jameson (1984) and Harvey (1989) are translated or modified when they become grounded. The local study of the sort carried out here also provides the opportunity to witness how the people who are the subjects of these social changes respond to the changes in their daily practice and, in this case, in their working lives. There is also a sense in this study that I am attempting to fulfil an objective which Laclau has described as honouring 'the dignity of the specific' (Laclau 1990). That is, it is my intention to fill out the spaces left behind by more abstract writing about, for example, processes of class realignment and the growth of identity politics which both Laclau and Mouffe have so fruitfully considered, but at an entirely theoretical level (Laclau and Mouffe 1985, Laclau 1990).

Finally, my defence of the Britishness of such an undertaking does not mean that studies of the same type in other locations are not of equal value. Just as I would like to have moved away from London with this investigation, including other cities with revitalised cultural sectors, so also it is important to know how new forms of work in the cultural industries are developing in different cities across the world. While there is doubtless much that is specific to London and to Britain which has spawned this focus among some sectors of young people, in producing cultural phenomena on a seemingly do-it-yourself basis, the same may well be true of other large cities as they shift into a post-industrial mode. In addition, culture travels as Tricia Rose has demonstrated so well – hip hop music began as a localised innovation and is now the most influential current in the global music industry (Rose 1994). On a much smaller scale, Nick Logan, who is from a working-class Mod background and who brought that experience to bear on the look of a tiny circulation, independently-funded style magazine, could not have anticipated that several years later the magazine would be looked at monthly by art directors in advertising agencies across the world, so that the magazine operates more or less as a mobile job centre for the photographers and

stylists as well as the fashion designers whose work it features. It hardly matters that Logan can still not afford to pay them!

Two other theorists, Pierre Bourdieu and Michel Foucault, have, alongside Hall, played a major role in shaping this study. Bourdieu in particular not only demonstrates empirically how the acquisition of cultural goods including food, fashion and other domestic commodities, plays a practical role in actively reproducing as well as confirming social inequalities, but also turns his attention to the cultural intermediaries who create such symbolic goods. However, as will be apparent later in this book, I part company with Bourdieu in his relegation of this strata of workers to the conservative 'rump' of the lower middle classes, and I concur with Lash in his suggestion that Bourdieu is overwhelmingly concerned with social and cultural reproduction, rather than with the dynamics of social change (Bourdieu 1984, Lash 1993). Nonetheless Bourdieu's work on the whole field of cultural production offers a most useful way in to conceptualising the work of fashion designers. In his short essay entitled 'Haute Couture and Haute Culture' he focuses upon what is a recurrent theme in his work on cultural production – the way in which it is the job of the critics and reviewers, the journalists and specialist writers to produce the belief in the object, to create and sustain the aura and the special, even sacred, status of art works (Bourdieu 1993a). Fashion journalism plays this role for the charismatic designers of French haute couture, but by extension the same could be said of the role of the fashion media in contemporary Britain, as we see in chapter 10. However, and this is the point at which this book departs somewhat from a Bourdieusian framework, Bourdieu suggests that a sociological analysis of a field such as fashion must inevitably act as a force of destruction upon the field: 'If any Tom, Dick or Harriet . . . can make dresses, then the specialist field is destroyed' (Bourdieu 1993a: 138) – which raises the question, is there life or fashion after sociology?

The status of the analysis presented here is less of a clearing operation. I would like this sociological account to contribute to the improvement or betterment of fashion as a place of livelihoods. I envisage this investigation feeding into a field already comprising of various competing accounts, of which, however, there are relatively few sociological studies of this type. I do not want fashion, under attack from sociology or cultural studies, to fade away, and anyway this is hardly a realistic scenario, as though sociology has ever had such an impact. Bourdieu implies that if it can be shown that there is really nothing special about fashion, and that more or less anybody can do it, then it ceases to occupy that special, sacred place in the public's estimation, and thus in a sense it ceases to exist, as it is this system of belief (i.e. words) which creates the thing. The aim of this book is to combine the sociological work of demystification with one of reconstitution so that fashion is better able to attend to its own business, particularly in the area of manufacture and production. I want these elements to be brought back into the field rather than seeing the field somehow disappearing. My aim is then unequivocally reformist, in that there is an attempt to connect sociological and cultural analysis with a concern for policy.

The other feature of Bourdieu's work which also informs this book is one briefly referred to earlier, that is his account of how a field such as fashion will attempt to gain a place for itself in the cultural hierarchy by developing a strategy for gaining autonomy, part and parcel of which will involve a kind of disavowal or spurning of commerce and of the need to earn a living (Bourdieu 1993b). This repudiation of money is, in reality, playing a double role. It protects young artists against feelings of failure. If they can console themselves that their work is misunderstood by the public which in turn accounts for their difficulties in scraping together a living, then they can at least be assured of their own artistic integrity. Bourdieu once again reveals this to be a strategy or a rule of the game which in fact benefits only those who are in a position to 'be poor' for some period of time. The history of painting and of literature shows that living on a shoestring is usually a long-term investment, on the expectation that eventually the writer or artist will gain recognition. Since only those who have access to some other financial means (a small private income, for example) can pursue such a threadbare existence, most cultural producers sooner or later have to compromise their art for the sake of earning a living. In this way economic capital, hidden away somewhere in the family vaults, ensures the reproduction of cultural capital in the hands of the already privileged social classes.

Bourdieu's account, rich as it is in explaining the disdain for money on the part of many of the designers I interviewed, requires some modification on the basis of the material context in which the designers were working. They most certainly were not from family backgrounds which could support them through years of poverty. But more significantly, these young designers were no longer a tiny, privileged few. They were educated and trained in the art school system which expanded its intake quite dramatically throughout the 1980s. More generally, art work no longer has the exclusive identity which Bourdieu attributes to it and instead it is a very crowded field. In addition, it is a field which attracts government funding in the form of publicly administered grants or unemployment schemes such as the EAS. These provide, at least in the early days, the financial underpinning for the creative work described in this book. Therefore, instead of describing the strategies of a privileged élite set on playing the game of cultural production, I explore the career pathways of a group of young cultural workers who are creating for themselves a series of micro-economies based on their own self-employment strategies.

The later work of Michel Foucault, and more particularly that of his followers, also provides a useful frame for understanding the power relations which produce creative work like fashion design as a field of pleasure and reward. In his essay 'What is an Author?' Foucault describes the way in which the figure of the author is created as a certain type of person. The author is produced from the 'individualising' and 'subjectivising' techniques which are also the normative means through which we come to recognise the existence of creativity, or artistry (Foucault 1984: 101). This could quite easily be extended to the fashion designer, whose distinctive characteristics and biographical snippets so frequently repeated

13

in journalism impinge upon and influence how we make sense of the work. However, in this book I have concentrated instead on the significance of the growth of new kinds of creative labour as a disciplinary technique (Foucault 1990, Donzelot 1991). These current incitements to make work a source of intense personal satisfaction (independent of financial reward in this case) can be understood in Foucauldian terms as a regulatory practice, an example of how governmental rationality is finely tuned to the construction of 'new ways for people to be at work' (Du Gay 1996: 53).

However, if people today are virtually 'forced to be free' in a deregulated, privatised economy and are forced to seek work which promises them the satisfaction of creativity, this is not a fixed state, a kind of final destiny for the workforce of the western world, as I argue later. Not only is there movement and contest within these positionings, there is also the strong likelihood that many of these 'rationalities' will fail. This makes the whole field of cultural work more open and less certain in its focus and direction than an application of Donzelot's model of 'pleasure in work' would allow (Donzelot 1991). There is no reason why the organisation of cultural work should not, in these circumstances, be more open to accounts which like this current one, will make a stronger case for the re-socialisation of creative labour and for new kinds of association between designers and producers in the field of fashion. This final note goes some way towards answering the criticism of the theorists who dispute the apparently privileged access of 'local' studies to political centres of gravity. What I have also taken from the work of Stuart Hall is the idea that politics cannot be suspended until such time as theory gets it right.

The image of the fashion design sector which has acted as a central motif throughout this research, is of a skimpy, silky dress, carelessly tossed between two pillars of support, but always threatening to slide to the ground into a crumpled heap. The dress itself is the underfunded, underrated design industry, a fragile, flimsy thing of some beauty and importance. One pillar represents the world of the art school, and the other the commercial world of women's magazines. These also provide the structural supports (or the corsetry) for this book. First, I look at the history of fashion in the art schools, then I consider the practices of the fashion designers and the fate of their skimpy, silky dresses and, finally, I consider the magazine industry as the other pillar of support. I have concentrated exclusively upon women's fashion and on the work of a group of young, female, British fashion designers who share much the same background in both training and in their London location. I define fashion design as the application of creative thought to the conceptualisation and execution of items of clothing so that they can be said to display a formal and distinctive aesthetic coherence which takes precedence over function, and which is recognised as such by those whose expertise allows them to categorise and evaluate work according to criteria established as part of a professional repertoire of meaning and judgement. In this sense, fashion is inevitably a fiction, and what follows is a narrative, a sociological story about fashion design, whose value or relevance will also be judged accordingly.

Finally, there are a number of brief points I should make about this book. First, it is based upon the assumption that fashion, despite its trivialised status, is a subject worthy of study. As part of the industrial society, it has been a place of livelihoods for over a century. Despite great variations in wealth and poverty, with all that implies for the meaning of pleasure, fashion has nonetheless given pleasure to women as a form of personal and practical aesthetics based on the bringing together of shape, colour and textures against the body to intersect with the body's own shapes, colours and textures. So my intent is a serious one; to give fashion the attention it deserves, in this case as a key part of the expanding culture industries. Second, I want to emphasise that this is, of course, also a partial account. As a non-specialist entering a specialist field, carrying the baggage of a cultural studies and a sociological vocabulary, I will inevitably tread on some more fashionable feet during the course of this book. In particular, my own academic language is both close to, but very different from, the fashion academics interviewed. I could not have carried out the study without them and for this I am especially grateful, but I hope that the different inflection I bring to an analysis of the fashion field is seen not as a critique of their practice, but rather as an additional voice in a field of cultural importance. Third, it may be appropriate to point out that some might argue that the historical moment described is already one that has passed. This was the moment of setting up alone as a fully-fledged fashion designer just after leaving college, a moment which for the sake of convenience we could take as 1987, exactly ten years before this book was concluded. Many experts will say that the recklessness of such an endeavour has been replaced by a much more carefully planned set of career strategies on the part of fashion designers graduating a decade later.[1] They have all, it is claimed, learned from the mistakes of their elders. While it is indeed most likely that a degree of realism has crept into the working practices of young designers, it remains open to debate whether or not the moment of this study has been completely eclipsed.

There is also an assumption that although the focus is entirely on fashion, this study has wider repercussions for the future of work in the culture industries. While it is difficult to prove this conclusively, in the absence of a comparative analysis with another sector (e.g. graphic design, independent film production) there is some attempt in the pages that follow to emphasise the absolute distinctiveness, indeed the sheer peculiarity of the British fashion design sector, without completely losing sight of how and where it intersects with other practices. For example, the chapter on fashion journalism shows editors, journalists and writers to be working within similar 'artistic' principles as the designers themselves. As one editor says, 'the page is art'. While the rationale for carrying out such a study has been to suggest this as a field which is somehow exemplary and perhaps prefigurative of future work in the creative industries, there is inevitably a tension between the specific and the general. Is fashion seen by its practitioners as a highly creative field, like being an artist, for the simple reason that it lacks the traditional career pathways of the established professions? If so, then we can see parallels between fashion and film making, advertising, television and video

production and, of course, the popular music industry. Is work in fashion, described in this book as highly fluid, constantly changing and requiring a multi-skilled, flexible and increasingly freelance workforce, a sign of things to come, or of things which have already come in other similar fields, for example, television journalism? Is fashion like these other fields, yet distinct from them in its gendered identity? Or, alternatively (and thinking more historically) is it fashion's feminine status which has marked it out as different from both a fully fledged fine art tradition and also from those craft traditions which generated their own training hierarchies based first on guilds and then on apprenticeships? This would certainly begin to provide us with an account of the historical distinctiveness of fashion as a culture industry.

The final assumption which underpins this book is that it provides a useful opportunity for developing and putting into practice a methodology for researching the new or emergent culture industries (in this case, fashion design). The necessity of an individualising focus, the need to simply pursue a whole range of individuals in isolation from each other, to find out how fashion works, tells us something about the desocialisation of work in the cultural sector. And although it is tempting to explain this by taking seriously the image of the designers as practising artists (who have always worked in an isolated way) this favoured self-image only takes us (and the designers themselves) so far. Like it or not, the designers are usually small scale employers who need the services of pattern cutters, machinists and others. So we are confronted with the reality of a post-industrial system based on the practices of a substantial number of designers doing much the same thing, dotted about the cities, rarely liaising with each other, never mind collaborating, yet experiencing exactly the same problems. It is the sheer anomaly of this situation which motivates the study as a whole. My starting point however, is a historical one. It is in the British art schools that the vast majority of fashion designers are trained. But the presence of fashion on the academic syllabus in a set of institutions dominated by the fine arts has not been uncontested and, as we shall see, the opposition to fashion design has been conducted along the lines of both class and gender. It is to these debates that we now turn.

16

2

GREAT DEBATES IN ART AND DESIGN EDUCATION

The moment the artisan student is taught to become an artist instead of a draughtsman, his mind becomes unsettled and aspirations arise in his bosom calculated to lead him out of the sure and solid path of commerce into the thorny and devious tract which leads to Fine Art!

(Tinto, quoted in MacCarthy 1972: 17)

ART AND INDUSTRY

The account which follows raises questions which go well beyond the confines of the education and training of fashion designers in the British art school system. Played out in this history are issues of gender and education, the distinction between arts and crafts, social class and skill, and most of all, the romantic image of the creative artist. The development of the British art school can also be seen as part of the history of modernity and the place made available for 'culture' in that undertaking. The individualising project of European modernity found, in the figure of the artist, a legitimate outlet for the pursuit of experiences and emotions which were otherwise seen as impediments to the great march of rationality, reason and bureacracy. 'Artistic freedom' was written into the brick and mortar of these great institutions. So important was this idea that it gave rise to endless debate and heated disagreement manifest at every level, from the painting studio to the parliamentary committee, about who could practise as an artist, who could occupy this privileged position? The history of art and design education in Britain has also been riddled with conflicts and disagreements about the most basic questions of what constitutes art? How can it be taught? How is design separate from art, what makes it different and how should students of design be taught? The intensity of these antagonisms cannot be underestimated. Nor do they ever get fully resolved. There are, in addition, tensions and disagreements which have particular significance for fashion design education and which have repercussions for how it is taught and practised today. Throughout these arguments we find isssues of both class and gender influencing the kinds of decisions that are taken. These battles are most

fiercely fought between 1830 and 1860 and inevitably they mirror many of the concerns with class, rank and station which have characterised the history of the British education system as a whole.

From the late eighteenth century onwards the patricians of the Royal Academy (est. 1768) were volubly defending and protecting a particular conception of the 'fine' arts and insisting that only gentlemen might practise portraiture and land-scape. Indeed it was ruled that the Academy would involve no teaching whatsoever and that 'the lower branches of art' including 'native artists' like William Blake should have no place within its walls (Macdonald 1970: 65). The early years of the nineteenth century saw an endless series of bitter disputes about what kind of provision could safely be entrusted to the hands of teachers and administrators without disturbing these relations of power and privilege. When there was eventually an agreement (in the 1830s) that some provision should be made available the debate came to centre around what should be taught in the new Schools of Design and to which sort of person. At this stage what happened inside the schools depended largely on the preferences of the headmasters. The secret of their success in attracting pupils seemed to lie in their willingness to offer the sort of courses which were most disapproved of by the senior officials and academicians based in Somerset House. It was the life-draw-ing classes which were most popular against the official recommendation that what should be taught were the decorative arts of ornamentation (faithfully copying patterns and decorations for a flat surface, including muslins or carpets). This was what was deemed suitable for the artisans for whom this provision was envisaged. Throughout the 1830s and into the 1840s schools were shut or headmasters removed when inspectors discovered that drawing rather than dec-oration was being taught. Overall, this strategy was destined to failure. It was as strongly opposed by teachers as it was by the pupils themselves. The sacked teachers often set up their own small private schools and frequently the pupils followed them.

There was therefore great public enthusiasm for art schools across the country and an informal system of provision was already in existence by the time the Select Committee on Arts and Manufacture elected William Ewart MP in 1836 to 'inquire into the best means of extending knowledge of the Arts and of the Principles of Design among the People (especially the manufacturing population) of the country, and also to enquire into the Constitution of the Royal Academy and the effects produced by it' (Macdonald 1970: 67). The outcome was the Normal School of Design which opened in 1837. Lectures and classes were already being provided in the Mechanics Institute as well as in the private schools established by drawing masters in most of the towns and cities. It was partly as a way of controlling and regulating these developments that the Normal School and the so-called branch schools came into being with their strict curriculum based around 'ornamental art'.

So concerned were the academicians and administrators with retaining control over who could practise what kind of art, that the Normal School required its

young male students to sign a declaration stating that on completion of their train-
ing they would neither set themselves up as landscape artists nor as portraitists.
Not surprisingly, given these constraints, the Normal School failed to attract the
pupils it was looking for. The narrow curriculum was unattractive to the middle-
class students and the fees at four shillings a week were too steep for the artisans.
During these years the branch schools expanded in number as well as in their
intakes, as long as they could pretend to abide by these rules. As the head of a
Newcastle school put it, 'I hung up the rules and broke them by my practice'
(Macdonald 1970: 107). What the academicians had underestimated was the
middle-class demand for art education based around expressive, rather than
mechanical, drawing skills. As Frith and Horne argue, 'The Schools of Design
pragmatic, slavish system was rapidly challenged by their students' counter com-
mitment to pure aestheticism; the schools became despite themselves Schools of
Art' (Frith and Horne 1987: 33).

Teachers and pupils alike rejected the idea of art being subordinated to indus-
try and instead embraced the emphasis on creativity and imagination found in the
Romantic Movement. This ethos is clearly expressed in Ruskin's address delivered
at the opening of the Cambridge School of Art in 1858: '. . . all idea of reference
to definite business should be abandoned in such schools as that just estab-
lished . . . it is certain that our immediate business, in such a school as this, will
prosper more by attending to eyes than to hands' (Ruskin 1858: 5–8). Thus there
was a prevailing resistance to the enforcement of a curriculum which was rigidly
restricted to practising a kind of art which would make British products more
competitive abroad. And while it was envisaged that artisans would learn these
skills in the schools, in practice it was the emergent middle classes who were
taught by largely middle-class teachers, each equally keen to learn sketching and
drawing.

It was the great Victorian reformer Henry Cole who attempted to overcome
these problems. He made progress in organising the teaching of design for
industry through conceding the introduction of drawing (i.e. sketching and
copying from a range of models, objects and artefacts). He managed this by
redefining the arts for his superiors as useful for the advance of industry but
requiring those very skills which, until he took over in 1852, had been consid-
ered only for gentlemen. Cole therefore went some way towards achieving a
more fruitful relation between design education and manufacture, at least in the
provision of design education. He had come from the Public Record Office and
was an astute administrator. In his enthusiasm for the world of art and design he
published his own journal in 1849, the *Journal of Design and Manufacture*. Three years
later he was given his own department of government, the Department of
Practical Art. Cole's reforming zeal, or as he put it 'straight lines are a national
want' (Macdonald 1970: 91), did not completely overcome the hostility of
those educators who considered art as suitable only for gentlemen, but he was
successful in creating a curriculum based round the whole range of drawing
skills, including that of the human form. He broke the academician's stranglehold

over the curriculum by redefining it for a middle-class constituency. He also developed a teacher training programme in elementary drawing and laid the foundations for art to be taught in the primary (or elementary) schools.

Cole's achievement could be understood as comprising three elements. First, as a utilitarian he argued that art should be seen as useful as well as simply beautiful and this allowed him to exercise his considerable power as an administrator transforming an uneven and conflict-ridden provision into something more efficient. Second, he allowed some of those aspects of artistic practice, most notably drawing which had previously been forbidden by his upper-class predecessors, to be officially sanctioned in art education as providing a foundation for art and design. And, possibly most significant of all, he presided over the middle-class ascendancy in the field of art education. It was the middle and lower middle classes (male and female) who flocked to join the whole range of classes in the schools up and down the country and they paid fees and brought in valuable revenue. Even the evening classes were more subscribed to by the lower middle classes ('clerks, builders, engineers and young architects', Macdonald 1970: 176) than by the so-called artisans who were in effect excluded, even from the scholarship system which required as a prerequisite passes in papers set by the Schools of Art. What we see during Cole's reign is therefore the consolidation of the middle classes' aspiration to cultural as well as economic power.

What happened after Cole also had a crucial influence on the development of the art schools for almost one hundred years. The fine art tradition continued in a few élite schools while the growing arts and craft movement, which defined itself in part in opposition to Cole's utilitarian principles, established a place for itself in many of the schools across the country, and particularly in London. Advocates of this movement expressed an intense dislike of factory-produced goods and sought a return to the value of 'sound workmanship'. Craft comes to be associated with truth and with the redefinition of certain trades as de facto arts:

> 'These "Art-Socialists" were greatly opposed to the public art schools being devoted to the production of drawing masters and fine artists. Working in conjunction with the London County Council and the Trade Associations, the members of the Guild began to transform the nature of art education in London.'
>
> (Macdonald 1970: 92)

The 'art-socialists' argued that good design and craft not only enhanced the quality of life through the production of beautiful, everyday objects, but that this then improved the quality of art in general. This approach was implemented most fully through the 1880s and 1890s in the Central School of Art and Design (opened in 1896) and in the Glasgow School of Art. The elevation of craft skills allowed embroidery and needlework to enter the curriculum which in turn gave women a more prominent place in the world of art and design. Indeed, the idea of

'cottage craftsmanship' celebrated by William Morris and his colleagues exerts a lasting influence on women in the art schools and in fashion design, most notably in the work in the 1970s of the British designer Laura Ashley (Sebba 1990: 101). As we shall see in the chapters that follow, many fashion designers define their practice as combining both a fine art and a craft approach.

Later in the twentieth century, particularly in the inter-war period, the arts and crafts movement was condemned on the grounds that its principles ran contrary to the interests of modernity, progress, and the importance of technology and industry. The emphasis on single items of furniture meant the neglect of the importance of design in industrial production, once again at the cost to British competitiveness. In the 1940s, the Council of Industrial Design argued over-whelmingly for more attention to be paid to design in industry. Through the concerted efforts of this body and others, design more or less supplants craft in the art school system and paves the way for a new post-war provision which encourages specialism in product design, graphic design and commercial art in addition to the kinds of courses in ceramics and silversmithing still provided at the Central School of Art and elsewhere. Fashion design is noticeably absent from this concern to modernise industry with design, to the extent that in Forty's influential history of design it barely gets a mention (Forty 1986).

By this point the reader might ask where women fit into these developments and what about fashion design? In fact, there are a number of reasons why, at this stage, fashion and dress as well as gender are omitted. First, fashion production remains dispersed and carried out largely in the workshops of private dressmakers. Second, the middle-class girls and women who attend the art schools come to learn drawing and painting and not primarily to sew (although later they may do some embroidery or needlework), so the demand is not coming from the pupils. Third, fashion production also slips the net of those concerned with modernising industry and using design skills to encourage this process. As Fine and Leopold point out, there is a limit to how far fashion manufacture can be transformed into a Fordist system (Fine and Leopold 1993). Fashion production technology has not developed so far beyond the sewing machines and the electric cutters introduced in the late nineteenth century. Unpredictable demand coupled with the use of fabrics like silk and chiffon which require hand-finishing means that the fashion system as a whole resists an easy or efficient process of Fordisation (see also Phizacklea 1990). These factors combined with its image as a low pay, seasonal and feminised field of production mean that it has never attracted the attention of the politicians or economists in anything like the way other industrial sectors have. If product design means cars, aeroplanes or even fridges, then it is not surprising that fashion only merits a note of passing comment in the many documents produced by the Council of Industrial Design in the 1940s and 1950s. The question, then, is how does fashion find a place for itself in the art school system?

FASHION EDUCATION FOR GIRLS: A DUAL SYSTEM
OF PROVISION

A dual system of provision based around differences of both class and gender came into being from the early years of the present century. This further extended and developed the already existing class divisions in the system. One strand of provision for girls and young women emerged from the system of public education put in place by the Education Act of 1870 and followed by the 1902 Act. The sewing skills taught to primary-age girls from working-class homes in the closing years of the century as part of the drive to improve the home-making skills of working-class and poor women extended into the continuation classes for those able to stay on past the age of twelve. These, in turn, connected with the more specialised courses established in the trade schools which provided skills in all aspects of sewing and dressmaking for those girls whose more affluent working-class parents could afford to keep them at the school until the age of sixteen. For those whose family budget could not extend to this there was an increasing range of part-time and evening classes, some based on a day-release system. Thus, until after the Second World War and the development of secondary school education for all those aged up to fifteen (introduced in 1945 but implemented in 1947), working-class girls only had the chance of learning these skills either in the top-up classes attached to the elementary schools or, if they were lucky, in the growing number of evening classes in the local authority funded 'trade schools'. This latter provision was primarily an urban phenomenon and the kinds of courses on offer reflected the nature and form of local employment opportunities. Situated just a few yards away from Selfridges department store in London (where there was a huge alteration and repair department) the Barrett Street School, now the London College of Fashion, offered a good example of such a local initiative.

For middle-class girls a very different picture emerges. These 'leisured young ladies' flocked to part-time day classes to learn to draw like those held at St Martin's School of Art in London (as reported in the *Chronicle*, 11 November 1913; St Martin's Archive). But, with the exception of the Glasgow School of Art whose progressive outlook resulted in substantial numbers of female full-time students, only a tiny percentage actually intended practising as artists. They came mainly from artistic or liberal families already familiar with the raffish or bohemian reputations of the art schools and therefore not intimidated into thinking of them as places of potential moral danger for their daughters. These girls usually chose to study fine art and it was through this route that a handful of middle-class female students came eventually to fashion (sometimes through embroidery). Fine art and at a later date, design, provided the institutional framework for the growth of fashion education. But the battle for fashion in the art schools was not easily won. Fashion retained a strongly feminine image in a male-dominated environment. And the further lingering associations of both craft and dressmaking skills meant that its passage into the status-conscious departments of the art schools was far

from smooth. Let us then look first at this broadly middle-class provision and then return to the education on offer in Barrett Street and its equivalents.

The first significant development in the mainstream of art school provision was the establishment of specialist departments in embroidery or textiles where, as was the case in Glasgow, especially motivated and talented young women were able to persuade or convince a handful of men in positions of authority that these were areas worthy of development. In Glasgow, in the years between 1880 and 1920, so successful were women like Mrs Jessie Newbery (wife of Fra Newbery, the director of the new Decorative Arts studios in the Glasgow School of Art) and Ann MacBeth, that their pioneering work spread out from the art schools into the local primary schools where needlework and embroidery for girls was introduced into the curriculum. This example shows how difficult it is to draw hard and fast rules around questions of class, gender and social control because in the case of these women (influenced by the Suffragette Movement) embroidery for girls was not only for housework but also for personal freedom: 'In becoming good craftswomen girls may become something more. Their work itself leads them to look beyond their homes . . . and to make of it a new world' (MacMillan 1911, quoted by Burkhauser 1988: 8).

The work of these two women encouraged others to follow them as artists and as teachers and this process in turn meant that art (in this case 'art embroidery') became a possible career for middle-class young women rather than simply a leisure interest. During these years, however, the Glasgow School of Art was the exception rather than the rule. Nevertheless, the women artists who emerged as a result of this access came to hold international reputations in 'artistic needle-work' and the results of their activity trickled down into the schools including the embroidery continuation classes where 'clothes were made which were suitable for and useful to the class of pupils they teach' (HMI Report 1906, quoted by Bird 1988: 27). However, Roszika Parker argues that despite the equations between art and personal freedom, the function of art embroidery in the art schools and its impact upon the school system was to reproduce class divisions with needlework playing a role in the preparation of working-class girls 'for their future as wives, mothers or domestic servants', while for middle-class girls it was 'taught as an art, following the principles established by the women at the Glasgow School of Art' (Parker 1984: 188).

The legacy of this progressive interest in embroidery at the Glasgow School of Art was to give women a place as serious students within the art schools and to also introduce the idea that textiles and clothing could be the object of legitimate artistic attention and imagination. Drawing partly on the vocabulary of the craft movement while extending it to items of clothing, and combining this with the design ideas developed by figures like Charles Rennie Mackintosh, embroidery was seen as an applied art. In this context, fashion design (which even today is not taught as such at the Glasgow School of Art) could eventually emerge as a specialism typically linked with women artists as the result of a fruitful drawing together of these particular aesthetic interests. That then is the kind of legacy

which one variation of the art and craft movement contributes to fashion education, where the emphasis is more on the decorative aspects of clothing rather than on the actual processes of designing a garment. This tradition works its way down through the art schools as a craft tradition and tends to find its fullest expression in textile design courses (like those established in the Central School) rather than in fashion.

An alternative approach, still led by and provided for middle-class women and girls began to develop during the inter-war years. It is primarily London based and it draws largely upon the fine art tradition while also exploiting the expansion of schools and places available as a result of the successes of the supporters of the arts and crafts movement. This new development also brings to the art schools some of the expertise gained by those women who worked in the private dressmaking schools for young ladies which had sprung up in London, for example, the school in Ennismore Gardens in Kensington next to the Royal College of Art. The establishment of fashion design in the curriculum is the result of the pioneering work of a handful of committed women. The upper middle-class or 'society' tradition which embraced the path from the finishing school in dressmaking at Ennismore Gardens to the art school to teach fashion, with some interlude working at *Vogue* as a fashion illustrator, becomes emblematic in this respect. This kind of trajectory was followed by two key figures: Muriel Pemberton, who established fashion illustration courses at St Martin's in the late 1930s which eventually became the Department of Dress in 1957; and Janey Ironside, who was responsible for developing fashion provision at the Royal College of Art (RCA). Pemberton's career is particularly instructive. Born in 1909, she took an art course first at the Burslem School of Art in 1925 before going on to the RCA in 1928 where she was able to set up a Diploma in Fashion. This occurred because, having first established herself as a watercolourist, she then found herself being congratulated on the dresses and prints she had designed for her own use. She developed the curriculum for the Diploma in Fashion at the RCA after taking an additional course in dressmaking at the Katinka School of Cutting. She told the then Head of Department that she wanted to do fashion, and was reportedly told to come up with her own curriculum. Combining what she learnt at the Katinka with her interest in watercolours and then adding a knowledge of dress history gained from reading James Laver's influential costume history (Laver 1938, 1983) she was appointed as a part-time lecturer in fashion drawing at St Martin's (where she remained for over forty years) advocating an approach which was 'open and experimental' (Wooton 1993).

The majority of Pemberton's students considered themselves primarily as painters, with design playing a secondary role. Throughout the 1930s, 1940s and 1950s Pemberton worked as a fashion artist (or illustrator) for magazines, including *Vogue*, and newspapers, as well as teaching fashion drawing at St Martin's twice a week. She is generally acknowledged as having defined fashion design education at St Martin's as based upon the principles of painting first and drawing second. Wooton, in his short introduction to the exhibition catalogue for Pemberton's

watercolours, says how she would 'banish pencils from class' relying instead on 'oil pastel and paint mixed with soap powder', with the aim of creating 'free and fluent lines'(Wooton 1993). Pemberton's ideas for the curriculum can be seen in the St Martin's prospectuses over the years when her influence was at its peak. The 1938–9 prospectus announces a fashion drawing course run by Miss Pemberton, involving 'training for the production of fashion drawings such as are required for the journal or catalogue'. By 1947–8 the three year course was titled Dress Design and Fashion Drawing including 'drawing of drapery and the figure as an essential part of the training in fashion drawing proper. Instruction is given in line, wash and colour reproduction' (Prospectuses from the St Martin's Archive).

Ten years later and now with its own home in the Department of Dress headed by Muriel Pemberton with eighteen part-time staff, the course includes 'creative design, history of costume, methods of production, flat pattern cutting, modelling, fitting, sketching, study of colour and texture, study of French, American and English contemporary design, visits, sketches from memory.' As Lydia Kenemy (who followed in the footsteps of Pemberton in running the fashion department at what was then the St Martin's School of Art from 1972–87) said, 'All fashion courses until then had been dressmaking courses which of course were as far from fashion as painting is from the application of paint on a surface' (interviewed September 1991). What Kenemy's comment clearly reveals is the way in which fashion design education sought to differentiate itself from the lowlier activities of dressmaking, this of course being associated with the training provided by evening classes and trade schools (later technical colleges) for working-class girls.

The courses at St Martin's during these years prepared some of the students for work in the fashion industry which was gradually establishing itself in London. They went to work for companies such as Windsmoor or Berketex which were producing ready-made ranges for the expensive sector of the market. The young women employed there were expected to use their drawing and sketching skills to translate Paris fashion into something more practical for British consumers. However, they were not as yet considered designers since there was little demand at this point for original design skills. Fashion trainees from St Martin's also had some opportunities for finding work in the major department stores such as Harrods and Selfridges which from the inter-war years were beginning to employ well-spoken girls to work as buyers for their fashion departments. More likely, however, the girls would have chosen one of two options. Either to try, usually through contacts, to find work on fashion magazines such as Vogue, or in the national press as fashion illustrators. Once again their job was to provide sketches from the Paris collections and from the French fashion magazines in such a way that clothing manufacturers and pattern-making companies as well as home dressmakers could envisage a whole new look. Otherwise these young women made clothes for themselves and also took orders for friends. This was the middle class or 'society' equivalent of dressmaking. These young women would acquire a showroom or studio and, depending on how successful they were and whether they wanted to expand their business beyond the scale of word of mouth, they

might also advertise their services in the classified back pages of *Vogue* magazine. This was a respectable and even glamorous job, especially if the 'designer dressmaker' had friends from the upper classes for whom she provided ball gowns, tea (or afternoon) dresses and possibly also wedding dresses on a made-to-measure basis. Typically this work did not include tailoring. For heavy outer garments, including suits and winter coats, wealthy women patronised tailors or, from the 1920s onwards, bought such items on order through department stores. This leaves unanswered the fate of the young women who did fashion but with a strong fine art focus. It is almost impossible to tell what happened to them except that, like Muriel Pemberton, they probably made their own beautiful clothes with their own printed textiles, a few may have drifted back towards the art schools to teach fashion and textiles or may have found work teaching in other sectors. Many others, like most middle-class women of their time, abandoned their skills in favour of marriage and children.

As a fashion pioneer Janey Ironside's career is also instructive. An upper-middle-class young girl living in South Africa, she remembers 'I was lent a sewing machine and began to make myself some cotton dresses from *Vogue* patterns' (Ironside 1973: 28). She arrived in London in her late teens and attended a private dressmaking class before enrolling on the dress course at the Central School of Arts and Crafts. From there she went on to teach at the private Fashion School in Ennismore Gardens in 1949, after which she left to set up in business at home as a 'designer dressmaker', advertising her services in *Vogue*. With fashion editors and society girls including debutantes as her clients she was soon employing machinists, finishers and outworkers. The Festival of Britain in 1951 provided a boost to the United Kingdom fashion industry and by 1952 Ironside had prepared a full collection for a major retailer whilst also specialising in made-to-order wedding dresses and evening wear. Four years later she was offered a job at the Royal College of Art as head of the fashion department which was slowly being established. Ironside was taking over from Madge Garland, another leading figure in the history of fashion education. Under both Garland and Ironside the course at the Royal College had less of an emphasis on fine art than the St Martin's course under Pemberton. Garland was well aware of the obstacles she and other fashion educators faced in gaining academic respectability for fashion.

> All the other Schools have behind them a body of literature, an accepted standard of criticism, a tradition which has accumulated over the years and which acts as a guide to professors, teachers and students, but the attempt to give to designers in the fashion industry the same status as that accorded to designers in other branches of trade, such as furniture, glass, or china, is less than three years old.
>
> (Garland 1957: 81)

She also argued that the fashion industry, which in the past had been comprised

of 'little dressmakers', was likely to expand as more middle-class women like her-self entered the world of work, and who would no longer have the time to make their own clothes. In Paris fashion was already taken seriously, but in this coun-try it was still considered 'frivolous'. The pressure to develop a British fashion industry would come primarily from the customer. This gave institutions like the RCA its impetus to provide a sound training in design which, in turn, would be of value to manufacturers.

The course at the RCA expanded quickly under Garland and then Ironside, partly because like many of the other leading fashion educators, both women were excellent publicists. Ironside forged links with Berketex, Marks & Spencer and Wallis. She also helped to establish the Fashion Advisory Committee. This, in turn, led to other developments in fashion education including trips to Paris for the students. Ironside describes her twelve years as Professor of Fashion at the RCA (1956–68) as being divided between teaching, administration and doing public relations for the school as a whole including liaising with industry. Ironside also provides a detailed account of the many partnerships she set up with industry. These included attracting sponsorship from Moss Bros and contracts from BEA (British European Airways, as it was then known) for air hostess uniforms. In addition, she worked through what came to be known as the 'Swinging Sixties' alongside many of the key figures in the emerging world of fashion including Ossie Clark, Janice Wainwright, Zandra Rhodes and the Reldan company. She also worked with the influential fashion journalist from the *Sunday Times*, Ernestine Carter, and she developed a strong profile for the RCA course as having close links with industry, a reputation which continues today.

However, it was precisely these connections that made those in positions of power in the art school system unwilling to take fashion seriously as an autonomous art and design practice. And this is exactly the obstacle Ironside con-fronted when, in 1967, as part of the transition for art and design courses from diploma to degree status, the fashion course was initially refused this. Until this point, art and design courses carried the title of National Diplomas and from 1949 onwards fashion and dress were recognised within the structure of this award. However, there was always the feeling within the art schools that fashion did not really count. Fashion education was largely a female field and many of the women teaching fashion at this point possessed few or no formal qualifications. They were either self-trained or had taken courses in private dressmaking schools. This is not surprising given the tiny number of women who had access to higher education prior to the 1960s. As women in a male-dominated and élitist set of institutions (many of the art schools still aspired to the model set by the acade-micians), at a time when middle-class women were still expected to be homemakers primarily, they were frequently dismissed as non-academics. This lasted until the late 1950s and only began to change during the Coldstream years of the 1960s. The ruling against fashion at the RCA reflected exactly the ambiva-lent status of the field. It was only reversed after strenuous campaigning and lobbying by Ironside together with her influential allies from the industry.

Politically it would have been unwise to deprive the fashion course of degree status precisely because of the strength of the arguments around the future of British industry under the Labour government of the time.

There is no doubt that fashion education, pioneered as it was by a handful of middle-class women, had an uphill struggle in convincing the fine art establishment of its value. As Madge Garland pointed out, this difficulty was exacerbated by the relative absence of scholarship and academic research in the field. In the end, fashion educators pragmatically (and often against their own inclination) had to look to the emerging world of consumer culture and, in particular, to the growth of youth culture and popular culture in Britain in the 1960s, in order to find support for their arguments about developing provision inside the art schools. In a sense the heads of fashion needed 'swinging London', Mary Quant and prominent 'fashion photographers such as David Bailey to justify the expansion and the status of fashion as an academic discipline. As I will argue later, this line of support was viewed with some ambivalence by the fashion academics. They could not be wholeheartedly enthusiastic about 'pop music' or, indeed, popular culture being a partner to the rise of fashion, because these things represented part of what fashion was trying so hard to escape from: the associations of being downmarket and popular rather than élitist, an activity associated with the world of youth culture and mass culture. These connotations could even be a danger to the existence of fashion in the art school since, at that time, the academic canon did not include the study of media, mass communications or popular culture. These were not judged suitable as academic subject matter.

TRAINING IN FASHION FOR WORKING-
CLASS GIRLS

What also caused the fine art academics to wince at the question of fashion education were the strong connotations of sewing and dressmaking which marked it as a practical and domestic activity. There were the trade associations which put fashion closer to the apprenticeship systems for tailoring. Worse still, there were the rag trade associations of the 'sweated industries'. In fact, educational provision in fashion for working-class girls grew out of initiatives developed by progressive local authorities, such as the London County Council, to establish trade schools to improve the skill level in the fashion industry overall and to counter the exploitative conditions of the rag trade. The history of the Barrett Street Trade School, later the Barrett Street Technical College and now the London College of Fashion, is illuminating in this respect. The school opened its 'continuation' classes in 1915 for fourteen to sixteen year olds who, over a two year period, would be taught dressmaking and embroidery, ladies' tailoring, hairdressing, trade instruction and general education. The fees were ten shillings a term and scholarships were available. The school was part of a plan by the London County Council to extend

secondary schools by taking in pupils from across the city, charging them low fees, and providing scholarships which would cover tuition fees and an annual grant of thirty pounds for the two years. The Barrett Street School was set up as a school for dressmakers, replacing an inadequate and uneven apprenticeship system. Two thirds of the curriculum was trade related and the remainder was given over to general education. In addition, some art classes and sports classes were also provided. These full-time courses were soon supplemented by part time and evening classes, and day release systems were also introduced. Throughout the 1920s and 1930s the school had the highest reputation for preparing girls for work in the sewing, mending and alteration departments of big London shops, including Selfridges a few seconds away from the school, and Harrods in Knightsbridge. The model status of the school can be seen in press reports of the time. *The Times Educational Supplement* (1920–1) commented:

> Looking at the results of the teaching . . . the observer must feel that here at least is an attempt to form the woman whose brain will guide her hands to good work, and whose leisure will be filled by worthy occupations.

The same article continued, 'Something beside cinema-gazing will surely fill the winter evenings . . . while the habit of being satisfied only with perfect finish in work is one to carry into active life' (undated Ethel Cox Collection, London College of Fashion).

Although the emphasis was on dressmaking, gradually the idea of the school training 'budding dress designers' began to creep in throughout the late 1920s and into the 1930s. Indeed, it was during the inter-war period that we first see the term 'dress designer' or 'fashion designer' appear in popular usage. While there are no official definitions available, 'design' in these contexts appears to be based on the practice of the established designers in Paris to describe work based on an original sketch, drawing or set of drawings and translated into a model or prototype garment. After this had been revised or reworked on a *foile* (or dummy) a pattern provided the basis for the garment itself. When the patterns were sized and graded the collection was ready to go into production. What made the work 'fashion' was the original quality and coherence of the formal features of the work and the way it positioned itself within a recognised tradition of fashion design so that, for example, it might be seen to bear the influence of an earlier designer, or else break new ground by challenging the tradition of the great *couturières*. The element of 'newness' emerged from both this engagement with tradition and from the representational 'framing' of the work, i.e. the 'seasonal' or 'social' context. The European *haute couture* tradition is modified in Britain to accord with the class divisions in fashion education. As we have seen, in the more middle-class environment of the art school, fashion found itself emerging out of a fine art practice, where in the Barrett Street School elements of design gradually found themselves introduced to a tradition of making. One evening press headline praising the work

29

of the school ran '20 Guinea Gowns Designed And Made By 14 Year Olds' (undated Ethel Cox Collection).

The design work in the Barrett Street School was, at this time, rigorously underpinned by training in every aspect of tailoring and dressmaking. Documents of the period record the precise nature of the tasks the girls were expected to master. These included box pleating, tacking, button-holing, pockets, cuffs and sleeves. The extensive publicity the school received throughout the inter-war period was very much the result of efforts by its Principal, Ethel Cox, another pioneering woman in fashion education. This, of course, was also the time during which the fashion industry was establishing itself in London and catering for the growing numbers of young female office workers. Blouses and skirts as well as dresses, suits and coats were now available in the department stores, produced especially for this sector of the market and thus less expensive than the main 'ladies' fashion companies like Jaeger, Windsmoor and Berketex. The skills learnt by the girls at the Barrett Street School would have taken them right into this end of the business allowing them to escape the sweated labour of the rag trade. Their work also attracted the attention of the 'society' market. A 1929 edition of the *Daily Sketch* ran a feature entitled 'Tech School Students Make Court Dresses'.

After the war the emphasis was increasingly on producing clothes and fashion for white collar workers and this entailed specialising in tailored blouses, suits and overcoats. The Barrett Street School came to be seen as the main supplier of highly-skilled, mostly female labour for the respectable end of the fashion industry in London. By 1950 the school had become a technical college and thirteen years later it became the London College of Fashion (LCF). In 1985 it was incorporated into the London Institute by which time it was preparing degree courses for validation as well as offering BTEC (Business and Technical Education Council) courses which were replacing the old HND (Higher National Diploma) and HNC (Higher National Certificate) qualifications. Throughout its existence, the London College of Fashion has emphasised its close links with the fashion and clothing industry and design work has played a more minor role. However, its location in London has meant that students were, and are, unlikely to work for companies supplying the big high street fashion retailers, since almost all large scale manufacture is carried out in the north of England. London fashion and clothing production has always been intensive but small scale and for this reason LCF students have more often found work in the department stores or in the smaller fashion companies and wholesalers which rely on local production teams or units, often working as part of a sub-contractual chain. LCF students also find work as highly-skilled pattern cutters, or in fashion retail and merchandising. The background of LCF students today remains more socially mixed than their art school counterparts. Many are drawn from ethnic minorities and hope to bring their skills back to either the Asian and Greek Cypriot fashion businesses of North and East London or else to the Afro-Caribbean fashion sector in South London.

What emerges from this brief account of the growth of fashion education is a

double set of determinations at work. On the one hand, the system is fairly strictly divided along class lines. This is summed up simply in the word 'trade'. On the other hand, it is also perceived as a feminised field and this extends across the class divide into both middle-class and working-class provision. Despite the attempts of social reformers, the art schools see themselves as middle-class, often élite, institutions providing an education in art and design, although how the two relate to each other and, as I mentioned earlier how design is actually defined and practised, remains nebulous. This education is aimed at a relatively narrow cross-section of the population, from gentlemen (and ladies of leisure seeking an accomplishment) at one end, to art school teachers (mostly male and lower middle class) at the other. Between these poles are architects, practising artists, sculptors, ceramicists, furniture designers and then in the post-war period graphic designers, film makers and photographers, and also fashion designers. Although some element of craft remains in the activities taught in the LCC schools, especially the Central School of Arts and Crafts (silversmithing and jewellery-making), the overall emphasis in the sector is on the integration of art and design and indeed the 'erosion of the distinction between painting and other forms' (Pemberton 1993). Fashion has to differentiate itself from the trade associations of dressmaking in order to find a secure place for itself in the art schools. The more easily it accomplishes this (e.g. through fine art embroidery courses or else through fine art-influenced textile design) the more comfortable its existence.

In the provision made available in the trade schools and later in the technical colleges and, more recently, in the non-degree awarding art colleges, the more practical aspects of fashion and clothing were taught to girls from largely working-class or ethnic minority backgrounds. These girls were being trained for more highly-skilled work than simple factory machinists. Depending upon the geographical location of the colleges, students would expect to enter the clothing industry at supervisory levels or to look for more highly paid work as pattern cutters or graders. Others would go into retailing or fashion wholesale. However, with the decline of British mass production over the last twenty years and the rise of offshore production among the bigger companies including even Marks and Spencer, skilled jobs and supervisory positions for working-class girls in fashion production are increasingly scarce. As we shall see, one solution increasingly attractive to students is to upgrade the courses to include a greater design component and to move towards degree status or, alternately, to develop BTEC and HND fashion courses providing direct routes into degree level work on completion of these two year courses. According to Inge Bates, this trend in combination with the increasingly prominent place occupied by fashion in the glamorous world of the mass media throughout the 1980s and into the 1990s, has given students like these unrealistic aspirations about being designers and having their own studios. They are more likely to be disappointed, she argues, when on leaving college they find their horizons suddenly limited.

The majority believed they could 'make it' as fashion designers. Some

were extraordinarily persistent in sticking to their ambitions, despite their tutors' constant advice to adjust their aspirations. A few still clung to their original ambitions, even after lengthy unemployment ('I shall be trying as long as I live')

(Bates 1993: 82)

What this shows is how pervasive the desire is to work in a creative field such as fashion. Bates' pessimistic realism must, however, be countered by the sociological significance of working-class girls such as these now having such strong ambitions in fashion design.

In conclusion, it is clear that because the art schools, drawing heavily on romantic notions of art, define for themselves a primary commitment to creativity and imagination, and consequently encourage an image of the artist as a different kind of person from the normal, average citizen and somebody who might be expected to break the bounds of convention and pursue an eccentric or bohemian existence, their history is one which has marginalised women and has discouraged working-class people in general from participation. Bourdieu has shown how, historically, access to a private income has cushioned many artists from the harsh economics of cultural production and has also limited access to those who could rely on such good fortune (Bourdieu 1993b: 68). Equally exclusionary has been the prevailing ethos of cultural élitism which regulated and controlled the types of people deemed suitable to enjoy the privilege of this kind of education. For fashion design this has particular consequences. Despite the endeavours of reformers like Cole, and supporters of the arts and crafts movement like William Morris, a system emerged where fashion design has occupied a position of consistently low status either because it is too closely connected with the world of work and manufacture or else because it remains associated with female interests and with domesticity. A dual system of provision divided along social class lines reflects both these anxieties. Even inside the prestigious art schools where fashion is recruiting largely from the middle classes, it still finds itself pushed into a position of subordination across the institutional hierarchies. As we shall see, the impact of this marginalisation continues to have some impact on the identity and practice of fashion design today.

3

THE FASHION GIRLS AND THE
PAINTING BOYS

INSIDE THE ART SCHOOLS

Fashion provision inside the art schools underwent significant changes in the 1960s. This was a decade of tremendous upheaval for the whole sector. The first Coldstream Report was published in 1960 and its main recommendation was the replacement of the old National Diploma by a Diploma in Art and Design which would be of degree standard, not necessarily vocational but providing instead a 'liberal education in art' (Coldstream 1960, quoted in Ashwin 1975: 98). This report was considered long overdue by those who had been calling for the introduction of higher academic standards in art education, including a component of art history. The report specified four areas of specialism, one of which was Textiles and Fashion (the others being Fine Art, including painting and drawing, and sculpture and drawing; Graphic Design; and Three Dimensional Design). All four areas were to include fine art. Coldstream thus consolidated the principle that art education meant, first and foremost, an education in the fine arts.

Four years later, however, we find a shift in direction for fashion and textiles. The Summerson report stated that these areas 'need not necessarily be related to industrial production. But the ties are . . . so close that some understanding of the processes of production and of the fashion industry is a necessary part of the designer's educational equipment' (Summerson 1964, quoted in Ashwin 1975: 111). The report continues, 'In this direction we found many of the colleges deplorably backward.' Recommending visits for staff and students to the main centres of fashion, the report adds, somewhat hopefully, 'If the phenomenon of fashion is to be taken seriously, it must be caught on the wing or it will never be caught at all' (ibid.: 111). In 1970, following student disruptions in 1968 at the Hornsey School of Art and elsewhere, a further report was published by Coldstream. This time the main objective was to do away with the fine art bias which had underpinned the First Coldstream Report of 1960 and replace it with a more up-to-date and relevant programme for design education. The experimental nature of fine art was now judged to be 'incompatible with the inherently pragmatic nature of design disciplines' (Ashwin 1975: 124). Fine art was therefore 'not universally appropriate. We now would not regard the study of fine art

as necessarily central to all studies in the design field' (Coldstream 1970, quoted in Ashwin 1975: 129). The report concluded, 'How well the need for trained manpower is met both in terms of quality and quantity, is obviously an important element in the evaluation of the art and design system' (ibid.: 134).

The year 1970 marks, therefore, a shift in vocabulary whereby design begins to be freed from its primary obligations to fine art, leaving the door open for a more concerted dialogue with industry and manpower. The questions are, what sort of industries do the policy-makers have in mind? And how does this thinking filter down to the education of fashion students? In fact, this new emphasis was resented by many of those working in art schools who saw it as marking an erosion of their autonomy and the end of the ethos of 'artistic freedom'. Fashion, as the weakest subject area in the sector, was forced to bear the brunt of the industry bias. This was also, however, one of the means by which fashion could secure stability for itself in the sector and gain recognition, if not status. Throughout the 1970s, design is broadly referenced as the focal point for links with industry but, in practice, it is fashion which becomes the enterprise and industry flagship for the art schools, allowing the other areas to continue more or less unchanged. This new role for design can be gleaned from the comments and debates which find their way into various documents (e.g. The Gann Report 1974, quoted in Ashwin 1975: 145, 'New areas of design employment are opening up and in our economic development within competitive markets, design is an increasingly important factor.') In practice, education in graphic design, product design and the other design-related areas, all hold back from this full commitment to vocationalism, arguing that the students need time in college to learn the basics of their discipline. The industry links are less foregrounded than those more publicly pursued in fashion. Given the already insecure identity of fashion, also the product of its feminised image, it is immediately vulnerable to such pressure. The fashion students and fashion educators alike felt they had no option but to fulfil this requirement. As one head of fashion said in interview:

> We have had the pressure to make links with industry from right back
> in the early 1970s, if not before. It's been the only way that fashion has
> managed to survive, but many of us have resented it, all the liaising and
> all the meetings, it's been an additional huge burden and often it takes
> us away from what we are really paid to do, which is teach the students.
>
> (Respondent A)

It is difficult to get a clear picture of what it was like inside the art schools during this period beyond the evidence offered by anecdotes or else in the memoir of the celebrity artist, musician or fashion designer (see Frith and Horne 1987). However, two very different accounts both point to the same thing, namely the exclusion or marginalisation of girls from the fine art culture which still prevailed. In the autobiography of Barbara Hulanicki, who went on to create the famous Biba store first in Abingdon Street and then in Kensington High Street (Hulanicki

1983), and also in the more sociological study *Art Students Observed* (Madge and Weinberger 1973), there are comments which reveal the aggressively male style of teaching which prevailed in the studios. Girls were pushed into fashion as a kind of refuge. Hulanicki began in the painting department but, following what seemed to be a typical experience in painting, departed to fashion.

> When he (the tutor) eventually reached me he just mumbled 'Christ, another fashion one' and that was the end of any guidance I got in life classes . . . It was a relief to join the fashion class over the road with the Higher National Diploma students. Joanne Brogden was a visiting lecturer from London. She lectured at the Royal College of Art and later became head of its fashion department.
>
> (Hulanicki 1983: 52)

Girls were seen as more suited to fashion than to fine art, indeed the extent to which they were discouraged in fine art is described clearly in Madge and Weinberger's study. Judging from the tutors' comments it is not surprising that the girls gravitated to what was considered a more feminine environment and subject area. For example, the authors include in their account the following comments: 'Liz is a stolid puddingy student of consistent attitudes and a plodding work-style' (Madge and Weinberger 1973: 124); or 'Pam is . . . a neurotic student who adopts defensive attitudes I would describe her work as boring, unadventurous, mediocre painting' (ibid.: 154); or, again, 'Diana is a neurotic girl Her work is turgid' (ibid.: 151); or, finally, 'Jackie is a nice girl, a serious girl even. Her work is diabolical' (ibid.: 154). The average male student, in contrast, is described accordingly: 'Arthur is an intelligent and literate student' (ibid.: 160); or, 'Brian works hard and I believe he is seriously committed to his type of work' (ibid.: 160). The prevalence of attitudes like these inside the art schools throughout the 1960s makes it inevitable that female students and teachers began to congregate in areas like fashion and textiles where they had some autonomy and where they were not subjected to this kind of judgement. With few friends to defend fashion inside the art schools and with this level of scepticism, fashion had to look outside the art school towards industry and the mass media for support.

It was the rise of pop culture in the 1960s, particularly that brand of pop culture associated with the graduates of the British art schools, which gave fashion a new place in the growing consumer culture. Fashion was able to legitimate itself in this informal field through its close association with the world of pop music. 'Fashion girls' play a key role in bringing the skills of style into the world of pop. Pop music in turn becomes as Hebdige put it, 'a discourse on fashion, consumption and fine art' (Hebdige 1983, quoted in Frith and Horne 1987: 107). The 'dolly birds' (as they were called in the mass media) decorating the background in the various pop films and documentaries of the time came to embody the new British fashion associated with figures like Mary Quant and Biba. Both

Quant and Hulanicki were trained in the art schools but then went on to use their training in innovative and unexpected ways. Their off-the-peg fashion took many in the field by surprise. *Haute couture* and luxury fashion suddenly seemed old-fashioned. In this new crossover field of 'art into pop', the rigidity and élitism of the fine art world was left behind in preference for the more popular world of Pop Art. One of its most celebrated artists, Richard Hamilton, described this as 'art manufactured for a mass audience' (Hamilton 1983, quoted in Frith and Horne 1987: 103). According to him, Pop Art included the following characteristics: 'Popular (designed for a mass audience); Transient (short term solution); Expendable (easily forgotten); Low cost; Mass produced; Young (aimed at youth); Witty; Sexy; Gimmicky; Glamorous; Big business' (ibid.) Each of these features informs not just the practice of Pop Art but also of the new fashion industry which came to be associated with 'swinging London'. Thus, although fashion had to battle inside the art schools for status and approval from the fine art world (a struggle which continues to this day) in the more public domain 'art' was now bending over backwards to explore the commercial practices associated with the world of style and fashion. In this context Parisian *haute couture* also looked to London and the United Kingdom. As Mary Quant suggests in her autobiography:

> I have always liked showing my clothes in this way and I am no longer alone in this. The description one journalist gave of the show at Courrèges this year might well have been a word picture of our first showing at Knightsbridge Bazaar. It was described as 'a display of far-out fashions that swung down the runways to the way-in beat of progressive jazz'.
>
> (Quant 1967: 132)

Art school graduates were now looking for work in commercial culture, in advertising, retail design, graphic design, and in film and television. Artists like Richard Hamilton argued that consumer goods should 'show the hand of the stylist' (quoted in Frith and Horne 1987: 14) and David Hockney brought pop and fashion references directly into his paintings, for example, in the famous early 1970s portrait, of textile designer Celia Birtwell and her then husband, the influential fashion designer Ossie Clark (entitled *Mr and Mrs Clark and Percy*). From the mid-1960s onwards fashion came to be part of the new youth-led consumer culture. It lost its associations with both the world of European *haute couture* and also the more middle market 'ladies' fashion' sector associated with women's magazines. It became both more sophisticated and more accessible, the product of consumer confidence, full employment, social mobility and sexual freedom. British fashion design took off outside the art schools and, in many ways, it didn't look back. Instead, it launched itself more confidently in the field of popular culture. This shift was symbolised in the space of the boutique. Shops such as Mary Quant's Bazaar in Chelsea (actually opened as early as 1955) and Biba which opened in 1966, were a focal point for youth culture. Loud pop music, darkened,

cavern-like interiors with clothes displayed in unusual ways set the pattern for what came to be distinctive about British fashion. The boutiques were as innovative in design as the clothes they stocked. They didn't look like any other shops. The items were not priced beyond the budget of the working-class girls who spent substantial sums each week, while the fast turnover of stock as well as the reputation these shops got from the publicity they attracted in the fashion magazines and the daily press (in particular the Sunday newspaper colour supplements), meant that they came to represent the ultimate consumer fantasy for ordinary girls and young women up and down the country, as famously recorded by Tom Wolfe in his essay, The Noonday Underground (Wolfe 1969).

> The nerve racking thing for me was that although Pierre Cardin and Norman Hartnell were showing expensive couture clothes, none of my things cost more than twelve guineas and most of them were around the five pound mark! I had to keep reminding myself that this was the whole point of what we were doing.
>
> (Quant 1967: 140).

The sudden international prominence of fashion through the launch of new magazines such as Petticoat, Honey and Nova, as well as the huge success of the new boutiques (with branches opening in every town and city), brought publicity to fashion courses in the art schools. Figures such as Janey Ironside began to attract celebrity attention in the form of profiles and interviews and there was an increasing interest in what it meant to study or to teach fashion. So, in a sense, the world of popular culture validated fashion education in the art schools in a way in which the fashion educators did not expect. It did this through the Pop Art connection represented by Hockney, Hamilton and Peter Blake, and through the new celebrities of the commercial culture, figures such as fashion photographers David Bailey and Terence Donovan, and models including Twiggy and Jean Shrimpton. This process inevitably increased the confidence of the 'fashion girls' especially since the 'painting boys' were by now themselves also looking to the world of pop and fashion for ideas and inspiration. From the late 1960s it was the students mixing with each other across the boundaries of fine art, graphic design and fashion and exploring the whole new world of popular culture which had a greater impact on the status and reputations of the art schools than the policy-makers and the teachers could ever have imagined. (John Lennon was studying fine art at Liverpool when he met his first wife, Cynthia, who was studying fashion).

Fashion gained recognition in this context just prior to that moment when the art schools found themselves under increased pressure to become more accountable and to relinquish their commitment to freedom, autonomy, experimentation and independence. By the mid-1970s, these values began to fade as the art schools were absorbed under the umbrella of the polytechnic system, and as a new vocabulary began to assert itself which emphasised the importance of the

market and the commercial principles of business management and accountability. Students resented this and responded by defending the values of freedom and imagination. Fashion students do the same thing and use the same vocabulary to defend the creative content of what they do in opposition to the demand to 'go' commercial. The fashion girls might still have felt less confident than the painting boys, but they began to overcome this by defining themselves as artists, just like the boys. In short, the values of fine art were put to work against the values of enterprise culture which were just beginning to find their way into the vocabulary of politicians and policy-makers (Callaghan 1976: Ruskin College Speech).

FASHION ACADEMICS

The power to influence what happens inside the fashion departments and how the curriculum is taught remains however firmly in the hands of the fashion academics. They are the experts and intellectuals, they embody the tradition of fashion education which, as we have already seen, remains remarkably undocumented, so in a sense these women carry around this knowledge with them. They themselves have usually worked for some time as designers and know the industry inside out. They are also constantly involved in the process of negotiating policy decisions in the art school sector as a whole and implementing them in the classroom or studio. Their own situation remains vulnerable since the very links with industry they are expected to develop can weaken their identity and position within the politics of the art school. While every aspect of their pedagogic practice (including work experience programmes for students, project-based teaching with 'live briefs' set by industry, as well as the use of visiting specialists and the sponsorship they frequently bring with them) is welcomed by senior management, it can put fashion out on a limb in the art schools where all other disciplines are either exempt from, or else vigorously attempt to, opt out of 'enterprise culture'. If they are forced to demonstrate their close links with industry then how they do this and what sections of industry they connect with is crucial for the way they define their identity as academics. This question will be explored more fully in the chapter that follows but one important way in which fashion academics do this is by sharply differentiating fashion design from technology, production and manufacture. There is a double tension with fashion. It is frequently thwarted in its ambition to achieve full fine art status and, at the same time, it has to shake off all associations with the rag trade. Image-making must remain quite separate from garment-making, and those who sketch must separate themselves from those who sew. Academics then find themselves in the role of dutifully guarding this boundary as a mark of their own professional status. As we shall see later, this horror of sewing, as though it is a shameful activity, comes to be a key distinguishing feature and mark of identity for fashion students. Not to be able to sew is a matter of pride!

The repudiation of sewing and dressmaking forms an important strand of the

argument in this book. As part of the process of professionalism, fashion design distinguishes itself vigorously from production even though, as I shall argue, this is harmful to the industry as a whole. It does not help the students that they are not actively encouraged to know about the history of production and manufacture and, indeed, labour relations in the industry for which they are being trained. Nor is it advantageous for the largely female workforce concentrated in production to be downgraded, and so far removed from the designers. It simply confirms their low status and makes it difficult for them to envisage moving up the fashion hierarchy in any meaningful way. It is a way of separating skills and maintaining divisions of social class and ethnicity. Fashion education finds it difficult to integrate the skills and techniques upon which it is dependent into its professional vocabulary because these are too reminiscent of the sewing and dressmaking tradition, or else because they conjure up images of sweat shops or assembly lines. One way out of this dilemma is to emphasise the craft aspects of fashion design, which several courses (usually connected with textiles) do. Others expect students to know about 'execution' but not necessarily to be able to practise it themselves. And a tiny number of courses do actually integrate technology and production into fashion design. One BA course in Creative Fashion Technology describes itself in its course documentation as 'nationally unconventional' for this very reason.[1]

These dimensions of the process of fashion production are further eclipsed by the rise to prominence from the mid-1980s onwards of the fashion designer as artist and celebrity. This reconfirms the emphasis on creativity and imagination. The rigid hierarchy of skills in fashion education means that the designer might know nothing more about production than the fact that if a problem arises with an order then it has to be solved rapidly, if necessarily by getting a better team to take over the work. These teams frequently remain totally invisible 'hands'. Indeed the word 'sample hand' can still be found in some course documentation.[2] The designer might be expected to oversee production, but the chain of activities which together comprise this process are not seen as active and dynamic social relations which involve significant numbers of people. The designer remains quite cut off from the people who actually make the clothes and this assumption is embedded in educational practice. According to designer Tracy Mulligan, students often never visit a design studio, never mind a factory (Mulligan, interviewed by Daniels 1996: 20). In response to this claim by Mulligan, one lecturer said in passing comment, 'It would spoil the romance of fashion for the students if they were to see that side of it.' Thus (and this will be demonstrated in the sections which follow), to consolidate its place in the art schools, the subordinated field of fashion, endlessly feeling itself perilously close to the discredited place of manufacture, production and dressmaking, actively repudiates this connection as a means of seeking confirmation and validation as an autonomous artistic practice.

39

'TESCO'S WINDOW'

Fashion education constitutes itself through the bodies of knowledge which comprise the curriculum. For the British art school-trained fashion designer to exist, fashion education also needs an idea of the 'fashion subject'. The fashion subject is first and foremost a creative individual. It is through the process of rendering the subject as creative, or 'bringing out' his or her creative potential, that 'the work' (typically, though not exclusively, the collection) becomes meaningful. For 'the work' to work it also has to fit a recognisable place within the criteria of assessment and distinction around which the courses operate. The student's identity should merge with 'the work' in such a way as to indicate a fusion of uniqueness, originality and what is often called 'vision'. Throughout the duration of the degree this kind of totality and integration is sought through project work and different kinds of assessment involving 'crits' when tutors individually or in groups give their critical response to the students' work.

This process takes place across the range of fashion courses. However, each department also nurtures its own brand of 'expressive individualism' as a means of distinguishing and confirming its own specific identity. This brand image is part of a whole social and pedagogic process. It is a means of inculcating into the students a kind of departmental trademark. The differences between each different departmental ethos are also a way of encouraging diversity in the sector. One head of department said, 'What I look for is portfolio and personality' (Respondent D). This breezily abbreviated account of selection criteria usefully describes the search for the student who shows potential to fit with what Rose has called the 'subjectivising processes' of the social institutions including education (Rose 1997). As evidence of the importance of being able to demonstrate these particular qualities of selfhood, another head of department emphasised her institution's policy of personally interviewing every single person who put the institution as first choice. The time spent interviewing up to 400 candidates was a good investment, as she put it, because it was the only way of getting a feel of the 'chemistry' between the applicant and department. But this individualising technique must also be seen as a kind of disciplinary action. The notion of a fit in this way suggests the perceived need for mutual complement between individual applicants and departmental ethos:

> It's a very open plan world here, you use the production room together, there is nothing hidden away. If somebody bursts into tears, everybody sees it. You get hugged and kissed if you lose a boyfriend. There are no blinds in the staff office and the technical equipment is in the corner. It's a very receptive, very caring environment.
>
> (Respondent B)

This is also a highly regulated space, the openness, as Foucault would quickly point out, gesturing towards non-hierarchical relations while in fact forcing both

the personal and the professional lives of the students to be lived out in front of everybody else (Foucault 1977). The ideal fashion subject must therefore allow him- or herself to be open to surveillance in this way. The appropriate show of emotions displayed in relation to the world of 'boyfriends' also contributes to the constitution of the fashion subject, indicating in this case a wholly feminised and heterosexual ethos. This expectation of open displays of normative emotional behaviour also becomes a way of reading 'the work', so closely merged is the self with the work. One head of department said in interview, 'We expect our students to be passionate about fashion', and another said, 'Our students are very passionate and often immature'. (Respondents A and F). Passion is therefore a further distinguishing and expected quality, also a means of regulating or constraining the subjectivity of the student of fashion design not in restrictive, but in expansive, terms. It is an expectation to expose the self in this particular way, as evidence of the artistic temperament. Likewise, immaturity marks a subjective mode which the three years of the degree will transform into maturity if the student is to be successful. The fashion student should demonstrate both a prescribed emotional intensity and sufficient youthfulness and vitality to fulfil the requirements and expectations of the academic course. These current and future practices of the self represent an important part of the whole pedagogic process, ways of 'shaping up' the student so that she or he will embody the desired departmental image.

Failure to fit with this prescribed subjectivity can mean leaving the course, being advised to transfer to another, or else simply not doing well. Students also learn these informal rules and use them as their own criteria for selecting courses and sometimes for transferring mid-way through a course. As Tracy Mulligan said, 'I was completely lost there (at Kingston) . . . I thought I was more commercial than I really was . . . Central St Martins allowed me to be really eccentric' (Mulligan, interviewed by Daniels 1996: 18). These forms of knowledge and experience and these processes of shaping up the talent are what produce the final product and thus establish and confirm the reputation of the department. These are also 'dividing practices' (Foucault 1984) which create a spread of categories of appropriate subjectivities for different departments, reflected in comments like, 'She's very much a Ravensbourne student, not a Central St Martin's type at all.' This is also a means of making fashion design intelligible to itself and to the outside world, it is the means by which 'fashion' is actively produced. The categories provide a grid for producing the kind of person who is a fashion designer, while also constructing the terms and the distinctions through which the design work is understood. This is also, of course, a way of setting limits and establishing norms and values. It regulates the student body and polices their behaviour while, at the same time, maintaining the idea that art students are expected to be more expressive and unconventional in their behaviour because the art school as a free and unregulated environment encourages this as a pedagogic practice conducive to 'good work'.

Since fashion is keenly aware of its subordinate status in the art school

hierarchy, the question of image and identity is also fraught with anxiety. This is manifest through the ambivalent status of publicity. Publicity is the link between the department and the outside world. Fashion attracts more attention from the popular media than any other subjects taught in the art and design sector. The combination of models (and sometimes supermodels) wearing the work of the students in the public space of the catwalk offers strong and highly sexualised visual images to the media and to the public. This attention is useful but also problematic for the professionals.

> We're Tesco's window. The cream on the cake. Fashion gets more attention than any other area. But even at the RCA fashion did not get degree status to begin with. My head of school was certainly of that opinion, that fashion isn't really degree level work. There is plenty of admiration for the funds we raise and the publicity, but in academic terms it's not easy to be taken seriously. It's a sexist thing. It's OK for graphics and for illustration but fashion is female dominated. Industrial design is also OK but fashion design is ephemeral.
>
> (Respondent G)

This statement confirms many of the themes raised in this and the following chapter. The reference to a supermarket chain indicates the anxiety about the status of fashion in the art school structure. If fashion is too popular, too downmarket through the degree of publicity it attracts, this can merely confirm its inferior status in the art school where the internal criteria for distinction is that of being not so popular, not so easily accessible by the public and not possessing such a feminised image. To have degree status must mean being difficult, abstract and theoretical, not an extension of the world of entertainment, as this lessens the 'cultural capital' of the discipline (Bourdieu 1984). Fashion must therefore rid itself of this popular image by promoting itself as a serious academic subject. It achieves this by fulfilling and safeguarding all the normal academic procedures and also by developing its own distinctive professional identity and curriculum within the academy. Each department and institution must also work to produce its own image and identity. These have to be distinct and different from each other so as to defend the diversity of the system. If there are so many fashion courses there have to be several ways of teaching fashion and also of practising as a designer.

What unites the academics and underpins this system as a whole is a commitment to 'tradition' and to maintaining what is distinctive and unique about British fashion education, that which sets it apart from the rest of the world, Europe, in particular. References to tradition are the means by which fashion legitimises itself as having a past and a history which is also part of the history of the art schools themselves. This is also a history which evokes individuals and personalities, departments and departmental battles. It accommodates different approaches and specialisms and it also acknowledges the difference between for example, the patrician image, which continues to linger around the Royal College

of Art (postgraduate teaching only and the lowest student staff ratio in the country) and the more radical image of Central St Martins which stems from the support it received first from the London County Council and then later from the Inner London Education Authority. Across the sector it is this 'great tradition' which, it is claimed, has actually created British fashion. It is the rigorous art-school-based training which is different from the atelier (or apprenticeship) system of European *haute couture*. As Lydia Kenemy said in interview, 'The work is, and always has been, completely different in Europe and that's because they have a different kind of training.' Fashion academics are also the subjects of the fashion system and they too are expected to embody and transmit this culture of fashion. Most heads of fashion have been trained in the British system and have worked in industry, many have also been practising designers themselves, often well-known names. Overall, the sector remains largely female, an exception in academia, and a vivid example of fashion as a gender-segregated labour market.

The work that follows and also the statements quoted above draw on two main sources.[3] These are, first, a series of semi-structured interviews carried out with twelve heads of department (ten female, two male) over the summer and autumn of 1992. In addition, I interviewed one retired head of fashion and I also talked informally with a number of lecturers in fashion as well as various cultural studies lecturers in the art school sector who had special responsibility for fashion students. Second, is the course documentation made available through the residual body established to conclude the affairs of the Council for National Academic Awards. This includes validation documents and course review documents for all fashion degree courses. The time-span covered in these documents runs from 1983 to 1993. This material allows me to begin to answer the questions, what is an education in fashion design? How does it shape or influence the practice of fashion design? What is the range of fashion courses and how do they differ? How does fashion manage its relation with popular culture and the outside world? The ideal types of fashion education described below provide an account of the main approaches to fashion design education. In practice, most courses combine some elements of at least two of the three models.

PROFESSIONAL FASHION

Until recently, courses falling under this type of education model have been exclusively womenswear courses. They have said of themselves that they seek to achieve 'broad range elegance' with a focus upon being 'glitzy' or 'very sophisticated'.[4] In this sense they represent what Bourdieu would describe as 'clothes which satisfy the demand for distinction' (Bourdieu 1984). This does not make them *haute couture* courses, however. Their market is broader and less expensive than the fashion houses of Paris or Milan. Course documentation points to a number of examples of the type of companies fitting this model. These include the British designer Nicole Farhi, the Italian company, Maramotti, and the German

label, Escada. Each of these companies focuses on well-paid professional women as their key target market. The emphasis is on elegance rather than imagination or originality. Maramotti is a huge Italian textile and fashion corporation with a number of well-known subsidiaries and ranges.

Professional fashion course documentation also stresses that this is 'mature' fashion design, indicating that graduates from these courses might aim for jobs in large, upmarket and possibly European fashion companies. Thus, while the British art school education system differentiates itself sharply from the atelier system of the European fashion houses, students trained within this professional model will be encouraged to look for work abroad and learn something of that tradition.

> The students go to Milan or Paris. They will not be working for Next or C&A. I believe fashion is dictated from the top and that is the way this course develops. In the first project they have their work sheets and they look at what influences figures as diverse as Versace or Courrèges. It would be fifteenth century Italian art or writers like Proust or novels like Lolita, and they go and research them, and suddenly they see where Versace got his colours from and they realise it is relatively easy to get inspiration. Ideas are all out there in art history and also in our common culture. What they have to develop are antennae. The street is very interesting and valuable but it does not create anything that is new. Even Gaultier, people say he just copies London, but he is also looking at postmodernism, and at the baroque, it's the street plus his own inspiration.
>
> (Respondent B)

This statement provides a rich account of the various tensions and issues at stake in fashion education in general, and also for 'professional fashion' in particular. There is a double disavowal, first of the mainstream high street retailers (Next and C&A. . . . and it is also interesting that these are placed alongside each other), and then also of the kind of fashion associated with 'the street'. The word in itself carries connotations of low culture and the common masses, even if this is now tempered by some slightly grudging recognition of 'raw talent'. More specifically, it suggests the untrained, unprofessional or amateur input in fashion from youth cultures. The respondent poses, against these influences, the more 'consecrated' references of the high arts, thereby suggesting the more suitable relation between fashion education and these more elevated forms. In addition, it is to the world of art and literature that the respondent looks for such validation. These are, as Bourdieu would argue, established fields of cultural legitimation. As a relative newcomer to the field of the arts, fashion positions itself in deference to these authoritative high culture traditions (Bourdieu 1993a: 132–8). The conventions of art criticism are also used to give weight to the respondent's reference to Gaultier. Not only does he look at the baroque and postmodernism, he also has 'his own inspiration'. Another head of department described the sort of students attracted to this kind of course as follows:

They read *Vogue*, they see Jasper Conran, Rifat Ozbeck and they get very excited by the shows. They are the sort of people who have been drawing ladies in stilettos and wraparound sunglasses in their physics books for years.

(Respondent F)

Both statements are reflected in course documentation where project work draws on themes taken either from the field of the fine arts or else from the luxury consumer culture of the upmarket glossy magazines. Sample projects include researching the 'Belle Epoque 1890–1910'; 'Portrait Painters'; and 'Explore What the Work of Man Ray Brought To Fashion'.[5]

A different but complementary slant to professional fashion is found in the following statement, 'We produce individuals who are creative but who are also supported by knowledge about those technical skills at the appropriate level to what they are going to be doing' (Respondent G). Here, the role of 'technical skills' is significant since professional fashion emphasises, in contrast with the more experimental or 'conceptual' course, the importance of knowledge about the whole process of production. The students are being prepared for 'creative fashion design' in what is 'an increasingly international industry'. Their overall professional training must therefore provide them with knowledge of the full range of skills employed in the fashion process. They must 'be capable of working with pattern cutters and sample machinists to achieve their finished results'. They must also know the basics of 'creative pattern cutting' and be able to 'reproduce as near as possible to a good design sample room, with work evolving from basic projects. Most important the students must have "high aesthetic standards"'.[6]

The students on these courses are probably more familiar than others with what is involved in fashion production. This knowledge is also considered helpful when they are looking for work in Europe or in the USA. And, to further ensure this, the courses also provide strong business studies components. Yet, despite all this it is the design work which is central and it is on this that they are assessed; 'Drawing ability is crucial to a fashion designer' and, second to this, he or she must be able to see through to completion the 'sketchbook collection'. Submitted work therefore focuses around the sketchbook, the research and the idea, with the 'finished rough stage' including colour and fabric indicators all being made to sample. Course documentation also indicates that these students are being prepared for work in 'design, consultancy, in-house design and successful self-employment'.[7]

Producing students for 'top range' fashion has come under some criticism, for the reason that the foreign fashion houses are looking less for these full professional skills from British graduates and more for the eccentric or experimental work with which they associate British training. In addition, there are a limited number of job opportunities in this sector. The students have too high expectations of costs for fabrics and overall quality to work for the middle range British

companies and for these reasons are more likely to have the same aspirations for having their 'own label' as their more experimental counterparts. The fashion departments have acknowledged this problem by extending professional fashion to include menswear and also childrenswear and they have more recently encouraged the students to consider careers in fashion management. There is, however, a degree of mismatch between the expectations of the big, upmarket companies and the 'professionally' qualified young designers. The foreign companies want British eccentricity although as we shall see in the section that follows, this does not necessarily mean they are willing to pay good wages or provide good working conditions for these 'English Eccentrics'.[8]

MANAGERIAL FASHION

Managerial fashion represents what might be called the 'new realism' in fashion education. Business and marketing are fully integrated into these courses rather than simply added on as a supplement. Typical titles of courses which can be included in this type are 'Fashion Marketing', 'Fashion Design with Marketing', 'Fashion Communication and Promotion' and 'The Business of Fashion'. The first of these degrees was introduced in 1981 and the others have emerged from the mid- to late-1980s. What underpins the thinking behind this provision is that not all students of fashion design are going to be successful as designers. There is also a recognition that too many young fashion designers find themselves with no option but to be self-employed. Given the difficulties in financing such an undertaking the 'new realism' emphasises the need for flexible skills and, in particular, provides students with training in marketing and management. There is also a 'correspondence principle' (Bowles and Gintis 1976) between this type of course and specific fields of employment in fashion, including fashion promotion and publicity, fashion styling, fashion retail management and fashion forecasting. These courses set out to solve the perceived mismatch between graduate skills and the needs of the industry. They do this by attempting to merge 'creativity with commerce' and, in particular, by stressing opportunities in business and management. These courses also reflect a realism in that they prepare students for the mainstream of the fashion industry and particularly, for those companies which have brought in a higher design content to their stock over the last few years. This connects with what, in the early 1980s, was labelled the revolution in high street fashion where, with the emergence of companies like Next, a new kind of consumer culture was created which catered for diverse markets and which redefined the chain retailer in fashion as being synonymous with cheap mass produced goods. With Next the whole retail environment was designed to represent a more distinctive and upmarket lifestyle. The emphasis was on small runs of goods with a fast turnover. This was made possible by the use of new computerised technology in fashion production and, in particular, of post-Fordist techniques including Electronic Point of Sales (EPOS) systems allowing manufacturers to

produce short runs of goods responsive to sales and manufactured on a Just In Time (JIT) basis – thereby minimising loss of unsold stock and also the cost of warehousing. The new prominence of design elements in goods produced for a mass, if differentiated, market also gave rise to new forms of fashion media. The popularity of fashion 'designer culture' spawned, for example, television programmes such as The Clothes Show (BBC) and the spin-off and very successful Clothes Show Magazine.

This broadening of the consumer culture meant more jobs for young graduates in fashion-related areas. These included styling, fashion promotion, window dressing and fashion retail management. The downturn in consumer spending from the early 1990s onwards put a brake on this rapidly expanding labour market. As we shall see, the fashion business had to adjust to the end of the designer decade and the bursting of the bubble of consumer confidence which the culture of Thatcherism had promoted so aggressively. Managerial fashion adapted to this with the same consistently new realist approach. And if designer prices even in the context of high street lifestyle shopping could not be sustained then education followed the lead from industry by adapting to the development of post-Fordist techniques being incorporated into and taken over by more traditionally Fordist-run enterprises. Thus, from 1992, Marks & Spencer and other similar companies introduced and maintained specialist designer lines alongside their more standardised and mass produced lines. They have employed freelance a number of well-known designers and allowed them more control over budgets and fabrics so that they can produce distinctive, signature lines manufactured in short runs or batches, but still carrying the St Michael label. The availability of this kind of work allows designers to stay in business and earn a living supplementing (or instead of) their own small independent label collections. Back in the art schools managerial fashion acknowledges this development and encourages students to consider work in this new retail culture. Employability remains the touchstone for these courses which also respond to the new images of the mainstream through the inclusion of these designer niches. It is no longer a matter of, as Tracy Mulligan put it, 'making raincoats for fashion companies' (Mulligan, interviewed by Daniels 1996: 20).

> We are interested in clothes for people rather than in purely 'ideas' fashion. And in the new educational environment, particularly for a department like ours which is part of a new university, we are doing well with this business studies approach. It's about bringing design into business and away from the old art and design model. It's contextualist. We also find it easier to get our students placements now, and they actively look forward to working for Burtons or Storehouse which, in the past, students would have wanted to avoid. What we give our students is a broad general fashion education. And they get jobs, even if they might not end up as the name on the door.
>
> (Respondent I)

This quotation usefully demonstrates various of the themes outlined above. The fact that students might not end up as the 'name on the door' is a direct reference to that model of fashion education which is overwhelmingly devoted to producing creative individuals as names, and even stars, of the fashion world and who, as Bourdieu once again has shown, emulate the star system of high culture with its emphasis on the 'rarity of the producer' (Bourdieu 1993a: 137). Other courses might seek to produce designers as names, signatures and labels: 'The creator's signature is a mark that changes not the material nature but the social nature of the object' (Bourdieu 1993a: 137), but managerial fashion courses pursue a more realistic path. The reference to 'people' indicates a move away from the traditional élitism of high fashion. The high street retailers are also recognised as vitally important for the fashion industry as a whole and for employment. The statement also emphasises jobs in favour of fame, immediate recognition and the ethos of creative individualism. This whole way of thinking is then packaged within the framework of the appropriateness of real jobs for the more down to earth students trained in such an institution. No mention is made, however, of knowing about or gaining experience in manufacture and production. The emphasis is instead on the managerial dimension, even though it might be argued that good managers need to know about precisely these aspects of the fashion industry. The same respondent justified this by indicating that questions of manufacture and production are better dealt with in separate types of courses:

> For the local women and girls, many of whom are from ethnic communities, there are other kinds of courses available. There is a lot of skill in these communities for garment production and we direct these applicants to the HND course and the City and Guilds courses offered in many of the local colleges.
>
> (Respondent I)

CONCEPTUAL FASHION

The third and final model of fashion education is also the most visible in popular culture and the mass media. Often referred to as 'ideas fashion', the word 'conceptual' is more accurate in conveying the strong orientation in this approach to experimentation and innovation. The emphasis here is to connect more directly with the fine arts and to defend this by arguing that this kind of work provides the lead with which the rest of the fashion industry will eventually catch up; thus, the importance of freedom to experiment without being accountable to industry or business. Only under these circumstances will creativity find its true expression. This approach resents the way in which experimentation is encouraged and expected in sculpture but scorned and even ridiculed in fashion:

> We are criticised from the inside and outside for wasting taxpayers'

money. But we allow that gamble, partly because there is a tendency not to recognise that the fashion discipline is conceptual. It is not intellectual snobbery, but we do value conceptual ideas here and we do want to challenge the status quo.

(Respondent A)

This is a strong defence of fine art values against those associated with the commercial market. Bourdieu argues that to assert distance from the market, to the point of embracing an 'inverted economy' where money does not matter, is in fact the clearest pathway to cultural consecration (Bourdieu 1993a: 39). This head of department recognises the subordinate place fashion still occupies in the art world, hence the gamble she takes in arguing her ground and staking a claim for fashion to be judged in these terms. There is also a suggested inversion in her claim that this is 'not intellectual snobbery'. What she is saying is that maybe it is intellectual snobbery (also a gamble) but this is exactly what fashion needs if it is to gain an acceptable place for itself in the art school hierarchy. This approach is then rescued from élitism by the respondent's reference to its anti-establishment ethos. In this sense it belongs firmly to the post-war art school tradition of challenging authority.

Another head of department described her course in similar terms:

The course is conceptual and research-based. It also involves the manipulation of materials and drawing. We really push drawing and research and we see manufacture as the realisation of an idea. I want to produce very inventive students, thinking students who are going to challenge, not do versions of things. I'd rather people loved it or hated it – they should have the courage of their own convictions.

(Respondent C)

This ideal type of fashion education is closest to the doctrine of creative individualism. In each of the above statements, there is no mention of the market or of the need to merge creativity with commerce. Indeed, the latter is recognised as being potentially detrimental to the whole ethos of fashion design education: 'When the courses go down the fashion marketing route the work that is produced is often disappointing. The students are being forced all the time to think commercially and the degree shows lack the energy and the spark' (Respondent F). For this reason the conceptual courses try to resist pressure to forge links with industry:

I'm not so keen on the education and industry emphasis. We want to generate people with ideas. Whether it's Galliano or working in the mass market, people have to be allowed to take a chance. Industry expects too much from the fashion courses. We were pushed into making these links from the late 1970s but there is no way you can teach students so that they fit in with every company.

(Respondent C)

This comment incorporates into the umbrella of conceptual fashion the extremes of the industry from Galliano, the most successful product of Central St Martin's in the mid-1980s and typically described by the fashion press as a 'creative genius', to the mass market. The creative individual is presented as having the freedom to choose the career options available in fashion, rather than being pushed in the direction of either professional or managerial jobs. Conceptual fashion allows itself both to repudiate industry and, at the same time, to describe itself as preparing students for every sector of the industry. Another head who might also be seen as a conceptualist, described at more length the pitfalls of working to an industry brief: 'Industry doesn't know what it wants. It needs ideas, quality thinking and flexible skills, people who can also be put into management. But pattern cutters is all they think about. They expect graduates to have immediate skills. In Marks & Spencer they have them in the workroom by lunchtime churning out twenty five blouses' (Respondent F). And finally another respondent explained her caution about pursuing links with industry:

> Industrial liaison is all very well but it is hard to arrange and it takes time out of everybody's timetable and syllabus. You have to explain your business and listen to him. Sometimes he makes money and sometimes he doesn't. Sometimes he doesn't understand his own business and he is looking to the students for cheap ideas. It doesn't always lead to a fulfilling relationship. It can be counter-productive. They think they have got me, and you know you haven't got them. Macs for Burberry, outerwear for Aquascutum. It's wrong. We start by leading. If they haven't got the ability to use the talent we've got here then the students will continue to go abroad.
>
> (Respondent B)

This, too, indicates a certain amount of realism in the exchange between education and industry. There is some degree of criticism of industry and there is a clear recognition that both sides of the exchange do not necessarily have the same goals. There is therefore an active debate in conceptual fashion about the meaning and significance of the question of links with industry. Elsewhere it is often assumed to be a good thing and the role of placements, work experience and sponsorship is accepted more or less without question. This more critical role is in keeping, however, with the conceptualists' commitment to being challenging. This refuses strict adherence to the correspondence principle already seen in the other models of fashion education (Bowles and Gintis 1976). Being challenging puts the products of conceptual fashion in the league of the established arts where individuals emerge as creative talents who will work independently and who will not necessarily fit into an appropriate job with an appropriate company. The extent to which they are described in the press in these terms is a further sign of their uniqueness and of their status as artists. This is the end product of the art school system which has sought to shape the 'fashion subject' in this way. The

'stars' are the students who are awarded first class degrees and who will demonstrate all the signs of the conceptualists on the catwalk while also being commended for 'professional finish' in their studio work. Most of the well-known names of British fashion over the last few years have fitted with this model. These include John Galliano, Hussein Chalayan, Pearce Fionda, Sonnentag and Mulligan (the only females so far), Copperwheat Blundell (a male/female duo), Flyte Ostell (likewise) and, more recently, Antonio Berardi. Although, as we shall see in the section that follows, this independent and creative pathway is possibly the most fragile and the most difficult to pursue, it is also the course which the great majority of graduates want to follow.

Despite the commitment to diversity in provision there is a sense within the sector that conceptual fashion occupies a position of dominance; it attracts the most attention, it appears to produce the greatest talent (a problematic claim as we shall also see) and it certainly speaks of its own practice with a greater degree of confidence. In a sense, it is not surprising that this is the model of dominance (in, as Bourdieu puts it, a dominated field) since this approach defines its own practices narrowly, and almost exclusively, within the terms of the fine arts: 'It is truly creative work that we do here. We are accused by our enemies of being very self-indulgent, very theatrical. But this is a fashion course, the rest is clothing' (Respondent B). In this case the accusations against fashion are exactly the terms upon which it wishes to be judged. Clothing is repudiated as something quite other than fashion. Fashion ought to produce these strong reactions if it is to be challenging. The fashion subject who takes on and continues to represent these attributes is envisaged then as equally singular, idiosyncratic and able to withstand criticism and even condemnation. This is consequently a more 'aestheticised' subject than that found in the other models of fashion education. He or she can be legitimately self-indulgent or rebellious. Course documentation supporting this type of provision emphasises the role of such individuality: 'This course is intended for the dedicated, very specialist focused designer Innovative fashion design requires deep knowledge generating a wealth of ideas'.[9] And likewise: 'It is expected that graduates from such courses work as 'creative fashion designers' or as 'experimental fashion textile designers' in combination with 'innovative international fashion designers or design teams'.[10]

Experimental courses like these have from the early 1990s inevitably come under pressure to introduce some element of commerce into what they do. In practice, this has involved extending the field of design to embrace more fully menswear and to incorporate some element of teaching marketing to the students. This latter element remains, however, subordinate to the students' deep commitment to innovation and imagination. Indeed, it is through this aesthetic intensity that the most fully defined fashion subject emerges. It is here that the self becomes literally synonymous with the collection, as we shall see in the section that follows. Creative individuality of this type uses the legitimating vocabulary of art and its movements – avant-garde, postmodern, deconstructionist – to explain itself to the outside world. The ability to provoke outrage or condemnation as

'wasting the taxpayers' money' is further evidence of fashion's standing within the art community. This places it alongside other famous 'outrages' in recent art history such as the 'pile of bricks' at the Tate Gallery, or Rachel Whiteread's concrete cast *House* in Bethnal Green, and it also allows fashion the privilege of being 'incomprehensible' to the ordinary viewer.[11] However, while the students on these courses appear to be given a free rein to explore their imaginations and bring their own personal experiences to bear on their work, this openness can be understood once again as a form of constraint and regulation. The more unique or idiosyncratic the creative individual is expected to be (and these traits are frequently described as flamboyance or charisma), the more emphatic are the 'technologies of the self' which the students must draw upon to produce themselves in this way. Both the fashion work and the student him- or herself become part of a whole performance. The star of the year is very often the (male) student who most closely fulfils the role of highly creative individual by virtue of his careful and studied deployment of the requisite attributes. These include a certain kind of brash confidence, the evident mastery of some key features of fashion technique such as bias cut and tailoring, the ability to apply in a seemingly casual way key art words to his own work, an eccentric or flamboyant personality, a sense of drama and theatricality so that the clothes are made to perform and, last but not least, a desire to break some rules and shock the public as well as the art and fashion establishment with his work.

4

FASHION EDUCATION, TRADE AND INDUSTRY

THE SWEATSHOP ON THE FOURTH FLOOR

Three themes now present themselves for further consideration. These are, first, the question of gender relations in fashion education; second, the place and status of popular culture in fashion education and; third, the extent to which issues of manufacture and production appear to be downgraded and removed from debates about the fashion design curriculum. The relationship between these three themes is, I would argue, the product of fashion's battle for recognition in the art school and the dominated place which it has occupied within the hierarchies of the art school establishment. Sex, class and also ethnicity have played a role in this process of subordination. Historically, fashion has been perceived as a field of feminine activity, and women working in fashion education have had to put up with prejudice and discrimination. As Lydia Kenemy said in interview: 'It never felt as if we were doing anything important. In fact, we all felt we almost had to apologise for our existence' (September 1991).

Fashion in the art school has been tarnished with the associations of trade and industry. As Madge Garland noted in her inaugural lecture, fashion suffered from its 'little dressmaker' image (Garland 1957). The connotations of low skill and low wage work in fashion extend from the local or domestic activity of dressmaking, to the immigrant sweatshops of the large cities to the textile factories of the north of England. Popular culture also detracts from the status which fashion wishes to secure for itself through its associations with the people, with mass commercial culture, with youth culture and, once again, with women. For fashion to achieve the high academic status that it seeks in the world of art and design, these connections must be broken.

While the fight for recognition on the part of the pioneering women of fashion education has parallels in other academic fields, an additional obstacle for fashion has been the relative absence of a strong critical tradition of research and scholarship. A handful of women came to occupy positions of prominence in fashion (such as Ethel Cox, Muriel Pemberton, Madge Garland, Janey Ironside, Joanne Brogden, Lydia Kenemy and a few others) but their influence has been on pedagogic practice. The relative absence of theory in fashion design education has

53

weakened its position in the academy and this, together with it being seen as fem-
inine and therefore subordinate, means that fashion academics still find themselves
located further down the institutional hierarchy: 'I think it's about fashion being
seen as a female sphere. Certainly we don't get anything like the space which
other departments insist on. They just push and push and they get it and we find
ourselves cramped and feeling that we have to put up with it' (Respondent E).
Access to space and resources is therefore recognised as a question of sexual
politics.

> Sculpture just stands its ground, you've got these demands from the stu-
> dents and there are always these big lads with their sledgehammers and
> their huge bits of stone or whatever and they want to do big pieces of
> work that take up the whole place. They all say they need to be able to
> move around and that it would be dangerous if they didn't have that
> space. It's the same in painting. But they assume we can just cram more
> and more students round the table and it doesn't matter if they are work-
> ing elbow to elbow. They'll fob us off with the promise of a few new
> pieces of equipment.
>
> (Respondent F)

Another academic agreed that fashion was seen by the art school hierarchy as a
female space which would more easily bend to pressure:

> I've had to introduce a shift system here, a kind of flexi-time not just for
> the equipment but for the actual working spaces for the students. They
> have to book in for morning or afternoons and on the knitting machines
> there is also an evening session. We've long given up the idea that the
> students will get the personal desk space they used to. Fashion has suf-
> fered the brunt of the cuts in this respect. They have this idea that we
> just need the end of the table to cut our fabrics and that as long as we
> have a few sewing machines we'll be OK.
>
> (Respondent D)

It was widely recognised that these issues of space and resources were influenced
by gender:

> When I took over this post, most of the senior posts were appointed
> from graphics and there was still a lot of sexism. And the visible side of
> the degree was the fashion show which was seen as frivolous entertain-
> ment even though it brought the institution a lot of publicity. Six frocks
> is what people thought we did. We were known as the 'fashion girls' or
> the 'sweat-shop on the fourth floor'. For these reasons I did away with
> the show and the students did a kind of performance instead, finding the
> sort of people they wanted to wear their clothes and bringing them in

for the day to do that. I have also tried to counter this image by doing
a lot of institution-wide work. Then they get a better idea of what we
actually do. And the modular scheme has also opened things up. One
half of our first year went into sculpture and the staff couldn't believe
what they did there. They had absolutely no preconceptions and they did
this really outrageous stuff.

(Respondent C)

These comments reveal the way in which gender differences in the art schools
operate to the disadvantage of fashion. The above quotations mesh a number of
themes. First there is the assumed privileging of painting and sculpure in the allo-
cation of studio space. This requirement was duly borne out in all my visits to the
different art schools. In every case, the fine arts students had more space to walk
about in, they could visit their friends on different floors, each of whom seemed
to have their own personal working space, there were fewer students about and
they certainly were not working at each other's elbow. The fashion studios in con-
trast were often overcrowded and visibly cramped. The atmosphere was busy and
the students were jostling each other for space, equipment and materials. Second,
the above respondent also mentions the danger of the popular appeal of fashion
detracting from its identity in academia as a serious subject area. We can refer this
back to the comment in the previous chapter about being seen as 'Tesco's
window'. The above respondent also attempts to challenge that idea by replacing
the catwalk show with a 'performance', thereby bringing to fashion something of
the more authoritative vocabulary of art. The third point is that fashion is rede-
fined as a kind of performance art. This emphasis is further reinforced through the
references to the fashion students' success in the sculpture modules, against all the
expectations of the sculpture staff.

Fashion tries to be taken more seriously as a discipline by demonstrating the
appropriateness of criteria for assessment of fine art models. It must relinquish any
attachments to the world of popular culture to achieve this end. In fact, it has to
rise far above its popular image.

The glamour and the stars and the publicity are fine at one level. But the
danger is that we are seen only in these terms in the institution.
Professionally, we cannot afford this because it just gives the engineers
and the men at the top the opportunity to confirm their prejudices.

(Respondent G)

Another respondent connected the popular image of fashion with the relative
absence of scholarship: 'There is an absence of a critical voice in fashion. Instead
it is celebratory or else it duplicates the voice of fashion journalism. But there is
no engaged debate' (Respondent C). As Bourdieu has suggested: 'To play the
(fashion) game, one has to believe in the ideology of creation and . . . it is not
advisable to have a sociological view of the world'. He continues '. . . Second

55

received idea; that sociology . . . belittles and crushes, flattens and trivialises artistic creation . . . at all events, fails to grasp what makes the genius of the greatest artists' (Bourdieu 1993a: 138–9). Bourdieu is arguing that rather than seeking the reluctant legitimation from the high arts, fashion needs the critical input of sociology. But as long as fashion seeks this elevated status, which can only be achieved through the production of 'belief' in fashion by the journalists and critics as a rarified creative activity, the input of sociology can only be unwelcome, tainted as it is by the concerns Bourdieu describes. Sociology as a discipline is too associated with challenging hierarchies and élites and with defending both low culture and the masses, for it to play anything other than a negative or even destructive role. If Bourdieu is right and sociology is seen somehow as the enemy of fashion then, not surprisingly, fashion students will be steered away from sociology, while being encouraged to develop a trained eye for relevant social phenomena:

> Fashion students need to observe what's going on around them and this means they can't be snobbish or élitist. They have to have an interest in the outside world, and the club scene is part of their research. They can also take advantage of being in a capital city.
>
> (Respondent I)

The professional skills of the trainee designer require him or her to have an anthropological interest in the common culture of the street but not to embrace it: 'Often they come in, full of the influence of the street, and one of our jobs is to get them to develop a bit of distance from this. It's very raw at this stage, very naïve' (Respondent A).

The street and popular culture are thus understood as an expression of the students' immaturity which will gradually fade as they progress through the course. And if we look more closely at course documentation it is quite clear that popular culture themes are noticeably absent. Most project topics and 'live briefs' are drawn instead from world of traditional aesthetic values, for example, 'Re-Create Andy Warhol for the 1990s'. Either that or they represent a particular endorsement of the luxury consumer culture including 'Cruising in the tropics . . . present a collection' and 'Winter holidays in a remote Russian dacha . . . a collection of fake furs'.[1] These fantasy scenarios overlap exactly with the narrative fragments which accompany the fashion spreads in the glossy magazines. In both cases, fashion is removed from any connection with pain or hardship. History (and geography) appear only as a series of set pieces or panoramic stages into which fashion can dip and retrieve some themes or ideas. Everything is transformed into an opportunity for creating beautiful and evocative clothes. This raises the question, if fashion is an art then what is its relation to society? While the politics of art has been the subject of endless debate in art history as well as in sociology and cultural studies, fashion as art has slipped this net.

We might expect this kind of question to be debated in the cultural studies

components of fashion degree courses. It is here that the students are free to re-explore the terrain of cultural theory, popular culture, the street, working-class life, ethnic subcultures as well as the more conventional topics of art history. However, social or political themes engaged with in cultural studies which then resurface in studio work are typically translated back into the more authoritative language of the fine arts. For example, at one of the degree shows I attended many students showed work which illustrated themes taken from popular culture (for example, a *Flintstones* collection and a *Peyton Place* collection, even a collection which comprised British Telecom phonecards stapled together), but this kind of work was presented as evidence of the influence of postmodernism:

> The influence of postmodernism means that the students are stealing all sorts of references from popular culture and putting these into their clothes. They know because of what they have read that it's OK to do this. But often the work itself suffers, if they have just lifted the ideas.
>
> (Respondent C)

The same thing happened with 'grunge'. In the early 1990s, a number of young designers teamed up with photographers and stylists to produce a distinctively 'poor' look, which was both a counterpoint to the extravagant 1980s and an attempt to make fashion forge a connection between itself and what the designers understood as a tide of despair and resignation among young people, best embodied in the US band, Nirvana. The look which emerged and which upset the fashion establishment by mixing old second-hand clothes with new designer items and showed models looking undernourished and bedraggled as though in a state of drug-induced carelessness was, however, given the philosophically more respectable title of 'deconstruction' in the quality fashion press and in the academy.

> It took them all by storm, the sudden shift away from fashion being glamorous or beautiful, deconstruction hit a note, it happened just when the fashion bubble was bursting and so many of the young designers were going bust. It was another British idea but the graduates from Antwerp really developed it. They made it a lot more formal, artistically.
>
> (Respondent F)

In both these cases, fashion which either shows some interest in society or politics or which clearly owes its existence to trends in youth culture is renamed and reinstated as part of a recognised art movement.

The third and final theme which also informs the practice of fashion education is a marginalisation and downgrading of the practical skills of making clothes. As I have already argued, this process of differentiation serves to separate fashion from the earlier associations it had with the menial skills of

dressmaking and with manufacture and production. For fashion to gain status in the art schools it had to be able to demonstrate that it was not the rag trade. Fashion academics refer to this history from the vantage point of having successfully broken the connection: 'I remember being shocked going into a college in the 1960s and there they were, using Butterick patterns to teach with. I couldn't believe it'. (Informal discussion with fashion historian.) This assumes that there is absolutely no relation between teaching fashion by using paper patterns and teaching fashion design. The former never merited the label fashion, it was always dressmaking. This distinction is formalised in a good deal of course documentation: 'The course does not propose to train students as pattern cutters';[2] 'As students are not being trained as machinists it follows that the selection of appropriate processes is more important than the skill with which it is executed'.[3] That is, studying fashion at art school does not necessarily mean knowing how to sew, how to cut a pattern or to finish off a garment. However, this is modified somewhat in the following statement: 'The designer must be capable of working with pattern cutters and sample machinists to achieve their finished results. Reproduction as near as possible to a good design sample room, with work evolving from basic projects'.[4] And one head of department summarised the whole ethos in the following statement:

> We are not here to educate students to be machinists. If they wish to be machinists we would advise them to leave the course and get a job in a factory. But having said that, the best way to design is to experience it through to the technical side and use it creatively. You have to be strong on the practical side. Some get to excellence in making things. Others are not quite so good. We like things to be well made but we don't take marks off for making up.
>
> (Respondent H)

This emphasises the division of labour in fashion. Creative work is far removed from manufacture, though this is immediately qualified by the recognition of technical skills. Then, and this is the key point, the speaker confirms that the quality of finish is not a criteria for assessment. To the outsider this fact is surprising, that students graduating in fashion design are not judged on finish as well as on the quality of design. It is, however, a key part of the professionalisation of fashion design as a discipline that production and finish are not the terms upon which design talent is evaluated. There are a few dissenting voices from this view, one of whom made the following comment:

> I am surprised when I get a student who has designed a wonderful pair of trousers and when I ask them to make a pair up they say, quite openly, they couldn't do it. Or that they don't know how to put in a zip. They should all be able to recognise basic fabrics and know about textile manufacture and technology. Building on that as an introduction they

would then be in a position to move into more specialist areas. The strengths of the education and training in the United Kingdom have been acknowledged countless times. It's the quirky cases and the diversity encouraged in art and design more broadly which have to be recognised again. But we also need textile technology underpinning all the courses and we also need something like a national curriculum. Of course, at the top of Yves St Laurent the designer will be supported by a pattern cutter but it is not right to concentrate only on this level of work, or on change in fashion alone. Part of the whole thing is to be able to do it yourself, understand the process and do it.

(Respondent J)

The comment about the zip illustrates exactly the sense among many figures in the fashion industry that the emphasis on design alone leaves the students ill-equipped to deal with the transition into work where they need to know how to put orders into production. As we shall see in the section that follows, the students' lack of knowledge about every aspect of production leaves them open to exploitation by manufacturers when it comes to both quality and costing. So, although their status and identity in the design field requires a careless dismissal of 'sewing', the reality of surviving as a designer means that they must hastily re-learn how to sew and become knowledgeable about every stage in the production process. The head of department interviewed above is one of the few people in the field who encourages a craft approach to fashion design and who is also in favour of tailoring being integrated into fashion design. He is also someone who demonstrates a keen interest in new technology and its use in design. More common, however, is a tendency to stake a distance between computer technology and design talent.

We have very little in the way of new technology here and we are horribly overcrowded but we still seem to be able to produce very high quality work. It's a matter of what you prioritise in the course. We realised that, for us, going down the pathway of computer-aided design was probably not what our students wanted. It's much better value for us to have a few more paid machinists in the studio. Then the students can get an immediate sense of what the work is going to look like.

(Respondent A)

This is more typical in that it downgrades the role of new technology in favour of pure design skills based around sketchbook ideas, translated into the more conventional processes of design where a machinist is at hand to do the sewing work on the spot. This point is important since, once again contrary to the lay person's expectations, students might even pay a machinist privately to make work up for them. This is not against course regulations. Indeed, not taking into account 'perfect finish' as a criteria for assessment is judged to be a fairer system. It means that

wealthier students who could afford to get their sewing work done by a machin-
ist are not advantaged against those who have to do it all themselves. And since
there is no way of checking that all the finishing work is done by the students
themselves, this is at least a means of ensuring that money cannot buy a higher
mark.[5]

In this context it is perhaps not surprising that production processes play a min-
imal role in fashion design education. During the research period, I heard of no
occasion of any students visiting a factory or production unit as part of their
course. There was never any discussion of the history of fashion production, of
sweat shops, homeworking or struggles for trade union representation. What the
students were provided with was a business studies package or module. They were
consequently slightly more familiar with the idea of a business plan, a CV and the
importance of getting a bank loan or a 'backer' than they were with employing
people to produce their clothes to order. So, in a sense, right from the start there
is a quite rigid division of labour.

This means that the designer will have no personal knowledge of who makes
up their clothes, on what basis, for what pay and possibly even in which part of
the country. Not only does this reproduce a strict social hierarchy, it also allows
the designers to excuse themselves from the responsibility of exploited labour at
the bottom of the hierarchy and it also permits the intervention of a whole range
of middlemen who will attempt to maximise profits by keeping wages as low as
possible while also safeguarding the autonomy of the field of production and
manufacture to protect their own returns in relation to the costs to the designer.
As we will see in the following section, this situation means that the middlemen
can also exploit the ignorance of young designers about costing, quality and quan-
tity. The designer will ideally delegate the task of bargaining for the costs of orders
to a production manager who will then liaise with the various wholesalers and
subcontractors. But many designers work independently without the services of a
business manager and, in this respect, they are as naïve to begin with as the
machinists and homeworkers are low paid. They retain this distance and distinc-
tion, not only as a mark of professional status and identity, but also as a style of
creative individualism.

FASHION FRAMES OF REFERENCE

How do the students represent themselves? To what extent does their work
demonstrate the kinds of vocabularies and models provided in education? How
does the process of transmission from teacher to student take place? How suc-
cessful are the students in utilising these vocabularies? Without interviewing and
talking to students at length (a task which is beyond the scale of this study) one
way of gaining insight into this process is by looking at how the students present
their work in language. Each final year student will typically produce a portfolio
which visitors and prospective employers can leaf through. They will also submit

a page of work with an attached statement for the graduating handbook or cata-
logue. These statements take the form of a short manifesto, an account of how the
students want their work and themselves to be seen. Often they comprise a few
short sentences, or simply a handful of words. The function is not just to promote
an image or self-representation (a sort of press release), but to act as a form of
'anchorage' (Barthes 1977: 40) by giving firmer meaning to a collection which,
conceived of as a visual form, requires the presence of a linguistic message to
convey more concretely to the viewer how the work should be understood. By
considering a range of these statements it is possible to see more clearly how the
fashion designer as artist is shaped and how particular meanings are given to col-
lections which emphasise creativity and imagination. We can also gain a more
precise insight into the range of available discourses which the students draw on
habitually and put into practice in this exercise of self-promotion.

There are several clusters of meaning upon which the students rely, the most
common of which are the influences of well-known artists, painters, photogra-
phers, writers and film makers. This is the conventional canon to which the
students refer. Sometimes their statements will merely itemise names. More often
this is combined with an indication of what specifically they have studied in these
bodies of work. This provides both a closer association with these particular
worlds and also a way of translating fashion into another frame of reference. It
becomes meaningful through a process of connection, association and deferral:

> The collection is inspired by the work of photographer George
> Hoyningen; he frequently used blocks of colour and geometric shapes.

> Inspired by the erotic vulgarity of Egon Schiele . . . and the photographs
> of Brassai and Lee Miller.

> Having been inspired by a Matisse exhibition entitled 'Jazz' I aim to con-
> tinue his collage technique through to applique details for beachwear.

> A chapel by Le Corbusier inspires a study of purity and spirituality of
> shape.

> Hiroshima Mon Amour as influence to this very simple and laid back collec-
> tion.

Broadly these indicate an interest in the modernist canon in painting, architecture,
film and photography and a wish to be associated with these so that fashion is
understood in the same terms as those applied to works of art, famous modernist
buildings and the work of celebrated photographers. These are the favoured
frames of reference of the aspiring fashion designer.

This process of naming offers one style of self-presentation. Another is sought
through the evocation of a distinctively poetic mode. This typically comprises
words strung together or else it takes the form of a series of impressions:

A sailor top becomes a pair of trousers, whilst huge oil-painted sail shirts in paper and canvas sway with the motion of the sea.

For this collection I have gained my inspiration from the unique formation and flow of a melted candle.

Fashion as an art form. Sculptures in their own right.

The Gallic girlie of flamboyance and panache, the inspiration of Audrey at Tiffany's.

Last night I had a dream of oriental lands where images were transformed into paper.

Nature also provides a framework for fashion aesthetics.

Woman meets bird in this surreal collection where powerful birds such as eagles inspire a desire to take flight.

The Mobius curve is the basis of a range which looks at continuous lines in nature and geometry.

Pencil-thin skirts and bodices reminiscent of crickets, beetles and fish.

This work progressed towards similarities in sculpture and the intricate line spanned throughout nature.

Most frequent, however, are the references to film. Whilst popular Hollywood cinema attracts a lot of attention as a source of inspiration, film is also understood as a fully aestheticised form.

I was inspired by the Chinese film *Days of Being Wild*, particularly the lines, 'She has no feet.'

La Dolce Vita lounge lizards strut their stuff with the Leisure Age.

Wings of Desire a womenswear collection for Winter.

A starting point of Doris Day meets Cindy Sherman results in a collection reminiscent of 1950s American suburbia.

J. L. Lewis' film, *The Nutty Professor*, provides direct inspiration for these designs.

This menswear collection takes a satirical look at 1950s film noir.

Memories, familiar and unfamiliar of 1930s' stars Louise Brooks, Marlene Dietrich and Rita Hayworth.

The final collection has been strongly influenced by the costumes from *Little Dorrit*, a film by Brabourne and Goodwin.

This designer is a self-confessed obsessive whose favourite films and books all star 'women with a story'.

Popular culture and street subcultures make only an occasional appearance in these statements, e.g.:

Faster armed and hard Chicano girls join Princess Leia over a metal cheeseburger.

or

This feisty look is based on the street clothes and identity of Spanish American girls.

These short 'manifestos' (all of which are drawn from degree show catalogues available to the public) show the extent to which fashion is understood as an aesthetic phenomenon by association. From Joseph Beuys to Pop Art, from David Lynch to 'very advanced looks', from 'hints of a liaison with the avant-garde' to 'Californian surfers and Soho style', this process involves a double action. First, fashion gains meaning through making connections between itself and forms whose cultural legitimacy and status are already assured and, second, both fashion and its diverse 'influences' gain further legitimation by virtue of being, in these instances, within the academy. The poetry of the statement also acts as a form of validation as does the use of terms and phrases found with great frequency in art worlds (for example, 'Balancing chaos and order with spontaneity', 'A study of dualities and split personalities').

These are all stock signs of creativity. They each allude to a mode of work which is immediately recognisable as artistic. Here meaning can legitimately be elusive or inconclusive. Abstraction is the surest sign of artistic intent. The creative subject (in this case, the fashion designer) can allow him- or herself the liberty of being whimsical, eccentric or idiosyncratic. Alternatively, he or she can take a stand, and be uncompromising; 'Burying dresses is symbolic of stories I wrote' (Chalayan, interviewed by Tuck 1995: 21). Indeed, the more the young fashion designer constructs him- or herself in this mode the more likely he or she is to be taken seriously as an artist. This, then, is part of the social construction of the self as a creative artist tutored within the institutionalised framework of the art school system.

Of course, this mode of self-presentation varies from one kind of course to another. Many of the above examples are drawn from the field of 'conceptual fashion'. In 'professional fashion' or 'managerial fashion' courses, the equivalent catalogue contributions combine art world references with those drawn from the more practical world of work experience:

My final collection is based upon the wardrobe of Sherlock Holmes, as

illustrated by Sidney Paget and published in *Strand* magazine. This has allowed me to use the tailoring experience I gained at college alongside my interest in combining traditional and unusual fabrics.

My interest in antiques and architecture has formed the inspiration for my summer collection which has been based on the decorative patterns of the Art Deco style, these patterns being incorporated into garments forming the structure and fit of my menswear collection made of linen and suede with knit for texture and pattern.

A visit to Bethnal Green Museum of Childhood inspired the final collection. Lost memories of childhood and nostalgia. Beading and hand-smocking reflect the attention to detail shown in the children's clothes I felt I would be suited to work connected with the theatrical profession.

Even in courses where the students are being trained for working in the high street, it is not unusual to express their preferences for working in a more independent and creative capacity as an ideal: 'As design is my forte I feel compelled to pursue it as a career and thoughts of working as an in-house designer or creating my own label are equally inspiring.'

These comments show how the graduates envisage themselves as artists and draw on a wide variety of artistic vocabularies to project a future for themselves.[6] Fashion is seen as a practice which exists comfortably alongside art forms which occupy positions of high cultural value and which provide cultural capital to those who consume these forms. As Bourdieu has persuasively argued, the high arts, in particular 'modern art', determinedly present themselves as difficult, abstract and unfamilar as a way of setting themselves apart from the more popular arts lower down the scale. The 'modern' arts require education, culture and 'refinement' to be fully appreciated and it is, argues Bourdieu, partly through these means that those who possess these forms of cultural capital reproduce their own power and privilege by both instituting and institutionalising such processes of differentiation and distinction. Inside the art schools, fashion has tried hard to achieve distinction but, as I have argued, in many ways it has been thwarted in this goal for reasons of its feminine status, its associations with popular culture and its history in dressmaking. In the concluding chapter of this book, I argue that fashion does not need this elevated status. It's a false goal. Fashion can do perfectly well inside and outside the art schools by standing more firmly on its feet as a cultural practice and as part of a cultural industry. Where art and pop music now sit alongside each other more comfortably, fashion ought to be able to exploit more readily and less anxiously its distinct identity and its history.

ACADEMIC POWER AND CULTURAL VALUE

This whole section has attempted in one sense to answer the question posed by Bourdieu, 'Who creates the "creator"?' (Bourdieu 1993b: 76). By looking at the development of the British art school system and, in particular, at the aggravated history of fashion design education inside these institutions, I have argued that fashion has only managed to create a place for itself within the field of the dominant arts and legitimate culture as these are upheld in the academy by disavowing any traces of manufacture or labour. This process is symbolised in the proclamations of the students that they 'can't sew'. The three chapters have also sought to demonstrate how these antagonisms and attempts to have high cultural status conferred on fashion date back to the nineteenth century and continue today. Following Bourdieu, I have argued that a sociological understanding of (in this case) the fashion world inside the art school would of course reveal the political stakes which are deeply embedded in these cultural anatagonisms. Sociological analysis shows the power relations which are, and have been, invested in maintaining and reproducing a field where women, and cultural phenomena associated with women, occupy a subordinate position, and where activities and practices associated with manual labour are equally relegated to the bottom of the social hierarchy.

The art schools occupy powerful positions in society. Their influence traverses the field of higher education and the whole world of the arts. They are in the position of being able to grant or withhold approval and commendation for cultural and creative practice. Again, to draw on Bourdieu, these institutions produce and reproduce 'aesthetic dispositions' (Bourdieu 1993b). They jealously defend artistic practice as incommensurate with concrete meaning and function. Art is ideally unaccountable to social interest. Its essence is in the distance it achieves from function and necessity and consequently the potential it has for a transhistorical existence. Despite the various critiques of and challenges to this dominant definition of art, it continues to inform working practices in art as a kind of common sense. The less cultural capital the subject area has (as in the case of fashion) the more anxious it is to be seen to embrace this model. In contrast, those fields like fine art and sculpture, which are more confident of the cultural capital they possess, can loosen their defences and talk more easily about artistic production in technical terms, for example, preparing canvases, having the right tools, brushes, cleaning agents. Their own sense of cultural worth is so apparent they can openly enjoy those elements of the work which are manual, technical or mechanical. Fashion remains far too nervous to acknowledge these practices. The only exceptions emerge from (invariably male) designers of such global celebrity and renown that they too need no longer labour under the shadow of cultural illegitimacy. Thus, in interview with *Die Zeit*, Karl Lagerfeld can insist on his dressmaking skills (Muller 1996: 56). Likewise, Yohji Yamamoto in Wim Wenders' film *Notebook on Cities and Clothes*, emphasises his background in the dressmaking trade: 'I'm not a fashion designer, I'm a dressmaker' (*Notebook on Cities and Clothes*,

1996 video release). In a camp version of the same sensibility, Isaac Mizrahi in *Unzipped* (directed by Douglas Reeve, 1996) enjoys his mother's admiration for his dressmaking skills. Mizrahi then provides a detailed account of the practical processes involved in producing a garment. Finally, reporting the death of Gianni Versace on 15 July 1997, one journalist wrote: 'Gianni was born in Reggio di Calabria . . . the son of a dressmaker who would copy Chanel and Dior outfits for her wealthy clients. Only last week, Versace wrote of his debt to his mother's tailoring skills in inspiring his career' (Spencer 1997: 3). I have not encountered any women of comparable stature in the fashion industry discussing the dressmaking element in their work. Indeed, if we take the three television programmes featuring Vivienne Westwood as comparable to the Mizrahi film and the Wenders documentary, it is quite clear that the anxious aspiration to fine art status in Westwood's case requires the downgrading and disavowal of all practical skills involved in the process of design (Westwood: Channel Four, May 1996).

Bourdieu characterises the mystification of the work of artistic creation as one of the means of making art sacred. This conferring value upon certain works produced by certain individuals in such a way as to maintain, in this case, 'the magic of the label' is also, he argues, a strategy of power (Bourdieu 1993a: 138). For example, the rhetoric of classification and differentiation in the personal statements of the graduating students is part of the 'logic of the field'. The 'most extreme indeterminacy' of language allows a good deal of scope for autonomy and control (Bourdieu 1993b) and it can be deployed to befuddle the uninitiated. It is a language which refutes accountability and which instead feeds into a vocabulary which defines the field and controls access to it. Bourdieu's strategy as a sociologist is to unbefuddle the uninitiated and reveal the social processes involved in the production and reproduction of both cultural value and belief.

Bourdieu also recognises the various attempts to achieve institutional autonomy as a means of safeguarding the power to cast judgement in as uncontestable a way as possible. This is done through 'the elaboration of an artistic language'. Likewise, it is my intention here to show how the art schools produce and give credit to certain types of working practice. They also reproduce the field of artistic production through the constitution of creative subjects who demonstrably possess and display the same 'disinterested' or 'gratuitous' approach to their work. They are self-disciplining subjects for whom creative work is understood as an expressive extension of self.

Autonomy, argues Bourdieu, promises freedom and 'pure aesthetics'. If culture is already a dominated field in a world where market forces and business and economic processes are dominant, then culture is forced to find a space for its own practices. It does this by reversing the logic of economics by claiming disinterest in the cash nexus. The further removed the artist is from the world of money and 'making ends meet', the greater the likelihood that in the longer term this investment in economic disinvestment will pay off. I have argued here that the experience of being educated in the art school system lays the foundation for this kind of outlook in the field of fashion. Academic power, as such, is concerned

here with elevating artistic and professional values over and above the vulgarity of commercial values. Fashion must adopt this to acquire status and recognition in the art schools even though, as a relatively new or emergent discipline, it possesses 'low academic capital' (Bourdieu 1984). The following chapter considers how these processes operate when the fashion graduates leave college and enter the world of work and employment.

5

WHAT KIND OF INDUSTRY?

From getting started to going bust

INTRODUCTION

The subject of this chapter is that part of the British fashion industry associated with the creative work of fashion designers who have been trained in the art schools. In chapter 1, I proposed that we envisage this sector as a gossamer-fine piece of fabric of great luxury, tossed rather carelessly between two pillars of support. On the one side is the great insititutional edifice of the art schools, the public sector of training and education, and on the other side, the commercial sector, in particular the magazines with their enormous readerships and lavish advertisements, a field of spectacular visual display and consumption. In the following five chapters I look more closely at those practices which, when considered together, can be compared to a piece of delicate fabric, a finely spun piece of silk or gossamer. This 'fabric' also forms the main body of 'material' for the book as a whole. This focuses upon the employment of young designers in the British fashion industry. I ask three questions: What kind of industry is it? How do graduates in fashion design navigate a course for themselves in this volatile field? What is the labour process of fashion design? The aim is to describe and analyse what it is like to work in fashion. There is, to date, no existing picture of what the industry actually comprises, what employment or self-employment opportunities are available, and how these come to be occupied. There are a few journalistic attempts to explain the peculiarities of the United Kingdom fashion design sector, and the occasional report such as that undertaken by the Kurt Salmon Group in 1991 on behalf of the British Fashion Council (Salmon 1991). (This latter will be considered in detail in chapter 9.) In the first instance, it is useful to address the explanations commonly found in fashion journalism since these regularly attempt to explain the perceived failings of the fashion industry: Why is there such a disparity between its international visibility and the economic returns? Why do so many of the most talented designers go bankrupt within a few years of leaving college? Why are 'we' not able to make more of this indigenous talent?

The most frequent answer to these questions is that young designers go abroad to work because the industry here is under-capitalised and lacking in government

support. Money is invested in training innovative and talented designers who leave college only to find few United Kingdom companies interested in hiring them. They are offered jobs by foreign companies and go to work in Paris, Milan, Tokyo or New York and thus the investment made in their training benefits foreign companies rather than the British economy. This is true but, as we shall see, it is by no means the whole story. Fashion journalists also claim that British fashion manufacturers have never been sufficiently interested in art school-trained designers to make good use of them and that there is a wariness and suspicion on both sides. Design talent is under-used in the larger companies and company managers in turn complain that designers are too creative or unrealistic when it comes to costs. These problems are further compounded by the dominance in British fashion of a handful of high street retailing chains or 'multiples' who exert enormous control over consumer habits, accounting for up to seventy per cent of fashion sales nationally.[1] This restricts the scope of independent fashion design sales and makes it more difficult for designers to survive when they can be so easily and quickly undercut in costs by the big retailers such as Marks & Spencer, Next and Top Shop. This problem is made more acute by another frequently repeated claim that British consumers spend less on fashion than their European or American counterparts.[2] They also want cheaper clothes even if it means lower quality goods. Together these factors create almost insurmountable problems for the designers, making it difficult for them to earn a living. Finally, there is the suggestion that fashion design is best regarded as the icing on the cake. This view was put to me in interview by a member of the British Fashion Council in August 1993:

> What fashion does is advertise the city or the country as a whole. So fashion works in this way, it's about creating an image. This is not unique to Britain, it's exactly what Armani does on a much bigger scale. His image and his name are exported across the world – he is Italy.

This implies that 'designer fashion' provides striking ideas on the catwalk which are too avant garde for the street, but which stimulate interest and gain publicity for the industry and, by extension, the country as a whole. Fashion design is a kind of spectacle, a form of entertainment which connects with the world of pop music, show business and celebrity culture and which keeps the public interest in fashion alive, getting front page coverage in the national press and stimulating the appetites of consumers who want to know about fashion as a lifestyle interest, even if that means the much cheaper Kookai or Miss Selfridge versions of the catwalk shows. Promoting British fashion culture is therefore one of the key functions of fashion design. The image industry which fashion design feeds into encompasses the huge field of magazines and newspapers, from young girls' weekly magazines such as *Sugar*, to the Sunday newspaper colour supplements. Is designer fashion, as the respondent suggests, really about spectacle and the production of images, a kind of service sector to the high street fashion retailers and to the wider mass media? If this is the case, what does it mean for the designers?

One problem with most fashion commentary is that it places overwhelming emphasis upon the stars and celebrities of the fashion world. My intention here as a sociologist is to look at the less exceptional career in fashion design. This will involve tracking the employment experiences of a number of young people, mostly female, who left college with a good degree, possibly attracting praise and publicity in the national newspapers for their final degree shows but not necessarily receiving the rapturous attention reserved for the two or three graduates each year who are immediately labelled as stars. One element of this analysis queries the space constructed for stardom both in the academic institutions and in the fashion media. This is a deeply normative and suspiciously masculinised position. The fashion star has an identity and a role more comfortably aspired to and assumed, it seems, by a boy. Later, I interrogate this subjectivity which appears to be more easily occupied by male students than by their female counterparts. I want to signal here its status as a space, a site of expectation into which he or she who can demonstrate the requirements of 'talent' will slot. While an analysis of what is understood as constituting talent or indeed genius is beyond the scale of this book, the sociological emphasis here interrogates the use of these words in professional judgement and their operation as terms of closure. The relation between, on the one hand, the work of self-promotion entailed in the production of the self as potential star and the possession of 'talent' on the other is at the very least debateable although, as we also see, the generalised construction of a 'creative self' in fashion culture is a requirement.

In this chapter I deal particularly with characteristic patterns in the careers of young graduates shortly after completing their degrees. This involves consideration of employment abroad as well as of starting their own businesses at home. This also becomes a work of demystification. Neither the leading figures in the British fashion industry, including the journalists, nor the politicians, have very much to gain from exposing the economic underpinnings of the glamorous fashion business, since this might well reveal as many business failures as successes and since it might also reveal an industry existing under the shadow of unemployment where low pay, long hours and different forms of exploitation, (including self-exploitation) are rife but apparently necessary for survival. In the face of these uncomfortable realities there is a tendency either to ignore these questions altogether or to adopt the position of weary resignation and fatalism, as if saying that the fashion industry has always been like this.

Fashion journalists and other professional figures tend to assess the state of the fashion design industry almost entirely in terms of sales and consumer spending, rather than on livelihoods and employment. The fashion industry goes into recession when sales are down and recovers when there is a consumer boom. When the industry is in recovery a new crop of names dominates the headlines (for example, the 1996 recovery has seen the 'triumph' of Pearce Fionda, Hussein Chalayan, Antonio Berardi and, most of all, Alexander McQueen, all male as it happens) but rarely do these new stars number more than half a dozen and rarely does a journalist question what has happened to the previous crop in the

intervening years – or, indeed, to all the other designers who do not merit this kind of attention. Sociologists, however, have not been much more helpful in this respect. They have looked only at manufacture and production and not at patterns of employment in design. Traditional labour hierarchies also locate professional fields of work like fashion design, although largely feminised, as privileged and inherently rewarding spheres of employment in comparison to the low pay, low skill work in the sweated trades. Fashion designers might even be identified as employers and consequently in an exploitative relationship to poorer, unqualified women working as machinists or homeworkers further down the fashion chain. However, although many of the designers who participated in this study were influenced by, and emerged out of the enterprise culture championed by, Mrs Thatcher, few can be described as successful entrepreneurs, and few were officially employers. In the fashion design industry as a whole only a handful of figures fit into this category and they, like Paul Smith, and Lucille Lewin of Whistles, have emerged from fashion retailing and then moved into fashion design. Although the designers I interviewed for this study were running (or had run) their own busi-nesses, the 'business side of things' was experienced as a constant burden and something they would ideally offload into the hands of a business manager if they could afford one. The following chapter explores these careers which range from running successful design companies to selling clothes on a stall or unit at London retail spaces such as Hyper Hyper in High Street Kensington, or Camden Lock.

This kind of employment activity is uncharted in sociology and cultural stud-ies, but it is an expanding field. It is also a feminised sector. There are more people working in fashion and in design-related activities than ever before, and this is not surprising given the expansion in training and in the range of qualifi-cations now available. The last few years have seen a shift in the fashion industry as a whole, from the expensive designer ranges such as Nicole Farhi, Katharine Hamnett and Jasper Conran, down through the high street middle-market ranges including Next, Benetton and French Connection, to the cheaper fashion ranges found in shops like Top Shop and Miss Selfridge. In many visible ways the sector has upgraded itself. More attention is paid to the design and layout of shops, and this has required the services of a whole range of new professionals, from inte-rior designers to window display artists (Nixon 1997). Sales assistants receive more training in customer services as well as in stock, pricing and availability. Many of the young women working in department stores like Harvey Nichols have degrees and hope to pursue careers in fashion retail management.[3] Pattern cutters also are expected to have BTEC qualifications and only lower down the scale does there remain, particularly for machinists and homeworkers, a rump of unskilled labour.

While fashion consumption has risen quite dramatically in Britain from the early 1980s onwards (between 1983 and 1988 spending rose by seventy per cent) and, with sales of £3.5 billion in 1994, employment in manufacturing in Britain has nonetheless declined as large scale production has relocated to the Free Trade Zones of South East Asia.[4] We can see a tilt in the general profile of the fashion

industry towards retail and design. But neither the 'new professionals' in the design field, who have become the most prominent feature of the fashion industry, nor the small scale producers have as yet warranted serious sociological attention. Instead their presence in the labour market has merely been signalled as indicative of a cultural shift in employment (Murray 1989; Lash and Urry 1994).

Overall it seems as if there has been sharp decline in United Kingdom manufacturing and its replacement by design related activities and retailing. But, in fact, this is not quite accurate. Much of the production carried out for the design sector still takes place in the United Kingdom and in the small inner city workshops and units described in detail by Phizacklea (1990). The British Clothing Industry Association estimates that in Britain in 1994, 380,000 people still worked in the fashion and clothing industry of whom ninety per cent were in manufacturing. While this marks a drop from the 450,000 employed in this sector in the mid-1970s, it is a less dramatic reduction than in many other industries over the same period.[5] It should be emphasised, however, that the focus in this current work is on fashion and indeed on one sector of the fashion industry, the fashion design activity associated with United Kingdom art school-trained designers. Most government statistics and official publications consider fashion and clothing together, with clothing referring to the manufacture of garments including underwear, outerwear, uniforms, workwear, and childrenswear and menswear lines which remain outside the symbolic meanings of the seasonal newness associated with fashion. Clothing is different from fashion precisely because it does not participate so thoroughly in the cyclical changes and the rapid turnover and premature redundancy of past styles – it is a slower and more utilitarian mode. Official employment statistics do not differentiate between these two practices and so it is almost impossible to produce accurate figures for designer fashion production, but since the small, local units are usually producing for all three sectors (designer, high street, and the cheaper ranges), at the same time, this would be a difficult task under any circumstances. Often the women themselves have no idea who the designer or company is for whom they are producing.[6] For all sectors, the advantage of these local units of production is that of proximity. They can produce short runs of items in response to unexpected spurts of demand. They can also provide a faster service, especially when goods have to be returned because of faults. Phizacklea (1990) and Tate (1994) have each explored the way in which these new forms of exploited labour emerge from social groups experiencing the sharp edge of economic recession. Later, I connect what Piore has recently labelled as the 'return of the sweatshop' (Piore 1997) with the employment experiences of young designers. I argue that the poles that separate the designers from the small-scale producers are not as far apart as might be imagined. Indeed, I attempt to show that it is within this distinct web of relations leading from art school training into small scale production, and relying on the labour of poor women typically from either the London Greek Cypriot or Asian communities, that a new kind of rag trade has emerged in Britain over the last twenty years.

FINDING THE DESIGNERS

The graduates and young designers interviewed for this book were trained in the tradition which I label in an earlier chapter as 'conceptual fashion' (although, as I argue, this is an ideal type which rarely appears in its pure form and will therefore contain elements from the two other approaches outlined in chapter 4). Starting with the names and contact addresses of students from two years who completed their studies at a London art school during 1984 and 1985, and after much correspondence and with the help of those I made contact with, I managed to come up with a sample of eighteen graduates. Supplementing this core group of respondents was a smaller group of eight well-known and established designers, and I rounded off this phase of the research by returning to the art school itself in 1994 to talk less formally with students who were preparing for their final degree show. In addition to these face-to-face interviews, I also draw upon interviews and profiles published in a range of newspapers and magazines from 1989–96. This fieldwork and newspaper work provides the raw material for the book, although it is also supplemented throughout by interviews I carried out with experts and professionals within the industry. These include figures from the British Fashion Council, merchandising managers, two chief executives from larger companies, as well as the managing director of a manufacturing company.

All eighteen of the graduates interviewed were female. The average interview lasted for ninety minutes and was tape recorded. I met the graduates at their place of work and the interviews were either conducted over an extended lunch hour break or at the end of the working day. The interviews were semi-structured to allow each respondent to expand on aspects of their own experience. Since the aim of the interviews was not to come up with an accurate national profile of fashion graduate destinations but rather to build up a picture of employment experiences in a more reflective manner, this open-ended style of interviewing proved most useful.

GOING ABROAD OR STAYING AT HOME?

One of the most frequently made comments about the failing of the British fashion industry is that, having graduated from art school, its young designers are forced to look for work abroad, in the big fashion houses in Italy, France or the USA. This, it is argued, represents a tremendous loss of talent as well as a waste of resources since so much money has already been invested in educating these young people to such a high level that their skills are eagerly sought by foreign companies. Of course, it could easily be argued that these courses succeed on the grounds that they produce very employable graduates who are able to find work in a global industry. However, no attempt has been made to examine the reality of working abroad, the kinds of jobs on offer and their duration, and how this

opportunity often unexpectedly serves to consolidate the distinctively non *haute couture* character of the United Kingdom fashion industry.

By looking at the experiences of young designers abroad and the reasons why they frequently return home within a couple of years, it is possible to begin to answer the question, what kind of industry is the British fashion industry? Seventeen of the eighteen young women interviewed had applied for jobs abroad at, or following, graduation. Several had made a number of applications and over half of them had actually been approached by foreign companies on the basis of their degree shows. These approaches, or offers, were usually made within or just following the highly competitive atmosphere of the final year degree shows. The full 'runway' show, with celebrity models and the press in attendance, made a job offer at the end of it all the more important. Otherwise the students realised that the anti-climax could be dramatic. After months of working around the clock on their collections and, knowing the amount of media coverage the shows attracted, the idea of signing on the dole within a couple of weeks after all the glamour of being in the spotlight was difficult to contemplate. For four of the group interviewed there had been an interim solution as they had won places and funding on MA courses and so were able to delay the prospect of job-hunting. However, the situation was not so different for them when they too entered the labour market the following year.

The interviewees were a group of designers all in their early twenties and launching themselves onto the fashion scene in Britain at a moment when it was seemingly at its peak. The mid-1980s marked that point at which the full impact of the 'designer decade' was being felt on the high street and in the pages of the press and magazines. The availability of consumer credit, the rapid translation of designer high fashion into the more design conscious retailers such as Next, the public demand for higher quality goods and, most of all, the encouragement of enterprise culture, all contributed to a sense of buoyancy and high expectations on the part of the graduates. Their assumption was that, come what may, they would be able to practise as designers under their 'own label', something that would commit them to either being self-employed or running their own business. It is the aspiration to 'own label' work which both epitomises the design career and which is the most difficult pathway to sustain. The graduates knew that the fashion industry was a tough environment to survive in and they were also aware of the anecdotes of back-biting and tremendous competition and rivalry – but they had no image or understanding of the industry as a whole. Consequently, they were not prepared for their own exploitation as eager, and possibly naïve trainee designers, nor for the economic volatility of practice within this sector as an 'own label' outfit.

Five of the graduates discovered the downside of the fashion industry before they even got as far as a formal interview. On the suggestion of the agents who approached them after the shows, they sent off items from their collection, and even made additional garments to demonstrate the breadth of their talent, to companies in Tokyo, New York and San Franscisco. The goods were either not

returned at all or returned in a crumpled state several months later, after expensive faxes and telephone calls. Each one of the graduates felt forced to acknowledge the likelihood that the garments had been studied, even copied, and then reluctantly returned. Even the interview stage demonstrated to them how badly they could be treated. One young woman was invited to Japan by a company who paid her hotel and air fare. But she was left waiting over several days for an interview and by the time she was due to return she was still no clearer as to whether there was any job with the company. She returned home and never heard from them again, leaving behind several pieces of her own work. Another student who got a job in Japan had a similar dispiriting experience:

> I was invited to Japan after I won a competition at college. I got some freelance work there after I did the order for the company which brought me over. But it was very frustrating because they wanted all the sketches and all the ideas but the clothes weren't being made up and I didn't know what was happening. I was producing piles of ideas for top Japanese designers who would show every year, but I never got a clear sense of what they were doing with them. I felt they were using them but there was no briefing about what they wanted and their interest began to fizzle even though they were still getting the ideas and the sketches. I came back to London on the understanding that I would work for them from home, but I was sitting around waiting to hear from them and when I didn't, I had to think what to do next. I didn't want a mainstream job, so I bought myself a knitting machine, made up a sweater, somebody bought it and from there it developed into real backroom stuff.
>
> (Anna T.)

This graduate opted for small-scale independent production at home after the experience of poor communications, unclear or insufficient contractual agreements with regard to work, and the suspicion that creative material was being used without her being properly rewarded. Many of the graduates had a much worse time working for European *haute couture* companies, to the point that they began to associate this kind of employment with exhaustingly long hours, low pay, low reward and poor working conditions. 'They treat you like a servant' was how one young woman put it. Another graduate reported her experience as follows:

> When I finished my MA I already had an offer from A. H. in Paris. I had worked for them as a student for £30 a day for three days a month. After the MA I went full-time. I stayed in a company flat which of course I had to pay for. It was a family run business but I could never work out how it was run. And they couldn't understand how I had been trained. Nobody in the company knew much about knitwear. I stayed with them for three years in extremely bad conditions. I was left in a dirty

room with poor lighting. I was doing all the designs for the knitwear
and was expected to work right through five weekends before the show
for no extra pay. Sometimes that was from ten o'clock in the morning
until nine o'clock at night. Often they would have you there, just to be
there, helping to do the cards or the labels. I'd be doing everything
before the show and then have to be in the next morning at ten o'clock
after the show. I'd be taking home £600 a month including all the extra
hours with no thanks ever for what I was doing. It is one of the worst
houses, but others are almost as bad.

(Melanie McF.)

The young designers were also taken aback by the snobbishness and the old fash-
ioned employment hierarchies in these prestigious fashion houses. One girl had
a job at D.:

I was freelance so I was working for D. from home – it was top qual-
ity work that I was doing, a jacket at £1,000 in mohair wool, and hand
finishing. But it was very isolating and I had to pay all my overheads.
Then D. suddenly didn't need me any more. They never said why and
I had no alternative but to go on the French dole system and apply for
the equivalent there of the Enterprise Allowance Scheme. The idea was
to make up my own collection and sell it round Paris. That was when
I really realised how snobbish and élitist it was, if you weren't already
a name. They would just turn me away at the door. At every point
during my time in Paris I was treated badly, and that's why I came back
here.

(Joanne A.)

When I interviewed this young woman she was waiting to become eligible for the
Enterprise Allowance Scheme. The equipment she had bought while working for
D. was due to arrive back in Britain and she was spending her time making con-
tacts in preparation for starting up on her own. Another graduate described her
experience working for H. in Paris:

French students are basically untrained and very sloppy. The quality of
their portfolios is abysmal. And many of them are not willing to put in
the long hours. This means that the British graduates get snapped up by
all the big houses: H.; R.; K., etc. But they are not treated any better,
despite their training and qualifications. In fact, given the standard of
their work they get treated worse than the French students. I stuck it out
for a year at H. I did a whole knitwear collection for them, from start to
finish. It was good to get access to quality fabrics and yarns and it was
a big collection, seven groups of garments with six styles in each. I had
to do the sketches, the themes, the colours, and there was only one other

person apart from me to handle this volume of work. Eventually I felt they were keeping their costs down by getting me to do all the work and they weren't even paying me a living wage. I got very exhausted and was worried about my health so eventually I came back to London with the aim of setting up on my own or with my sister as it turned out.

(Paula S.)

These young designers had no notion of companies such as these being capitalist organisations willing to exploit their workforce if they could get away with it. Not only were they confronted with this side of the fashion industry for the first time, they also had to fit in with the French or Italian structures which were organised around a different 'atelier' system. This is a form of apprenticeship which allows French trainees to learn on the job rather than as full time art students. They are paid little or nothing for the duration of their training. This means that the houses are used to a supply of young people usually from wealthy backgrounds whose parents can afford to pay all their living expenses during this time. They were likely to treat their United Kingdom recruits in a similar way, even though they were taken on as qualified design assistants. Being treated badly, while also being expected to work exhaustingly long hours, undoubtedly had a profound effect on the young designers I interviewed. It put them off working for a large company, even one that had a reputation in the international world of fashion. The young designers became more determined to 'go it alone' and work for themselves.

These encounters show how United Kingdom graduates are filling a gap opened up by the absence of state-funded art-school based training in fashion design in France, Italy, Germany, the USA and Japan. The uniqueness of United Kingdom provision is what gives rise to this mobile labour market. But the availability of these jobs is in itself no guarantee that there is a smooth transition from training into employment. While some fashion graduates have positive experiences to report of their time spent working for foreign companies, more often than not these were temporary posts. Few United Kingdom graduates find themselves working permanently abroad and, like so many other jobs in the fashion industry, these tend to be short term or temporary, and after two or three years the young designers move on. Although there are no accurate figures collected on this phenomenon it is widely recognised that the flow of United Kingdom labour to foreign design companies grew rapidly from the early 1980s when *haute couture* houses saw the opportunity which the thousands of enthusiastic and highly creative graduates flooding onto the international labour market afforded. They were in a strong position to cream off the best and replace this design talent on an almost annual basis. Jane Rapley, Head of Fashion at Central St Martins in London, describes this process as follows in the *Guardian* 21 May 1994: 'Foreign companies are generally prepared to encourage (graduates) to experiment for the first six months They also invest in young designers in the way the rest of industry does with accountants and engineers.' But, she adds: 'Some students . . .

are bled dry on short contracts and then have to move on' (interviewed by Wilson 1994: 30).

The availability of jobs abroad has to be seen not only in the context of United Kingdom graduates filling a skills gap, but of the poor job opportunities at home. As Rapley indicates this is, to some extent, the result of United Kingdom companies being unwilling to encourage the creative and experimental dimension in art-school trained young designers. This means that the choices are more starkly those either of trying for a job abroad or going on the dole and then setting up in business alone or with a partner. Another United Kingdom graduate put this dilemma in the following terms: 'When I won the award (as Harvey Nichols European Graduate of the Year) I thought it would be easy to get a good design job in Britain. I was wrong; nothing happened. Oh, apart from Laura Ashley offering me a technical drawing job.' This prize-winning young graduate then took a job with a Dutch company where she reports being well paid and respected: 'My friends who stayed behind are working for designer rip-off companies for the lower end of the market, earning £20 a week and fiddling the dole' (interviewed by Wilson 1994: 30).

Thus both during the peak years of designer culture (from the mid- to late 1980s) and in the mid- to late-1990s, after the sudden downturn of the fashion economy in 1989/90, the same kind of pattern emerges for these young designers. It is either a low paid form of employment in the United Kingdom or a temporary or short term job abroad. While there are doubtless some employers abroad offering good working conditions to young designers and allowing them to develop their talents, it seems as though the graduates are just as likely, if not more likely, to be confronted with the fashion industry at its most aggressively competitive and unscrupulous.

Acknowledging the trading of their own personal creativity in exchange for low pay and poor treatment abroad, many graduates return to the United Kingdom with an even stronger commitment to the idea of setting up in business alone. They also realise that whereas in the *haute couture* houses they produce design work of a high creative standard, returning home to work for a United Kingdom company such as Laura Ashley involves quite a dramatic drop in creative input. As young and ambitious designers, it is not surprising that they want to develop their talent rather than having to put it on hold. In this context, talent is inextricably connected with youthfulness, it is an asset which has to be continually nurtured and developed. Art-school training prioritises this as the basis of creative work and, not surprisingly, the students do not want to see their talent squandered. Job offers from abroad seem more appealing because they promise opportunities for creative talent to develop further. But this international labour market reveals itself to be as willing to exploit the talents of the students as it is to nurture them. One graduate described this as follows:

> The first few months I sent my CV and portfolio worldwide. D. B. got back to me in January from France. I actually thought I was more suited

to Milan but I thought I'd go to France anyway. In Paris they didn't even remember that I had an interview. They eventually agreed to interview me but clearly had no intention of giving me a job. I was taken on by H. as a design assistant but after four weeks I still didn't have a contract and after six weeks I was unpaid. So I left, having worked for them completely unpaid and I never got the money I was owed. I had heard stories about this kind of thing in France and Italy through the graduate grapevine and I wouldn't have taken the risk if I hadn't been desperate. I came back to London in May and then again there was the chance of work with V. in Italy and I very stupidly did six to eight weeks of work on samples to send him and then I never heard a thing, and they were only returned to me eight months later without even an acknowledgement. So that's what's wrong with *haute couture*, they treat young designers with contempt.

(Yvette S.)

The more informal style and culture of British fashion design stands in stark contrast to the stuffy and conservative world of *haute couture*. Many fashion students come from working-class backgrounds and an increasing proportion are black or Asian. The success of figures like John Galliano (inevitably described in the press as 'of Spanish origin' and 'son of a south London plumber') and, more recently, Alexander McQueen ('son of an east London taxi driver') is celebrated in the United Kingdom media as the success of two working-class boys made good. Even if, as in these instances, social class and ethnicity are transformed into (mythical) signs of Britain being a successful meritocracy, they are also recognised as evidence of the social mix and multiculturalism of contemporary British society. The United Kingdom graduates were astonished at how class- and status-conscious their European counterparts were. Most had absorbed through school and art college some understanding of social inequality and of the consequences of class, sex and race disadvantage. Many of them professed a kind of 'popular feminism' (Stuart 1990) so for them the very traditional attitudes in the fashion houses in relation to women and to ideals of femininity were, at the very least, old-fashioned. Against this they developed a particular sense of themselves as 'British' designers. There is more than a touch of irony in this rejection of European *haute couture* and American fashion since it was their 'Britishness' which got them the jobs in the first place and it was the British fashion industry which failed to provide them with similar opportunities.

Haute couture is snobbish and élitist. Until you are recognised they treat you like a speck of dirt. They only value wealth and what kind of family background you come from. All the trainee designers are these rich kids and that kind of attitude also feeds into the whole system. Of course, you are also being trained to make clothes for very wealthy women, and somehow fashion's not like that in England. You like to think you are making clothes that lots of people could afford They

are basically very unfriendly. If you are looking for work they talk down to you and won't give you the time of day. Their attitude is that you are of no interest which means they don't even need to be polite to you. I sent my CV and portfolio to the houses that I liked in Paris and I had some interviews but they were with design assistants and since it was their jobs you were after you never got very far with them, and you never get to meet the designer. They look at your portfolio and that's it. It's all so rigid you never get a chance just to chat to people.

(Philippa D.)

Being treated badly was the most common complaint, especially after being invited for interviews and after some interest had been expressed in their work.

I got a letter from New York from D. K. saying we like your work etc., etc., and would you come over? So I saved and borrowed and got the ticket myself, but when I got there the woman who was told to come out and see me just said 'we're not hiring right now', and that was going to be the end of it, no explanation, but I pushed and they reluctantly agreed to see me one more time but there was nothing on the table, so I just came home.

(Lisa R.)

These experiences form one kind of backdrop against which the distinctiveness of the United Kingdom fashion design industry can be understood. The old-fashioned and rigidly hierarchical working practices of *haute couture*, the wealthy clients who patronised these houses and the aggressively late twentieth century freelance and sub-contractual terms which left many of the young designers working without a formal contract (for employers with no social obligation whatsoever to them), had the effect of pushing the graduates back into self-employment in the United Kingdom. In her recent autobiography, Helen Storey describes her experience of working in Italy in terms similar to those of the graduates I talked to:

At its worst *Signoraism* (Storey's own term for Italian female style) was, and is, a form of snobbery – a lazy attitude to life that said provided the exterior looked tanned, thin and 'hot', then the interior could remain under wraps Self-worth was transcribed into an Armani jacket or a Valentino dress I tried in vain to adopt the uniform and, in the process, I came to understand something of the habits of a transvestite, only in my case I was unhappy and unconvincing.

(Storey 1996: 37)

Some pages later Storey says: 'Starting out on my own had been little more than a reaction to dressing women with whom I had little in common' (ibid.: 67).

What all the above accounts show is the way in which fashion design graduates very rapidly learn about the industry (and also about international capitalist enterprises), often at their own expense. Their initial enthusiasm and the need for a job led many of them to tolerate conditions they soon recognised to be exploitative. Over the longer term, they were not willing to put up with being treated in this way. However, instead of asking why the industry was like this and how it could be improved they tended instead to interpret their experiences, individualistically and retrospectively, as part of fashion folklore with its notoriously bad employers, its tyrannical star designers and celebrities, and its gossip grapevine of unscrupulous practices. The solution was to establish their 'own label' at home. This was seen as a way of avoiding those aspects of the industry which they perceived as exploitative.

'WE'LL JUST START MAKING SOME DRESSES'

Belief in one's own work supplied graduates with a desire to pursue personal creativity without having to prioritise either the market or commercial values, and in these beliefs the young designers shared an outlook with those trained as painters, sculptors and fine artists. Creative work existed, therefore, as a kind of utopia set against the experiences they had of working for the big foreign companies. 'Enterprise culture' came along at the right time and gave them an opportunity to pursue this goal. The Enterprise Allowance Scheme allowed graduates to 'be their own boss' as an alternative to unemployment.[7] Most were openly sceptical that they could create a thriving business on the basis of a £40 a week benefit. However, the scheme did connect directly with their ambition to work in an independent capacity.

Du Gay has suggested that the ethos underpinning initiatives like the EAS works by 'inviting us to feel as if we are our own boss, to become entrepreneurs of ourselves' (Du Gay 1991: 56). He argues that the language of enterprise which was so fiercely championed by Mrs Thatcher marked a virtual redefinition of work for those who were subjected to its rhetoric. He also shows how the idea of creativity came to play a prominent role in this new vocabulary. By encouraging the kind of close identity of self with creative work 'the government of work now passes through the psychological strivings of each and every individual for fulfilment'(Miller and Rose, quoted in Du Gay 1991: 51). Creativity is consciously deployed as part of the enterprise rhetoric. This new kind of person is a self-regulating, self-disciplined and creative individual. He or she is the product of the enterprise culture's attempt to 'win' social subjects to a new conception of themselves – to turn them into 'winners', 'champions' and 'everyday heroes' (Du Gay 1996: 67). This new kind of worker can rise to and transcend the challenge of work in an economy where unemployment is high, where companies as well as public sector organisations are continually looking for opportunities to slim down their labour costs and more people are forced into considering self-employment or consultancy roles.

The art school graduates in my study represent this ethos almost in advance of its spread into the wider world of work and corporate culture described by Du Gay. As one interviewee said 'College expected you to leave being somebody.' But although the rhetoric of enterprise culture had an impact on the way in which the graduates launched themselves into business (with special emphasis on the business plan) it was subordinate to the creative ideal. It remained primarily a means to an end. The EAS allowed the graduates to work for themselves and it got them off the dole. The ethos of self-discipline which they adhered to, and which often involved their working willingly through the night, belonged not to the idea of the entrepreneur . . . as 'the new culture hero' (Du Gay 1991: 49) but much more to the tradition of what Bourdieu describes as 'the artist's lifestyle'. Bourdieu emphasises this by quoting from a novel by Goncourt and Goncourt: 'Anatole . . . was attracted by the artist's life. He dreamt of the studio' (Goncourt and Goncourt, quoted by Bourdieu 1993b: 66). The important point is that as the very idea of the artist in British society in the 1990s undergoes dramatic change, as the artist is robbed of some of his or her 'rarity value', by virtue of the sheer number of people engaged in creative work having emerged as graduates in creative disciplines, then 'creative labour' becomes not the exception but increasingly the norm, yet its participants still dream of the studio, and art work continues to have a special romantic aura. 'Artistry' provides a supremely effective vehicle for the production of a workforce for whom creative labour is also a labour of love. Being willing to create their own labour market as well as put in long hours for low returns, and to opt for independence through freelance or consultancy work, could not be more opportune for a government wanting to get rid of 'dependency culture'. And for capital this means an unsalaried workforce!

If this image of being 'like an artist' gives the graduates the incentive to work the sort of hours that no employer could ever expect of his or her employees, then this in itself is evidence of the success of the new form of creative self-disciplining in work. These young people might be seen as 'subjects of creative enterprise', willing workers who surrender themselves to the promise of 'pleasure in work' (Donzelot 1991). This represents a new and more subtle form of self-government in tune with the requirements of a post-industrial economy. If hundreds of young graduates embark upon careers as self-employed fashion designers, and if they put in unimaginably long hours and accept the low financial returns on their labour, are they therefore merely conforming to a broader and more hidden political agenda which, as Phil Cohen argues is reminiscent of the self-help ethos of the nineteenth century: 'What is practised for pleasure can be practised with profit!' (Cohen 1997: 297)? Both Cohen and Du Gay appear to follow Donzelot in seeing the new emphasis on creativity in work as dangling the promise of self-reward and immense gratification in work and thus producing a new kind of worker, one who enjoys the dream of creative satisfaction in work and also the 'fantasy of entrepreneurship' (Du Gay 1993). Cohen, writing on the recent focus on developing personal creativity in training schemes and in the 'new vocationalism' in education, suggests that: 'Creative individualism has here

become a recipe for social success, rather than a symbol of Bohemian excess' (ibid.: 293). Cohen thus sees enterprise culture as preying on aspects of youth culture by crudely turning personal skills and radical lifestyles into livelihoods. Young people are made into petty capitalists with the creative work they now undertake for personal gain embodying a 'neutralisation of the counter-culture'. In this way, Cohen continues: 'Leisure' [is] a cottage industry for the unemployed' (ibid.: 298).

What Du Gay and Cohen both point to is a new kind of subject emerging for whom work is understood in terms of individual creativity. What used to be a life of unrewarding 'slog' is now a possible site for personal fulfilment. Ideologically, work is turned into a source of reward through the emphasis on creativity, no matter how irregular the earnings and regardless of how long the hours. This ethos also encourages a new and distinctive merging of the self with work, as Du Gay suggests 'the identity of the worker has been differentially constituted in the changing practices governing economic life' (Du Gay 1996: 55). The creative worker thus embodies the aestheticisation of labour as a strategy of government. Helen Storey describes this with poetic clarity in the introductory blurb to her recent autobiography which chronicles her rise to fame (she was voted Most Innovative United Kingdom Designer in 1991) and her experience, four years later, of bankruptcy:

> Beyond the eyes of men, and of any female state that is named – mother, lover, worker, wife – my creativity is my difference. I cannot resist starting again, as if in rediscovering the possibility of a creative new, I am on some level reaffirming that I exist.
>
> (Storey 1996)

This process can also be understood as society offloading its responsibility to people by turning work and employment into a matter of self-love, individual will, talent and commitment. This new ethos creates an intensification of labour, not through coercion but through its opposite, through the love of one's own work, which is also a kind of self-love and a means of gaining self-value. During and after the Thatcher years, these ideas have virtually reshaped the meaning of work for significant numbers of people in Britain today. They also offer a useful way of looking at the careers of the graduate designers in this book by providing a framework for understanding more broadly the new careers in the culture and media industries which depend upon this fusion of entrepreneurial values with a belief in the creative self, with the latter providing a rationale for the former.

The question I raise here is how does this work in practice? Du Gay acknowledges that accounts of 'top down' redefinitions of work, especially those which draw on a Foucauldian framework which stresses the multiple attempts to 'shape up' a new kind of worker by transforming 'the meaning and the reality of work' (Du Gay 1996: 53), do not tell the whole story. Inevitably there is a dislocation (or a slip) between this regulationist grid and its implementation. These practices

also raise further unanticipated issues, such as the fact that the main beneficiaries of the EAS were actually artists and writers (occupational groups historically predisposed to an anti-business ethic), suggesting that in terms of 'real results', 'government is a congenitally failing operation' (Rose and Miller, quoted by Du Gay 1991: 58). Was the EAS cleverly utilised by the designers as a means of pursuing not good business sense, but rather their own artistic talent? Or, is it more the case that the odds were stacked against the young designers who faced unanticipated competition from bigger, more successful companies, so that the EAS was merely another ill-fated attempt to revitalise the small business sector? Or, finally, did the EAS provide the designers with an opportunity to further their experience in the industry as a transitional stage in the relatively uncharted territory of a career as a fashion designer? This would interpret the EAS as a training grant, the results of which were inevitably uncertain. One of the more certain effects is that, according to Dr Jane O'Brien of the Arts Council, the EAS provided a small cushion of support for practising artists during the Thatcher years which had notable effects, in particular the revitalisation of the East End of London where many of these artists settled in the 1980: 'The blue touchpaper was the introduction of the enterprise allowance in 1983, which was underwriting 10,000 artists a year before it was scrapped' (O'Brien interviewed by Harlow 1995: 3).

A good deal of the material presented here is concerned with the day to day practice of design. What happens to the young cultural entrepreneurs? Are the small businesses in the cultural sector capitalist in the traditional sense? Are these young designers entrepreneurs or are they the hapless victims of the ideology of 'enterprise culture'? I will argue that although subjects of 'enterprise culture' the graduates actually succeed in redefining the meaning of this term, they put a 'spin' on it so that it becomes more compatible with their own goals. Out of the EAS emerges a quite unexpected and vigorous field of creative activity whose meanings are somehow at odds with that heroic vision of enterprise envisaged by Mrs Thatcher. This kind of cultural practice resembles what, in the late 1990s, has been labelled 'social entrepreneurialism'. Here values other than those typically associated with the market, for example, culture or social welfare, are apparently brought into a new relationship with the world of business.[8] The logic of this is that setting up in business is a way out of unemployment, a possible way of creating employment for other people who might also be otherwise unemployed, and also a way of avoiding some of the problems of being an employee, particularly a low paid employee. The following comment made by a young designer interviewed in The Guardian 22 April 1993 sums up the way in which the graduates used enterprise culture to create their own labour market:

> When I graduated there wasn't a designer around who made me think, wow, I want to work for you. I was on the dole, on a Business Support Scheme course, when I realised why should I worry about somebody else's business? I may as well worry about my own.
>
> (Vicky Poole, interviewed by Wilson 1993: 14)

With one exception, all of the graduates interviewed have participated at some point in the Enterprise Allowance Scheme. To qualify for the scheme they had to be unemployed for at least thirteen weeks. They also had to prepare a business plan and have a bank account with £1,000 deposited in it. The following comments provide a sense of what happened to them in their careers as young entrepreneurs:

> We had known each other at college, we met up and realised we had both had these terrible experiences trying and failing to get jobs abroad, so we thought we'll just start making some dresses. . . . The EAS helped solidify our ideas, draw up a business plan, and find out how much things cost, our target markets. We even stood in the street with questionnaires. . . . We borrowed £1,500 from each of our fathers and that was it.
>
> (Yvette M.)

However, only four years later, after an enormously successful run of shows with orders of £30,000 in the spring of 1994, followed by £100,000 of orders in the summer, and with praise and publicity and media coverage across the whole fashion press, these two designers who shared the same joint label realised they could not fund the production of the following year's collection: 'By June the bank had refused automatic overdraft facility, the business manager was "suddenly very busy" and one of the backers was getting edgy.' In October 1995, their summer 1996 collection crashed. 'We got £28,000 but needed £150,000. After the show we knew we were stuffed' (Yvette M. and Lisa R.).

Another young woman describes her entrepreneurial activities as follows:

> After the Japan work fell through I started back on the EAS. It was all casual sportswear stuff I was doing, which I've always really loved. I was knitting away night and day. I got loads of orders after the Store Street Gallery exhibited some of my work. I found a studio in Portobello Green with a shop attached. I stayed there for three years, just doing knitwear. So, in that sense, the EAS worked for me. I got the kind of turnover I needed to keep going, even though I was working myself to the bone. The highlights of that period were the three designer collections I did for Harvey Nichols, Snob in New York and the Academy on the Kings Road. However, soon after this things began to go wrong. I had overworked right though this period and I was ill with exhaustion. But I was a young designer and I believed in my work.
>
> (Gillian P.)

As we can see, this young designer clearly identifies the creative aspects of her work as the most important. She draws attention to the interest in her work shown by the fine art world and it is this which legitimates her long hours 'knitting away night and day' in her studio. She continues:

The crunch came when I was ripped off by the real businessmen. They came into my shop and posed as customers and bought a huge quantity of stuff. They must have unpicked it to see how I had done it and then got it made up again at a fraction of the cost using much cheaper materials and yarns. They marketed my whole stock in the US at a quarter of the price. I found this out through being in New York and seeing all my designs on the rails and knowing that I hadn't sold to that particular store. It all became clear how it had happened. I saw them there on the rails. I didn't have the money to pursue it legally and it put me out of business since the big department stores immediately cancelled all my orders once they realised the same stock was on sale at a much cheaper price in any number of stores across the city.

Gillian P.'s experience demonstrates not just the dishonest and disreputable practices common in the fashion industry but also the vulnerability of the small-scale designers. The practice of ripping off designer styles or of copying them for the mass or middle market is a standard industry practice. The boundaries between the legal and the illegal remain foggy and for this reason few cases make it into the courts. This raises the question not so much of what the real designers can do about it or how can they protect themselves, but rather, if copying is common practice in the fashion industry, on what basis can the designers survive? Do they simply produce their catwalk collections to see them photographed and then manufactured by high street retailers such as Kookai, Top Shop, River Island and others? Is the designer label a viable business proposition in the context of the designer 'rip off'?

This story, like so many others, also demonstrates the difficulties of keeping up this level of labour-intensive activity over a prolonged period. Compared to many of the other young designers I interviewed, this young woman survived longer in business and achieved a remarkable degree of success. However, this success has to be seen in the light of the hours put in and the stress and exhaustion which most of these young people experienced.

I started off unemployed and freelance and I approached the International Wool Secretariat and I got some work from them on the small fashion shows they put on. It was very much an 'if and when' arrangement and that lasted for almost two years. But, by then, I was desperate. I decided to try for salaried jobs and wrote hundreds of letters but really nothing much came of it. Then I bumped into a friend from college at Kensington Market. She had got a unit through a friend and offered to share it with me. I was on the dole and applied to the EAS. I somehow managed to afford the fabric that I needed to make up a range of dresses. I also borrowed a few quid from my mum. For the next eighteen months I spent three days a week sewing and three days a week selling. I watered down a lot of my designs to make them cheaper. I

made enough to live on and it was better than sitting at home vegetating. My friend from college thought it was time to expand so we moved across the road to Hyper Hyper. It cost £600 a month. Then the rent went up to £900. One week things would go brilliantly and I'd pay off the overdraft, the next week I'd be thinking I'd have to give the whole thing up. Then when the lease ran out I gave myself a week to think about it. I decided I had gone the wrong way about getting into the fashion business. I was twenty six with a £20,000 overdraft. I got a copy of the Evening Standard and applied for a job as a shop manageress.

(Ruth A.)

Ruth's experiences demonstrate with clarity the patterns of work experienced by many of the young designers who participated in this study. Even though they might deny it, 'sewing and selling' on a small scale is a more accurate picture than the idealised image of running a studio and handing over all the sewing to a part-time machinist. Paula S. was working for Jean Muir when she decided to go it alone. Frustrated by the lack of input she was able to have at Jean Muir she found out about the EAS. She was pleased to have that support for the first two years but after five years of working a seven day week, and with orders coming in from prestigious retailers across the country, she was still not making enough money to live on. She then had to take on freelance work for a bigger company which took up two full days each week, leaving her with the task of somehow squeezing the volume of work for her own business into a five-day week.

Rachel F. was one of the few designers who had managed to avoid accumulating large debts. She had done this by staying very small, a one-person business in effect, and she was also lucky to have cheap subsidised studio and living space as a result of a local council initiative. This kept her overheads down and allowed her to function on a self-employed basis. For these reasons she was able to function over the longer term as a one-woman business, although this, as she pointed out, also meant a high degree of isolation during the working day. She was sitting in her studio sketching, doing foiles and also some sewing herself. In effect, she was earning her living by doing one-off orders almost like a traditional dressmaker:

In my last year at college I was working in the Lagoon Bar and I got to know loads of people in the fashion and magazine business. From some of them I found out about setting up on my own and when I left college I already had an order book. I had started making clothes to sell before I graduated and then after college I shared a unit at Hyper Hyper. But the costs were so great that I had to give it up and work freelance. During this time I saved and got equipment through the Princes Trust, went on the EAS and, about the same time, I got the flat and workshop. It's been incredibly hard work and I sometimes feel very isolated but I've kept my head above water.

What can be seen, then, is that the whole activity of setting up in business following graduation, revealed to the young designers how difficult it was to survive in fashion. They experienced harsh working conditions if they were lucky enough to get a job abroad, and more often they were back in the United Kingdom within a couple of years. Working in an independent capacity they experienced high levels of stress, exhaustion and were forced into patterns of self-exploitation way beyond that which any employer could legitimately get away with. This was the case right across the whole group. No single graduate student had avoided the extraordinarily long hours, the low pay, the bad employer who wouldn't issue them with a contract, or the anxiety of mounting debts and the recognition that there was a whole string of factors over which they had little or no control. It was by no means uncommon to have been left with £20,000 of debts to pay off, after working day and night with no breaks, no holidays and no real salary.

This shows that the shift from graduation into self-employment or into establishing a small business in fashion design was hardly sustainable as a sound business proposition unless the designers opted to work as very small scale producers (Paula S., Rachel F.) using the services of a pattern cutter and machinist on a temporary, freelance or part-time basis. However, all said that where creativity came into conflict with business, the former won over the latter. They saw the EAS as a means of allowing them to develop their creative talent further. It came as something of a shock to them when they found themselves operating within a sector of the rag trade rather than in the art world of their dreams. In the light of all the manoeuvres they had to do, the experiences of the young designers sheds light on what it is to be part of the new flexible and creative workforce, in particular it raises questions about surviving in the face of fierce competition from bigger, stronger companies and it also puts on the agenda questions of government support for the sector and the need for fresh thinking on social insurance. As we shall see, the eventual course taken by the average 'fashion career' is working on a freelance basis for a number of bigger companies while holding onto some of the threads of independent work. This suggests a 'mixed economy of fashion design', to which we will now turn.

6

A MIXED ECONOMY OF FASHION DESIGN

FASHION DESIGN AS A TEMPORARY CONTRACT

What emerges from this study is, as we shall see, something like a 'mixed economy' in fashion design . Almost all of the respondents had worked their way right through the industry, gaining experience at every level so that they were in effect multi-skilled. However, it was not choice which motivated this high degree of labour mobility; rather it was the short term viability of the business ventures which the graduates embarked upon by themselves which forced them then to try out every other possibility of work within the fashion sector. This chapter deals with the range of ways young designers try to survive: these are, on the dole; stall-holding; shop assistants; teaching; own label; company job.

On the dole

For most of the interviewees, being on the dole was a taken for granted part of the experience of being a fashion designer, not unlike the periods actors spend 'resting' between jobs. For the designers these periods were, in the first instance, tied up with going on the business enterprise scheme which required that applicants be unemployed for a minimum period of thirteen weeks before becoming eligible. This scheme became the official route for young designers setting up in business. Its existence ameliorated the reality of 'signing on' and, once they were on the scheme, they suddenly moved in status from being unemployed to being 'fashion designers'. The scheme got young graduates off the dole since, as we have already seen, few received job offers of any type in the months following graduation. Over the eight year period since they had left college many found themselves reapplying to the scheme until it was withdrawn by the Government in 1994.

Originally the scheme was designed to support small businesses in their first year of operation, after which the young entrepreneur was expected to be able to manage without the supplement of £40 and later £50 a week. When it became evident that this was not long enough to create a healthy cash-flow the scheme was extended a further year. Of the young designers only one had not been on

the EAS (and this was because she couldn't raise the £1,000). Five had reapplied after an interval in employment, and one designer had also been on an equivalent scheme during her time working in France. The young designers who later ended up on the brink of bankruptcy with substantial debts, or had actually declared themselves bankrupt, had no alternative but to go back on the dole. Despite this heavy reliance upon the dole as a kind of fallback mechanism, the graduates were signing on for relatively short periods of time. For most, being unemployed was a temporary gap in their careers. None had been fully unemployed for a stretch of more than nine months, and they tended to use these periods to renew contacts in the business, and to rethink their futures in fashion. In addition, while signing on they took on some freelance work which was paid 'cash in hand' to supplement their dole. This activity in the hidden economy was not so much a matter of criminal intent, more a means of surviving and getting back into work. Like many young people living in London they knew that dole payments were not sufficient to live on, never mind provide the kind of resources needed to look for a new job. Making dresses for a stall in Camden Market or helping out as a stall assistant, or making clothes for friends in the club scene, allowed the young designers the opportunity of keeping in touch with the industry until they found a proper job. This was also a way of negating or overcoming the reality of being unemployed.

Even the established, well-known designers, of whom three out of eight acknowledged their experience of signing on at Job Centres, treated the dole in a matter-of-fact way. The stress of keeping their businesses going, knowing that they were making losses, and the exhaustion and anxiety of dealing with the banks as they headed towards bankruptcy, meant that retreating from business by going on the dole felt like a temporary unburdening of responsibility. Helen Storey describes her experience of being on the dole as follows:

> What does it feel like when the need to run has gone? I now deal in the small, in the detail of pennies rather than the rounding-up of thousands. I am down to collecting premier points from that supermarket and Income Support of £25 a week. It's during the day that I miss the part of me I thought I knew. . . . there is me, and the rest of the long-term unemployed.
>
> (Storey 1996: 2)

Signing on the dole has become an expected and routine aspect of life in the creative sector. The fashion designers, like so many other workers in the culture industries, know that they will experience periods out of work. But because they have such an investment in the kind of work they do, they adjust to this rather than confront the possible reality of failure. They neutralise being on the dole so that it comes to signify the spaces between work, almost like days off. It is assumed that everybody has been on the dole at some point and going from the dole into the spotlight of success is as much a part of fashion mythology as it is

in the music industry. The moment that a band who have eventually had a hit can celebrate being able to 'sign off' is parallelled in fashion with the point at which the designer can also 'sign off'. Fashion history, like pop history, is full of stories like that of the internationally recognised Bodymap team preparing for their 1984 catwalk collection while still having to sign on and working from the kitchen table. This kind of folklore destigmatises unemployment while also confirming the artistic integrity of the designer.

Despite this reliance on the dole as, at least, a fallback mechanism, these young people can hardly be described as dependent upon welfare or benefits. Their periods of unemployment were intermittent and they sought to find ways of getting off the dole. Nor were they in any sense intentionally fraudulent in their claims. Rather, they recognised that occasional freelance payments or the odd few days' work here and there could hardly allow them to sign off and eat. This poses urgent questions about the sustainability of employment and 'regular' work in these increasingly casual creative fields and the consequences of shifts in unemployment benefits as dole in 1996 is transformed into a 'jobseeker's allowance' with a workfare component.[1]

Dole is understood, then, not simply as being without work and therefore having to find any job, but rather as a stretch of time which is to be filled with activities aimed at getting back into fashion and creative work. This is a particular way of managing the uncertainty and risks of working in the creative field. Dole becomes another temporary contract. However, if being on the dole is bearable for short periods, this is only possible because the graduates are young and without major financial responsibilities such as children or mortgages. Theirs is a high risk strategy. The day-to-day existence which their occupational choice forces upon them means that they have to suspend or put on hold major decisions in their personal lives, and it also leaves them underinsured and ill-equipped to cope with unexpected illnesses or accidents.

Stall-holding

Just as everybody in fashion design seems to have spent some time on the dole, so almost everyone has been a stall-holder at some time. Indeed, getting a stall was and is the standard route into setting up as a fashion designer in the United Kingdom. It is almost a *rite de passage*. It also offers relative ease of access. With a sewing machine and a few other pieces of equipment, and enough capital to buy fabric, the young designer can enter this market. And the availability of such units in most of the large cities provides access to a market of (mostly young) consumers and, also, tourists. Fifteen of the young designers, and six out of eight of the established designers had, at some point in their careers, a lease or a share in a unit or stall in one of the fashion retail markets. For many this proved a more expensive and labour intensive option than they had imagined. At the same time, with £40 a week from the EAS it was the best way of trying to get recognised as a 'name' designer. Having a stall allowed the designer to produce a range of 'own

label' stock without having to rely on other retailers placing orders and then adding a substantial mark-up onto the price. It also allowed the designers to set their own working pace and they could adjust their output according to what was selling well at any one point in time. In addition to this, without being tied to an order they could vary fabric and quality according to their cash-flow.

This kind of stall-holding arrangement frequently relied on two or three young designers working together. They would share the rent of a unit at one of the London street markets and spend one half of the week designing and making up the clothes and the rest of the week selling them. Alternatively, they would supply a unit with an agreed number of items each week and be paid by the stall-holder on the basis of how well the clothes sold, with only a small mark-up going to the stall-holder. While initially exciting, in that it meant the graduates could immediately call themselves designers with their 'own label', this actually proved to be very exhausting work, especially when the designer was also either doing the production work at home with the help of friends or family, or else relying on the services of a single machinist to make up the clothes on this rapid production line. Once again contrary to their own public images many of the designers were also doing the sewing.

For a small number of the designers interviewed, this cottage-industry style of working was the best option for staying in business but, for others, the rising rent of the unit or stall or the slow volume of sales from these kinds of outlets put them out of business (in 1994 Hyper Hyper rents were running at £900 a month). If the stock did not sell quickly the designer was left with it, still having to fund a further range in the hope that it would sell more easily. In effect, the designer was carrying all the costs and all the risks. It was at this stage in their careers that two of the designers, Ruth A. and Anna T. abandoned independent design work each with debts of over £20,000. But for those who did well with a unit, it was a transitional stage to acquiring a proper shop, and a more fully-fledged business. Three of the better known designers who participated in this study had retained a stall even when they had other outlets, on the basis that the stall provided them with a more immediate response to new ideas, and also allowed them to produce slightly cheaper ranges for a younger market. Having a stall was a way of keeping in touch with the club scene and with youth culture.

The merchandising manager of the Hyper Hyper store in London, which provided rented stall space for up to seventy young designers (until 1997 when it relocated a few doors down the street and renamed itself Hype DF), described how she helped the young stall-holders to develop a more stable and reliable turnover. She was surprised by how little they knew about marketing, promotion and production. To be offered a unit in the shop the designer must have already produced three collections and must be able to present the merchandising manager with a whole range, including a minimum of twenty-five items. Under her advice they would then 'edit' this down to a range which fitted both the pricing levels in the store and the outlook of the market it served. While a shared unit provided a valuable outlet for young designers, one of the main difficulties in

sustaining or developing this further as a way of working in fashion lay in the high cost of renting a stall. A stall at Camden Market at a cost of £250 for the weekend was a good deal cheaper, as was Kensington Market and also Portobello Road, but this also meant that the clothes were cheaper and so the returns smaller.[2] In addition, the kind of support and advice given to stall-holders at Hyper Hyper was not available elsewhere.

Having a space at Hyper Hyper was a more professional and less informal arrangement, the costs were higher but so were the prices of the clothes and therefore, the possible returns to the designer through sales. And as we have seen, to be offered a unit at Hyper Hyper the designers already had to have established some kind of reputation, so entrance to this market was not as direct as it was elsewhere. In all cases, however, producing for this kind of outlet soon led to a make or break moment, since to move out of a unit and into a proper shop, or to be able to work independently as a designer for stockists or for wholesalers, required a good deal more capital upfront than the returns from having a stall provided. So at this point the young designers were forced to think and plan more strategically about what it would take to build on this as a business foundation. Of my sample of young designers only three, at the time of the interview, had retained a unit-style of outlet. Gaby T. had a shared unit at Portobello Market which was producing a small but relatively steady income; Rachel F. had made a conscious decision to stay small and focus on selling from Hyper Hyper while also producing individual items to order; and Celia M. was one of the longest remaining and best-known designers based in Hyper Hyper. All three of these designers knew who they were producing for in these outlets. Celia had a cheaper line of clothes made specially for the club market; Rachel specialised in party dresses for stylish young professionals; and Gaby was producing slightly cheaper versions of her freelance work for 'young, working mums in the Notting Hill area'. All three also benefited from the tourist trade which these market outlets attracted.

Shop assistants

At the time of the interviews, only two out of the eighteen respondents were sales assistants, and a third was a shop manageress. Ruth A. was pleased to get the job in an upmarket designer outlet in Knightsbridge after she was forced out of business with spiralling debts. Although she was not employed in a design capacity, her experience and knowledge of design were useful in her work. During the three years she had been working in this boutique she had paid off most of her outstanding debts and was beginning to be able to make more of a contribution to the flat she shared with her partner. It was, as she put it, a relief not to have the responsibility of running her own business. She also felt she was able to learn much more about the fashion business in her capacity as manageress than in the more stressful and isolated role as young designer. Philippa D. had applied unsuccessfully for several jobs as design assistants after her attempts on the EAS failed. Eventually she was employed by Coates and Storey but was made redundant a year

later when the company was forced to lose staff. After another period on the dole she was employed as a sales assistant at Laura Ashley. This was a step back since obviously it provided her with no opportunities to develop her design skills, but it did pay her a regular salary and she was considering applying to their management training scheme which would mean abandoning hopes of returning to her design work in the meantime. Finally, Nana F. also worked as a shop assistant even though her official title was design assistant. She was one of the few students who had no savings or parental support to fall back on following graduation and for this reason she was not able to consider looking for work abroad. Nor was she able to go on the EAS although she did spend a few months unemployed after graduating. This experience forced her to look for a job in the industry and she spent three years with a wholesale company before finding work with a company who produced under its own label for a number of outlets across London. The promise was that Nana would work her way through the various parts of the group to the point where she could take on responsibility for the design work. However, after four years this still had not happened and when interviewed she was looking after the unit the company had at Hyper Hyper. All three graduates who worked as sales assistants or shop manageresses felt that the work they were doing was less taxing and certainly less creative than they would have originally wished. At the same time, they were less concerned to project the strong and emphatic sense of self which the other designers did as a matter of course. They did not share that sense of themselves as 'stars'.

However, the shift into retail and retail management for design graduates is not an insignificant transition, even if it means giving up the dream of design celebrity. Paul Smith, the most successful of United Kingdom independent fashion retailers, indicated (in informal discussion) that this was a wise step for graduates, and that he himself had several design graduates working on his own shopfloor. As a progressive employer, he was committed to training people to be able to work at various levels within his company. This was not a route into design but a good means of using the skills and knowledge of design graduates in more flexible ways, given the difficulty so many of them had in making a living independently.

Teaching

All of the established designers had been guest lecturers at a number of different art colleges and, at the time of interview, one designer had actually moved onto a part-time teaching contract whereby she taught two days a week in the fashion design department at one of the London colleges. Of the more recent graduates, those who had either gained the most publicity as designers or had graduated with a first class degree all found themselves doing some part-time teaching. Only Jasmine S. had seriously considered moving towards a more full time career in teaching. She had come to this decision once again through the stress and exhaustion of trying to run her own business and then reconciling herself to the idea of

combining a number of design related activities, one of which would be teaching.

Jasmine S. occupies a kind of emblematic status in this study. Her career pattern best exemplifies the experience of the British fashion designer working through the 1980s and into the 1990s. Having gained great success and attracted a good deal of publicity as a talented young designer she had, at the peak of her career, two outlets in London, one in Hong Kong and a substantial order book from all the main department stores in the United Kingdom and New York. Three years later she had lost everything and had to begin all over again. Her working week at the time of interview comprised of teaching for two days, working freelance for another two days for Jones, one day for Pied à Terre and, at the weekends, returning to her own work. In this respect, Jasmine was actually following a time honoured tradition. Many of Britain's best known designers move from running their own business to going back to the academy. (Wendy Dagworthy who in the late 1970s and early 1980s was one of the leading figures in British fashion design, is currently head of fashion at Central St Martins.) Teaching provides a degree of income security for designers as it has also done historically for fine artists, film makers and others in the creative fields. But to be offered posts like these it is, of course, necessary to have an established reputation and, for designers, this means success in running their own companies with their own labels.

Own label

What designers aspire to is being able to concentrate entirely on their own creative work. This usually means designing a range which, carrying their own name or label, they will then oversee into production and from there to the retailers and stockists who have placed the order. Having your own label also means being able to put on a show at the London collections, thus attracting the attention and publicity of the fashion press and media. All eight of the well-known designers interviewed had achieved this prominent position, although not all of them were able to sustain this level of success. In fact, of the eight only five were still trading in the same capacity by the following year. Celia M. gave up the business in 1995, in order to spend time developing a career in music; Coates and Storey also went out of business in 1995 and; when I interviewed her, Jasmine S. was in the process of re-establishing herself as a freelance designer having achieved great success as an 'own label' but still having reached the brink of bankruptcy the previous year. Another three of the companies were reputed to have been rescued by lucrative contracts from bigger textile companies such as Coates Viyella and Courtaulds, or by freelance contracts with Marks & Spencer. Of course, it is a small sample but this pattern does correspond to the forecast provided by the Kurt Salmon study carried out for the British Fashion Council in 1991. Despite the fact that it was looking at the fashion design industry at its late 1980s peak, it predicted that of the 150 companies surveyed many would not exist in the same

shape in the next couple of years. The economic analysis conducted by Salmon estimated that many of these were unsustainable, something we will return to in the final section of this chapter.

'Own label' work appears to be viable only when it is supported by other more profitable activities. The most successful of the companies considered here, Paul Smith and Whistles, remain, and have always been, retailers first and designers second. Paul Smith's turnover is an enormous £142 million (1997 figures). Smith is also remarkable for having the biggest selling menswear range in France as well as seventy-eight shops or outlets in Japan alone. Whistles is way behind this but nontheless has twenty stores nationwide and has recently opened three outlets in Japan. In contrast to this, for their own label work to continue, designers such as Betty Jackson, Ally Capellino and what was Coates and Storey have all been reliant on freelance work, consultancies or other forms of support or sponsorship, while English Eccentrics have undergone various slimming down operations over the last two to three years. The issue then is the significance and role of 'own label' work.

If it is 'own label' work which creates a fashion design industry, is this industry one which literally sparkles for its major participants for a few short years before they 'burn out' or retreat with financial losses while other new talent rushes in to enjoy the limelight? Or is 'own label' work the only way in which the designers, working flexibly for a number of companies and also perhaps doing some teaching, can hold onto the notion of their personal creativity, even if they can only get back to it irregularly and produce for a tiny market? Is 'own label' the necessary fiction which fashion needs in order to exist? All but one of the young designers produced an own label collection, or at the very least a range bearing their own name or label, for a stall or unit like those available in Kensington Market, Camden Market or Hyper Hyper. But for most respondents this proved difficult to sustain on the longer term. At the time of the interviews only Rachel F. was able to continue with this kind of work without resorting to freelance work for another company. She only managed this by keeping her overheads and her costs low, and this in turn meant that she often worked to order in a dressmaking capacity. Her own label was relatively unknown to those outside her small group of clients and her range was more or less restricted to evening- or party-wear. She virtually made her name on the basis of one dress which was featured in an advertisement and subsequently ordered by a number of celebrities. She made more money out of this dress alone than from all her other pieces put together, another indication of just how unpredictable fashion livelihoods are.

Freelance and consultancy work

Freelance and consultancy work proved the most common way of earning a modest, but relatively reliable, income as a fashion designer. Of course it left the designer responsible for his/her own equipment and other overheads, and as a self-employed person he/she was also responsible for paying into insurance

plans. Being freelance meant being hired by a larger design company or retailer to work on a fee basis. If the relationship became regular the designer might find him/herself paid on a retainer basis. The freelance had to forego the right to use his/her own name or label and had to produce work to go into production under the label of the company. (In some cases the clothes carry a double credit, for example, Jasper Conran for Debenhams.) This kind of arrangement has become increasingly common since the early 1990s when so many designers went out of business. It was recognised within the industry that there was a consumer demand for clothes with a higher design content. A handful of big companies, including the retailer Marks & Spencer and the textile conglomerate Coates Viyella, initiated schemes which funded designers on a freelance basis to produce work which would then go out under the main company label. With Coates Viyella these schemes also included playing a role as sponsor or backer to the smaller design unit. One of the more established but still small design companies, Ally Capellino, was able to avoid going under (so it was rumoured) through the collaboration and partnership provided by this much larger company. As another designer commented: 'They gave her the money to exploit her brand name so it must be worth something to a big company like that.' Ally Capellino's personal assistant explained the relationship with Coates Viyella in rather different terms:

> It gave us an advertising budget and each season it supports a catwalk show and a promotional brochure. They also give us access to their own in-house public relations which means we don't have to employ an agent or a press secretary. As a two-way project it is good for them and good for us. We have a minimum five-year contract and we can use their tremendous knowledge of fabrics and production. They don't say what we have to do design-wise, it's very much a matter of what we want to do. For our diffusion range we have full use of their small factory and all the technical facilities are available. It's taken us out of the recession, touch wood, and it also allows us hopefully to plug into much bigger international licensing deals, that's the idea. It allows us to work more on design and not have to do everything else.
>
> (Personal Assistant to Ally Capellino interviewed June 1995)

More often, the designer would be invited to produce a range or a collection for a bigger chain store or for a smaller high-fashion outlet such as Jones in Covent Garden. What this meant in effect was a more profitable design company buying-in the talent of an individual designer. Jasmine S. has worked under such an arrangement producing clothes for Jones' own label for the last couple of years. This allowed her to continue to work in a creative capacity without having to shoulder the burden of running her own business.

But while this kind of practice seems like a good solution to the insurmountable problems many of the designers experienced having set up by themselves,

and while it also allows a higher design input to filter into mass market clothes, the obvious question is how many designers can win contracts like these? Is it necessary to have already established a brand name in order to be offered a contract of this type? The answer to this seems to be yes. Many of the respondents referred to other designers who had been successful and become well-known but a few years later had gone out of business and were now working on this kind of basis for a range of companies. So freelance work of this type was an available option, but only to those who had already earned their place in the fashion scene. This suggests something of a predatory relationship on the part of the big companies. They tend not to take a risk with young design graduates to whom they would have to pay a salary and then allow to experiment. Instead, the companies leave it to the graduates to make a name for themselves, perhaps run into financial difficulties and even go out of business altogether. Once that kind of groundwork has been established, they might consider sweeping in and rescuing them on the understanding that they both use and relinquish their 'brand name'. Companies will only consider taking this up as an option if they can be sure it will pay off: 'Named designers are simply an added bonus. Competition is extremely fierce and the differentiating factor any supplier can offer when they are competing for business at Marks & Spencer is design' (Sally Smith of Coates Viyella, quoted by Brampton 1994: 40–1). This constitutes what can best be understood in sociological terms as a kind of competitive post-Fordist practice (or flexible specialisation) within the over-arching terms of a more conventionally Fordist enterprise. Marks & Spencer now provide for both a mass market with their standard ranges made in runs of hundreds of thousands, and also for a smaller design-oriented, or segmented (or niche), market. They do this by bringing in design talent on a freelance basis direct and also through their suppliers. These designers produce high quality short runs of a handful of key items which then enhance Marks & Spencer's reputation as a store which can deliver simultaneously to the widest variety of fashion consumers. Helpful though this may be to designers who are finding it hard to stay in business, the commitment of the big companies or the key suppliers is highly selective, short-term and involves relatively few risks or substantial investment. What this also shows, and this is an important feature in the overall analysis, is that the designers are themselves placed uncertainly as very small, often one person businesses within a competitive capitalist industry where the stronger, bigger companies are able to determine the conditions of work for their freelance labour force as well as their own employees.

A company job

Relatively few of the interviewees had worked in a design capacity as a full-time employee for a major fashion company. Given that it was quite clear that the big companies prioritised their own profits first and considered creativity much lower down the agenda, and that they frequently 'ripped off' the designers by

copying their clothes and then manufacturing them on a mass basis which meant that their economies of scale could allow them to sell them cheap, most of the young designers had strong views about how the larger companies operated. There was a high degree of distrust, they saw larger companies as interested only in profits and willing to forego quality and design input in order to keep costs down. They also agreed that one of the major problems working for fashion companies was having to compromise with fabrics and work with inferior materials which inevitably spoilt the overall look of the item, no matter how well-designed it was. Some of the respondents were put off working as a paid employee after spending a relatively short time in this kind of job:

> My nightmare came true and I had to take an agency job with W. I was an in-house designer for over two months, they paid quite well but I did not enjoy the work. There was no scope for putting in your own ideas. It was all grey-suited men. W. is a dinosaur, you have to fit in because you cannot change it.
>
> (Gillian P.)

What this indicates is the scale of the investment young designers have in developing their creativity and their own ideas in their work. As it happens, this same graduate, having left W. to teach part-time and do freelance work, in fact ended up, at the time of the interview, with a salaried job for a German fashion company. Its strong reputation for quality in design meant that she did not feel that she had entirely compromised her design integrity. She was also able to pay off all the debts she had accumulated when working on her own label collection. Opting for a salaried job was also by this stage a realistic choice, given that she had experienced almost every one of the categories of work in fashion outlined in this chapter. Other company jobs were viewed in fairly negative terms:

> I was approached by a guy setting up a new company. He had a shop and a shop designer and he wanted me to provide the clothes. But he also wanted me to contribute £10,000 on an equity share scheme and then he also wanted me to work for him on a tiny wage. In the end it seemed he just wanted a young girl with some cash upfront to sit and sketch and do the design work. I really wasn't interested.
>
> (Terry G.)

More attractive to the graduates was a job with a well-known British designer. Even if this paid minimal wages, this kind of work counted as good experience and brought young designers closer to the heart of the fashion industry. One of the graduates was working for Coates and Storey at the time of the interview. She was a lot more enthusiastic about being an employee and described in detail the variety of jobs she was doing:

Working with Helen and Caroline is terrific, it's completely non-hierar-
chical and although I've only been here a year I have been involved in
almost every stage of the whole process. I'm seeing garments through
from the very beginning and I've been learning a lot about the business
side of things. Much more than I ever learnt at college. I've also been
doing castings for the shows and I've written some press releases, and
I've also had some experience in the shops.

(Adele B.)

However, in 1995 when Helen Storey and Caroline Coates were forced to call in
the receivers, this young woman's job disappeared too. Overall, the graduate
designers felt disappointed by the experience of working for bigger fashion com-
panies for the simple reason that they felt that their design skills were not being
developed or even used in any way. They were not opposed to salaried work as
such but the investment they had in their own talent and in their creativity as
'young designers' encouraged them to find work in areas where this could be fur-
ther developed rather than put on hold indefinitely.

In conclusion, both this and the previous chapter have shown the young grad-
uates of fashion design to be trained to work all hours in a flexible, freelance or
self-employed capacity, but unprepared for the economic reality of this kind of
work. Their willingness and motivation in this respect are apparent, but their abil-
ity to create successful small businesses on the basis of the support provided
through a number of government-funded schemes (for example, the EAS) or
other schemes (such as the Princes Trust) is strictly limited. Moreover, the time
scale within which they can reach relatively high levels of success (with their
names becoming well-known through press and television coverage) only to head
rapidly towards bankruptcy or the closure of the business, is remarkably short, on
average between three and five years. On the other hand, this stage of setting up
as a small business enterprise is important, even necessary, in establishing a
name and a reputation and can be seen as a transitional stage. The graduate is
caught in a no-win situation. Developing personal talent and creativity soon after
graduation is a way of maintaining some kind of public visibility and it can only
be done by producing 'own label' work. However, this runs the risk of accumu-
lating huge debts and being forced to work at such a pace that illness and
exhaustion are almost inevitable. And, as we will see in the following chapters, the
take home pay is often minimal. Their turnovers are low and frequently they only
stay in business by paying themselves on a pocket money basis.

Working abroad for a well-known fashion house certainly counts as useful
experience because generally there is some opportunity to do design work, but
these opportunities tend to be short term and, as Lucille Lewin (founder of
Whistles) pointed out (in informal discussion), the fashion capitals (Milan, Tokyo,
Paris and New York) are expensive to live in 'and not terribly friendly cities for
young British graduates'. This current study shows how the graduates doing this
kind of work found the fashion culture in *haute couture* ('haute culture' as Bourdieu

(1993a: 132) aptly put it) to be élitist, hierarchical and exploitative. Such a reaction demonstrates British fashion to be something different from this *haute couture* tradition, a cultural phenomenon suffused instead with elements of the popular: music; multi-culturalism; youth culture. We will return to this issue later. What we are left with at this stage is a micro-economy of fashion design. What we see is a sprawling network of uncoordinated, even chaotic, activities. It is therefore all the more surprising that these actually add up to something significant. This is creative work whose distinctive, not to say peculiar characteristics, mean that it connects with and depends upon the *postmodern* image industries which translate the design work into visual images and then circulate them for consumption in this form, regardless of their existence as real objects for sale in the shops, and the (almost) *premodern* sewing machine (and hand-finishing) which remain the tools of the trade. At the same time, it is the truly *modern* ethos of being a struggling, if not starving artist which provides the graduates with an idea of who they are and what they are doing. This combination shows fashion to be an unstable phenomenon which contains not just traces of the past but is actually founded on elements which span almost two centuries. This is what I mean by a 'new kind of rag trade'. In the final chapter, the sociological consequences of this distinct social and cultural practice will be considered in more depth.

7

THE ART AND CRAFT OF
FASHION DESIGN

SOCIOLOGICAL ANALYSIS AND FASHION DESIGN

So far I have attempted an initial documentation of the working practices of fashion designers in Britain from the mid-1980s to the mid-1990s. In addition to revealing a small scale and economically wobbly set of activities, more or less a cottage industry though now thoroughly urban and studio based, this book also highlights some of the tensions embedded in these practices. There is a great deal of fluidity as the designers flit from one employment or self-employment option to the next; there is the continuing attempt to project a public image as creative artist while having to develop expertise in business; and there is also the reality of being a one-woman enterprise and relying on some of those skills including knitting and sewing which the art school training suggested should be relegated to low skilled, paid employees. This is summed up clearly in Gillian P.'s comment 'I was knitting away night and day'.

In this chapter the focus is on how the young graduates themselves describe what they are doing, how they envisage it and how they make sense of their own labour processes. I argue that they rely on a double discourse of arts and crafts. These often conflict with each other. The craft element is relegated to the more private vocabularies of the practitioners, while art provides an identity in the public domain. They are nonetheless mutually dependent categories which function together as professional ideologies for fashion design. The discourses of art perform two further and articulating roles. They connect with those relatively new patterns of meaning used in designer retailing which present fashion as art at the point of consumption, and they also feed directly into the broader social process which Jameson has labelled the 'aestheticisation of culture' (Jameson 1984). The idea that society is somehow becoming more and more cultural is one which is threaded throughout this book. For this reason it is useful at this point to comment more concretely on how this broad social process, which Jameson argues is one of the defining features of the postmodern society, connects with fashion.

As I argued at the time in response to Jameson's seminal article on postmodernism (McRobbie 1989, 1994), there was a marvellously panoramic account of the world of images, with one picture, film or advertising image being flimsier

and more superficial than the next, and yet there was little sense of where these came from, who produced them and what their training comprised; what sort of educational or other institutional practice supported or grounded this production of a 'postmodern culture' and how attention to these dimensions might provide a different, more expansive account from the gloomy prognosis offered by Jameson. This book is in many ways an attempt to offer in the British context a more sociological and historical analysis of these processes by showing how some of the fashion 'signs on the street' are produced and circulated in particular urban economies. I also try to counter that tendency in the thinking of Bourdieu (1984) and Donzelot (1991) as well as Jameson (1984), which sees these practices as futile or as merely evidence of social and economic regulation.

For Bourdieu, cultural products are the result of the activities of the lower, or sunken middle classes, the new culture intermediaries, who have stumbled across a relatively undesignated field in which they hope to profit. Advertising, design and marketing all offer opportunities for the 'dream of social flying' and thus, for Bourdieu, a strategy on the part of this class strata for upward mobility. Donzelot, in contrast, implies that the young designers are part of that group of new workers for whom some distant promise of creative reward transforms unendurably long hours into a labour of love! And, for Jameson, as late capital further tightens its grip on production, its goods are increasingly those which take the form of culture, not invigorating, thought-invoking culture of the modernist imagination but, instead, a sorry stream of tawdry 'second-hand' and recycled images, of which we might conclude fashion imagery is typical and also embodies so many of these uninspiring currents.

However, I suggest that we ought at least to listen to how designers themselves describe the work they do, before dismissing it as self-exploitation. The various forms of work thrown up by the deindustrialising impetus of late capital might well push these young women from pillar to post in the context of the United Kingdom fashion economy, but there is also in this activity a real determination to make work something more than dull, routine and meaningless labour. It is this idea of work being a source of self-actualisation, a means of escaping 'alienation' rather than experiencing it, which is a key issue in this book. The theoretical problem is how to interpret the designers' own accounts of what they are doing, especially in the light of the analysis provided by the Foucauldians which would explain such statements as examples of the subjectivising discourses at work in creating human subjects who are also the subjects of new kinds of work. I argue that such perspectives leave little or no room for the actual manoeuvring around governmental strategies (such as the EAS), which indicate some degree of negotiation on the part of the designers, and which even give rise to a redesignation of the category of 'work' altogether so that it means something quite different from how it was conceived of within the rhetoric of enterprise. It is equally important, however, not to veer towards an account which rests on 'agency' as the voluntarist mechanism by which these redesignations are produced. We have seen quite clearly how enterprise culture frames such activities as

a strategy of government, understood loosely as the 'conduct of conduct' (Foucault 1977: 221, quoted by Du Gay 1996: 54), yet that alone does not explain the various means by which the designers also make work work for them. As Du Gay acknowledges, the conditions of dislocation which now prevail across the whole society, where so many parts no longer fit in the way they once did, make all the more urgent those practices of government which aim to ensure that we 'govern ourselves' in the right way. Yet we cannot judge the effectiveness of these incitements without examining the way in which they are operationalised, and how they appear in practice.

This book attempts then to steer a middle pathway between structure and agency by providing a concrete description of those practices which constitute the micro-economy of fashion design. This means that it seeks simply to show the extent of both the constraints and the manoeuvring around them. In addition, it raises a number of suggestions for policy. Social theory (from Foucault to Giddens) too easily discards or refutes the possibility of 'small improvements' in the field of the social. But this is a limitation. Sociologists have to be concerned with the world in which we live, and not to consider how the insights of sociology can be used to analyse and improve a field of employment, and livelihoods might also be seen as, if not an abrogation of responsibility, at least a refusal of the challenge to recognise the potential role of sociology actually impacting on the world in any meaningful way. Or, to recast the same argument in more Foucauldian terms, the role of sociological analysis is presumably to produce discourses which feed into and compete with the already existing accounts of how (in this case) fashion is, or how it should be. In this book this policy objective is perhaps more foregrounded than is the case in other more theoretically charged accounts of changes in work and employment (for example, Du Gay 1996) precisely because of this intention to demonstrate the potential usefulness of sociology.

'THE GHOST OF MATISSE GETS IN THE WAY'

What then is the purpose of graduates utilising the language of art to explain and interpret what they do? First, it justifies poor turnovers and the way many designers are barely scraping a living by appealing to notions of artistic integrity. As Bourdieu would see it, this 'poor performance' in business confirms the legitimacy of fashion as a practice which possesses high cultural capital through its existence also as an anti-economy (Bourdieu 1993b). According to this logic it almost pays to be bankrupt in this inverted world where the rules of cultural value rely on an apparent, or initial spurning of the principles of profit. The true artist, as Bourdieu puts it, has an interest in disinterest. Fashion relies on this 'anti-economy' to align itself with fine art and against the marketplace. Second, the adoption of an art language also explains the work to potential consumers. But this is not simply a question of explication or instruction, it is also the start of the representational

process more thoroughly pursued by the retailers, when the clothes are there to be seen on the rails. So, in a sense, art language serves both to protect the designers from the logic of the market and to mark their distinctive and differentiating presence in the market. This is clearly expressed by Jasmine S. who was working freelance for a Covent Garden retailer at the time of the interview. She explains how the presentation of the clothes was intended to challenge the customers in the same way as a trip to an art gallery or exhibition might do:

> The director of the company was trained as a fine artist and that makes all the difference. It means he knows what I'm talking about and he lets me go off and if I come back not with sketches of clothes but with some quotes and some colours and objects . . . and some idea of superimposing them together . . . he really appreciates that. For the advertising campaign I have just done, we use no clothes or models at all, only abstract images. We chucked the ideas around It was a kind of anti-fashion campaign but the director liked that because he is a fine artist. He understood that what I wanted to get across was the idea of fashion as constructed from debris and from obliteration How it will be received comes down to the question of who is the J. customer? I would want them to think about it. We shouldn't feel we have to spoonfeed the customers all the time.
>
> (Jasmine S.)

This can be seen as a way of flattering consumers by acknowledging their possession of the sophisticated codes of art and culture, thus differentiating them from the average or mass consumer. This form of segmented retailing, or niche marketing, would fit both with Bourdieu's scheme of class inequalities being maintained through taste cultures, and also with Lash and Urry's notion of 'aesthetic reflexivity' which comes into play more broadly across the society as a whole as culture, knowledge and information feature more prominently in the emergent post-industrial society and feed directly into everyday life providing categories for experience and understanding (Bourdieu 1984, Lash and Urry 1994). Bourdieu also explains at length how the middle classes expect images and representations designed for their consumption to require the play of specific codes and competences which are the sign of a middle-class upbringing and education. Thus, advertising images of the sort Jasmine describes will be abstract and 'difficult' for the simple reason that this corresponds to the cultural expectations of this class strata in their consumption of high culture. It should not be easy, direct, gratifyingly emotional or sensual since these are the expectations of a lower class of consumers (Bourdieu 1984). This differentiating process can also be seen with clarity in the promotional material for the Helen Storey collection at the fashion retailers, Jigsaw[1]: 'Her own woman . . . in a suit yes . . . but shockingly bright; a dress sometimes . . . but gossamer light in chiffon and jersey it could slip away in the blink of an eye . . . but the ghost of Matisse gets in the way.' The liter-

ary–poetic image is further emphasised in the interior design of the Jigsaw shops. Not only are the distinct features of the architect's work described in the press material accompanying the opening of a new branch ('noteworthy details include Nigel Coates' tongue armchairs in brickdust velvet'), but there is also special mention of 'a spectacular specially commissioned wall painting by the artist Stuart Helm'. Fashion design is connected here with architecture and with painting, to create an aesthetically defined 'experience' of fashion shopping and, simultaneously to confirm the existence of fashion design in an art world and to legitimate the class and status of the Jigsaw consumers.

So far, then, it seems that Bourdieu offers us two contradictory ways of understanding the role of art in fashion. First, it provides the necessary distance from the vulgarity of cash and commerce and, second, it acts as a strategy of taste and distinction within the field of cash and commerce. I propose a slightly different scenario. This would see the aesthetic transformation of fashion and consumption as articulating both with a traditional feminine discourse of pleasure and desire, one which Barthes found most clearly manifest in his 1960s study of fashion magazines, and also with the more recent breaking down of the traditional boundaries of high art and low culture which has been taken as one of the distinguishing features of cultural postmodernism (Barthes 1967, Jameson 1984). This suggests that there is both something familiar in the contemporary feminine aesthetics of 'art' (the *Vogue* tradition) and also something new (the widening of the audience, readership and market for the fashion as art imagery, the *Elle* reader). This, in turn, indicates an opening out of 'culture', not so much a flattening or deadening effect as claimed by Jameson, but more a feminisation and a popularisation. The consequences of this, for artists and designers still educated in the modernist tradition which venerates the charismatic status of art and the art world, are far-reaching and as yet unresolved, as art work becomes less exceptional and more 'normal' and as the categories of art travel further into the commercial field and into the marketplace for clothes, magazines, food, leisure and lifestyle and the whole arena of consumer culture.

ART VOCABULARIES IN FASHION DESIGN

The availability of the codes of fine art operates for the fashion designers both to insulate them from the failures they might experience in the market and, at the same time, to promote or market themselves as creative practitioners. This is how they distinguish themselves as professionals. It is also a rhetoric of persuasion – this is how the fashion designers want to be recognised and because there is a risk this might not happen, they are all the more insistent. Only two of my own respondents struck a note of discord by refusing the pretensions of their peers. For example, one young woman said: 'Quite honestly that stuff about walking through the woods and being inspired I think is nonsense. I work on new shapes and I know a good collection means a slim pair of trousers and a wide pair of

trousers' (Marcia P.). Another commented: 'I'm one of the sensible girls as distinct from the gay boys. I'm not going to make big announcements every season. And I also happen to think Galliano is a load of overrated pretentious rubbish. I want to make clothes that women enjoy wearing, whatever shape they are' (Gaby T.).

The closer the graduates still were to their time at art school, the more pronounced was their commitment to a fine art based identity. This is best summed up in a statement made to me by a male graduating student interviewed when I returned to college after completing the body of the fieldwork, to get a renewed feel for students graduating ten years after my main group of respondents. This boy said (and his comment also displays all the signs of casual flamboyance adopted by 'the boys' in the hope that their provocative style will get them noticed):

> In my work I want to explore the deeper meaning of my laziness and link it with imagination. I want to hold onto and work with spontaneity. And I want to engage with eclecticism. I like the idea of a perfect finish but not the work that it involves. By far the most advanced designers are Miyake and Galliano. They are doing what they want to in spite of the need to make money. Nor is their work just about fashion. It's about imagination and projection. Like them, I find two-dimensional work exciting. And I like the idea of a crossover between fashion, painting and illustration.
>
> (Tony A.)

This is one of the best examples of the 'creative self' as a performative strategy which constitutes the graduating designer as artist through the very act of self-description (Butler 1990). Everything he says contributes to confirming this identity. The exuberant conflation of fashion with the fine arts serves as a kind of (over)statement of intent on the part of the student preparing for his degree show. It also echoes the art school ethos of exploring the boundaries between different art practices. The student clearly wants to challenge the basis of what we mean by fashion and this is summed up in the disregard he shows for finish. He emphatically doesn't care about 'finish' and doesn't want to have to do the sewing and handwork to achieve this polished or professional look. He discounts money in favour of the designer doing what he or she believes in. And he positions the fashion designer firmly within the landscape of the art world. The more shocking his stance and his collection, the better, since shocking or outrageous clothes are not only more likely to attract attention, they also bring the designer closer to the kind of artists who find themselves ridiculed or scorned (though hopefully admired by the significant audience) for wasting the taxpayers' money. And finally, abstract or difficult work on the catwalk is also testimony to the avant-garde aspirations of the designers. Whether or not this approach pays off, it demonstrates very clearly how so many of the designers ideally see themselves,

especially in the first year or so after leaving college. The girls may be less sure of themselves and more muted in their hopes and dreams, but the imagery of the creative artist tallies exactly with what they want to achieve. And for some like Celia M., as we shall see, this language is utilised with the same vigour as it is by the boys.

The designers working in the United Kingdom who most clearly personify the fashion designer as practising artist are John Galliano, Vivienne Westwood and, more recently, Hussein Chalayan. Both males are graduates of Central St Martins, Galliano in 1984 and Chalayan ten years later in 1994. Westwood's design education came through the do-it-yourself ethos of the punk movement in the mid-1970s and is reflective of the kind of informal training I described in the introductory chapter as not unusual within the field of British youth subcultures. Despite these similarities the artistic strategies they employ are quite different. Galliano is frequently described as a 'maverick genius' possessing 'outstanding talent' (Brampton 1993: 43–6) and, as the acknowledged favourite of fashion journalists, has received more coverage than almost all the other well-known United Kingdom fashion designers put together. He 'claims never to have read a book' but, according to Sally Brampton in the *Guardian* (Brampton 1995: 21) 'one need only look at the collection of John Galliano or Vivienne Westwood to appreciate the mastery of fantasy – sometimes wantonly perverse and sometimes lyrically beautifully – that this culture can produce.' Galliano also fulfils all the qualifying criteria as a struggling artist, sometimes misunderstood but true to his own ideals and talent. One of the graduating students (who has since followed the same rapid pathway to success) described his time working for Galliano as follows:

> It was brilliant, I learnt so much from him. He is like a child excited by ideas. He's got no business sense at all. It's all complete naïvety, the way he works. It's instinct, feeling and imagination. He would ask me out of the blue, what do you think of this? He has such vision and strong themes, like his bias cut, throughout all his work. He's also aware of other influential designers like Westwood and he looks closely at what she is doing.
>
> (Marko B.)

This comment demonstrates once again those 'technologies of the self' which can now be recognised as producing the fashion design 'subject'. Galliano is childlike, instinctual, ignores the need to make money, possesses 'vision' but has also mastered specific and recognisable techniques, for example, bias cut. Journalists, friends and admirers help to make this space for the creative subject by repeating, often mantra-like, its mythological elements. Galliano's various financial disasters and his time spent sleeping on friends' floors in Paris with no money to buy food, never mind the fabric for his collection, have been told and retold. He has consequently emerged as head designer for the French house of Givenchy (and

more recently Dior), as a haute couturist of acclaimed genius ('He is fantastic, beyond imagination, a grand couturier': Joseph Ettedgui, quoted by Sally Brampton 1993: 44).

Hussein Chalayan 'performs' as an artist even more uncompromisingly than many of his counterparts. He attracted the attention of the fashion press at the Central St Martins degree show in 1994 when his collection was accompanied by a text which told the narrative of its own construction. The story of how the clothes had been buried in earth for some weeks and were then disinterred and shown on the catwalk in this grimy state was then further explained in the context of another story, a fictional meta-narrative written by Chalayan himself. This kind of 'textual fashion' bore all the hallmarks of contemporary mixed-media art. It attracted a lot of attention and put Chalayan on the fashion map almost instantly. As he said to journalist Andrew Tuck:

> I just happen to symbolise my ideas with clothes. I am a fashion designer technically because my clothes are sold in shops, but on my card it doesn't say 'Hussein Chalayan, fashion designer', just 'Hussein Chalayan'. I think some of the clothes could be hung on a wall and because there are pieces of writing in them perhaps that would remind you of things like an ornament does.
>
> (Tuck 1995: 28)

As part of his prize-winning collection Hussein had yet another piece of narrative printed onto one of his full-length dresses which could then be read down the dress from top to bottom. He explained:

> I wrote a fictional story which related to the collection and printed it on a dress, the clothes symbolise the story. Parts of the story are sewn into garments, it involved you with how the garment evolved, the garment had a history, as labels, facings, back, pocket
>
> (Ibid.: 28)

Chalayan envisages himself less as a fashion designer and more as an artist working with ideas through the medium of clothes, fashion and textiles. In both the above examples of his work, he is concerned with drawing attention to the material processes of garment construction. He presents himself as an intellectual or theoretical designer: 'Basically I'm very much against the mechanistic world view, this whole idea of mechanising everything and creating formulas and models for things we can't really rationalise. Descartes was someone who created this whole world view' (ibid.: 28).

Vivienne Westwood also embraces a strongly fine art mode. She does this by returning to the world of classical painting and incorporating elements of dress and costume and other items found in a wide range of works, drawn from over the centuries. Westwood combines these historical references with a number of

more constant themes based around contemporary femininity, female sexuality and ideals of beauty. She presents herself with an air of practised eccentricity, which is of course a recognisable and accepted way of being an artist. She affects a combination of British matronliness (a 'dame') with girlish naïvety. This exonerates her from the charge of taking liberties with history. She can delight in the production details of the dresses of Marie Antoinette, for example, without any broader references to their symbolic significance as signs of unacceptable wealth and luxury in the context of the French Revolution. So, despite the radical vision of Westwood in terms of the images she creates of women which break sexual taboos and suggest female strength and power, she actually reactivates the most conservative tradition in the history of costume (which is to extrapolate items of clothing from their social context) and integrates this into her work as an innovative fashion designer. Westwood makes definitive, often disconnected, statements in relation to her work: 'I work from my academic interests, like baroque theatre, for example The Rococo period offers wonderful drapery' (Westwood 1993).

Despite this blindness to the political context from which she selects her historical references, fashion journalists heap praise on Britain's most famous woman fashion designer: 'Vivienne Westwood uses fine art and literature as her inspiration rather than poring over the rails of clothes on the high street' (Chaudhuri 1996: 8–9). However, like Galliano, when Westwood talks about how she actually works, she becomes a craftswoman. This corresponds with Becker's account of how artists make use of, or draw upon the language of craft when discussing the technical details of their work (Becker 1982). So it is quite admissible for Westwood to say, as she did in her recent television series, 'my work is anchored in English tailoring.' Or that creativity comes through technique, or that fashion is 'the manipulation of materials, as it is with painting' Every tiny decision you make, this is technique You have to work in a craft way or a technical way to be creative. You have to build up the finished result.' At the same time she says: 'students must learn to draw, life drawing builds up judgement and aestheticism' (Westwood 1993).

All three of these designers conform to the accepted image of the practising artist. Their interviews frequently take the form of statements or proclamations. These comprise a 'poetics' of the work, a commitment to technique and a location of the work in philosophy (Chalayan's *Descartes*), history (Galliano's *Les Incroyables*) or period (Westwood's *Rococo*). These provide titles, captions and headlines for the shows which are easily appropriated by journalists, and so once again the art dimension is qualified by the pitch for the market and for publicity. This particular 'articulation of elements' has set a standard for that distinctive presentation of work which is now the mark of identity of the United Kingdom fashion designer. For most of the young designers, and for the less well-known designers interviewed for this book, these elements are less flamboyantly combined but they still provide a crucial underpinning for the work by providing an authoritative art-world frame of reference:

We are both strongly influenced by the fine art tradition in fashion. Our last collection started off by drawing on two colours combined in the work of Mark Rothko – a very distinctive blue and a chocolate brown. For this coming season we have been going back through Paul Klee's paintings and that feeling will come across strongly in the clothes we are planning to make.

(Yvette M. and Lisa R.)

Several of the graduates associated this crossover between art, fashion and also literature with their training. Christine F. commented: 'The emphasis at college was on ideas and history. I did a whole project on the world of Vita Sackville West. I've tried to hold onto the art aspect of fashion in my current work.' This kind of approach was confirmed in an article in the London *Evening Standard* which included a statement from the Dean of Fashion at Central St Martins, Jane Rapley:

We deal with concepts and visual metaphors, not one shirt, two jackets, three pairs of trousers. Our students are more likely to say 'I'm really excited about the American heartland'. We've bent over backwards to 'keep our flexibility. It's a gamble – sometimes it works, sometimes it doesn't.

(Rapley, interviewed by Watson 1994: 12–13)

The journalist added: 'Certainly Central St Martins is more serious than it was, but it's still a place where you are more likely to be asked to design around a piece of music than draw up a co-ordinated collection for Principles' (ibid.: 12–13).

Fashion design culture needs art to explain its dynamic and its creative drive both to itself and to the outside world. Art acts as a source of legitimation. For this reason the designers eagerly refer to its authority. It provides a means of explaining themselves and their work to the public. Celia M. echoes the romantic tradition of Wordsworth to describe how she works:

I am not like most fashion people who think things out in advance. It pours out of me. It's a totally emotional process. I'm a designer with passion and motivation, and I work like that. I like making clothes and dressing up. Sometimes I dream my next collection, I have millions of clothes in my head that I haven't got the time to produce them. It's like painting with the body as a canvas. Every garment in my collection has been on my body.

And it is precisely this kind of identification which led a spokesperson for the British Fashion Council to comment in August 1993:

Living on a shoestring is how most fine artists exist. How many of them make a decent living? British fashion designers see themselves in the

same way. It's a distinctive mentality. They would rather do their own thing, even if it never sells. It's a complete cottage industry in the United Kingdom.

CRAFTSMANSHIP AND FASHION DESIGN

We have seen how art provides a vocabulary of value and personal confirmation for fashion designers. It also grants them legitimate access to a language which permits a degree of abstraction, not to say obfuscation. In fact, when they talk about how they actually work there is a noticeable shift away from an aesthetic vocabulary towards a more technical or practical one. The values of craftsmanship suddenly appear on the agenda and the more rhetorical flourishes of art temporarily fade away:

> I work with plain fabrics, never prints. It's a very small collection and very careful. I do viscose jersey, silk trousers and crepes. It's simple and understated. I go to the fabric shows twice a year and I know my clothes are pricey because I only use expensive fabrics. Tweeds are OK in Britain, but nothing else. You have to buy from France or Italy. We work on a shoestring, no doubt about that. I am committed to my design work and I like to work in a totally creative environment which is what we have made the studio, with the bits of sculpture, the music and so on. The problem is finding a way of doing this kind of work and making a living. I don't know the answer to that one yet.

(Paula S.)

Paula's account of her working practice offers a clear insight into 'creative labour' as a combination of artistic endeavour and craft-like skill. Her expertise is evident in the conception of the collection and the knowledge of fabrics, while the studio decorated with its pieces of sculpture and with background music provides a 'high art' environment for inspiration and ideas. It also provides the important 'space' which confirms her creative identity.

Yvette M. and Lisa R. lasted only five years in business before being forced to declare themselves bankrupt. They were interviewed twice for this book, once just when they were heading for the media spotlight and then briefly again a few months after they went into receivership. At the time when they were attracting enthusiastic publicity they described their creative labour as follows:

> We start with a colour and a piece of clothing that we like. With the last collection we began with a seventies pair of trousers and a jacket to go with it. We made them both up in calico as we couldn't afford to make up in real fabric. Then we did the amendments and the changes. For example, with this navy crepe suit we put in a lace-up front in the jacket

112

instead of the buttons, which gives them what is basically a seventies shape but with a new feel to it. We pattern cut ourselves unless it is a jacket, in which case we pay a freelance pattern cutter to do it for us.

(Yvette M.)

Despite the emphasis on drawing as the basis for innovation and originality in design, and also as the point of connection with the world of fine art, during the interviews the graduates were keener to talk about working with the fabric and the idea than with the drawing and art-work stage. Overall, they were less concerned with being at the drawing board and more interested in seeing the garment emerge as an object in itself. Only one designer mentioned drawing and she quickly moved from there on to talking about the next stage:

At the beginning I'm at the drawing board all day and if I end up with three sketches that I like, I'm happy and I feel I've done a good day's work. Then I do a sample on the knitting machine and then I go back and rethink the colours and the texture and it just keeps developing until I've got the right yarns, the right shape and the feel for the whole garment.

(Joanne A.)

Celia M. who, as we have already seen, most closely conforms to the image of the designer as visual artist, also repudiates the drawing stage, but this time from a position which reconfirms her identity as an artist/sculptor:

I work in a very unorthodox way. I cut straight into the fabric as soon as the ideas have formulated. I find that drawing beforehand stunts the natural direction. I follow any interesting mistakes, which somehow determine my whole collection. After having adjusted and readjusted a garment, I then make a pattern by taking the rough sample apart. It is then re-cut and passed onto my machinist to finalise the small finishing details.

The three women team who work under the English Eccentrics label developed a division of labour as follows:

The starting point is Helen Littman's abstracted, lushly coloured, rich prints, mostly on silk but also on heavy cotton. The three women work on colours and themes together but the actual designing of the prints is done by Helen who is exceptionally talented in her field.

(Brampton 1994: 13)

In another interview for the *Telegraph* magazine, Helen Littman describes how they got started: 'We would print, cut and sew and then try to sell what we made.' The

journalist comments that like so many other British designers, English Eccentrics 'began by selling homemade clothes at Camden Lock market in London.' 'We used to carry huge rolls of fabric around on the Tube,' Judy says. 'We would print it ourselves on the concrete floor of this place in Wapping and then smuggle the clothes into a launderette and bake on the dyes in the tumble driers' (McHugh 1993: 37–8). The emphasis on craftsmanship in the work of English Eccentrics has been praised throughout the fashion press:

> It is the beautiful patterns which make the garments of English Eccentrics so distinctive. The clothes themselves are those simple, well-cut classics – shirts, tunics, waistcoats – which hardly deviate in line from season to season. The silks from which they are made, however, are printed with Helen Littman's designs. These are rococo fantasies peopled with cherubs, dodos, whorls and curlicues of fantastic colours. . . . An outfit by English Eccentrics does not come cheap. . . . The fabric is cut by hand to ensure that the design is centred on the back of each garment. . . . The printing too is done by hand and a screen has to be made for each colour.
>
> (McHugh 1993: 37)

Helen Littman also remembers the influence of the arts and craft tradition on the undergraduate course she did at Camberwell School of Art, and the way this influenced her own practice as a designer and her preference for producing individual handcrafted garments in favour of long runs and higher profit margins: 'There was a craft emphasis, a William Morris feel to the course and it was very good indeed on the technical stuff' (Brampton 1994: 14).

Engrossed in work, the designers, like those mentioned above, switch their vocabularies to embrace the craft dimension of their practice. They emphasise their involvement right through from the start to the finish of the single garment. They rely on a machinist close at hand and also need the services of a pattern cutter, and it is this small team-based approach which actually provides the framework for 'creative labour'. Indeed, it is this craft element which provides a crucial underpinning for the art work. Becker has described this process in the following terms:

> Members of art worlds often distinguish between art and craft. They recognise that making art requires technical skills that might be seen as craft skills, but they also typically insist that artists contribute something beyond craft skill to the product, something due to their creative abilities and gifts that gives each object or performance a unique or expressive character.
>
> (Becker 1982: 272)

Designers like John Galliano who have reached the heights of fame and success are

more able to acknowledge this dimension than others who still need to promote a more inspirational and purely creative image of the designer. Galliano shrugs off the label of artistic genius by claiming that 'It doesn't take into account all the hours of work that go into making something look right. Or the people I have around me who are brilliant' (Brampton 1993: 46). This also corresponds with Becker's important argument that art is the product of collaboration: 'art is social in being created by networks of people acting together' (Becker 1982: 369). Galliano's interest in the fine details of technique, '. . . we had the spots especially printed down, so when the fabric's cut on the cross, all the spots go round the body and are never interrupted by a seam' (Brampton 1993: 46), forces the journalists to acknowledge that his work is as much about craft as it is about art, 'For it is his craft which most absorbs him, he is one of the greatest technicians working in fashion anywhere today' (ibid.: 46).

In conclusion, art codes introduce the work of the designers, typically in the form of a 'statement', and function also as promotional devices (in the press releases). Most importantly, they provide an anchor of identity for the graduate designers. This language is strategically deployed as the highest status of the available discourses of self-representation available to graduates who have been through the art school system. It makes the misery of being poor, and the disappointment of not being successful, something that can be turned into a legitimate mythology of being misunderstood. It is also a discourse of hope since the mythology of the struggling artist is that quite suddenly and unexpectedly he or she will find success and recognition. Finally, it is appealing because it corresponds with the images (and fantasies) of creative work which in a post-industrial economy have taken on a new importance. Fashion in this respect has benefited from the new culture of creativity as the aura of art has moved beyond the fine arts to embrace cultural fields previously seen as 'lesser arts'. However, in the day-to-day environment of the studio, a more practical and technical language evolves and this involves knowledge of, and expertise about, fabric and cut and the way a garment will hang and it is also about trial and error and process. Skill and technique come into this as does the need for collaboration and for teamwork. But this all stops short at the point of putting a collection into production. The 'arts and craft' vocabulary, anxious to rid fashion of any connotations of the 'rag trade' and thus secure its own autonomy, conceals the equally important but menial practice of manufacture and production.

Back in the outside world, the art language and the individual image of the designer (with his or her own distinctive design 'signature') is part of the process of marketing and also branding. These come together in the concept of the label. So there is a double movement around the status and meaning of art. On the one hand, it represents integrity and the disavowal of the marketplace, on the other hand, it gives fashion the aura, status and the distinctiveness it needs to set itself apart from the high street and the rag trade, as a kind of niche market. It therefore also functions, with all its pretensions, as a commercial device. The designer as artist retains a value on the freelance or consultancy job market as a name with

an image. But the imperative of the market is balanced by the sheer effort of the designers to see their work hung on gallery walls, featured in art magazines such as *Artforum* and acknowledged as an object, piece or collection like an 'installation' or 'performance'. Ally Capellino's new outlet, opened in July 1997, describes itself as having an 'exhibition space' at the far end of the store. This kind of art space is where the fashion designers want to be. They also want to sell clothes and make a living. Celia M. and Hussein Chalayan are 'artists' who happen to be working with fashion and, as we have seen, the scissors and the fabrics are their paint and canvases. This raises the interesting question of whether fashion actually offers a more successful career for the conceptual artist, than the more conventional practices of fine art. In which case the business of fashion takes a legitimately secondary place, while the market and the publicity for this kind of 'art-fashion' is even more extensive and enthusiastic than it is for conventional art, for the simple reason that the supermodels add a further element of visual interest. This scenario suggests an even more fluid mix of the categories of art and craft, high culture and low culture, practice and production.

8

MANUFACTURE, MONEY AND MARKETS IN FASHION DESIGN

'I CAN'T SEW'

Fashion design comprises artistry, craft and manufacture, but the disregard for 'making' contributes directly to some of the difficulties the designers experience in their attempt to build up sustainable small businesses. This inattention to the fine details of manufacture also produced difficulties in the study of fashion itself. I wanted to know how the designers produced their collections but they were reluctant to discuss the relationships they had with the Cut, Make and Trim (CMT) men who took their orders and then farmed out the work to a long and labyrinthine chain of producers.[1] This was a sensitive issue. It seemed as though the various production deals struck by designers with the Cut, Make and Trim men who offered their services either through advertisements in trade magazines, or locally, or through word of mouth, were closely guarded trade secrets. There was a degree of secrecy because good deals were hard to come by and designers were scared of losing out to competition. It was important to find a manufacturer or supplier who would guarantee that the order would be done in time and to the right specifications. Alongside this were issues of cost and payment. The designers were always worried that somebody else would slip in an order that would either be easier to make or more profitable, they would lose their place in the queue and the order would be late getting to the stockists. They knew that the CMT men played the market promising the designers that theirs was the only order they were taking on, while knowing that they had said the same to at least three others.

The designers needed to establish a steady relationship with one supplier but this proved difficult, not least because the orders they placed were erratic. But the volatility of the designers' orders were mirrored in the production field. CMT men also went in and out of business. The designers themselves rarely had a clear idea of the cost of runs and the precise volume of fabric needed and this meant they could quite easily be overcharged. They knew there were profits to be made through 'cabbaging' garments made to the original design from fabric left over from the run and sold by the supplier through the network of London street markets. Despite the designers' concern with finding the right fabric, and despite their

117

technical knowledge of fabric, this interest was not pursued through the whole production process, thus making them vulnerable to unscrupulous practice on the part of the producers. Steven Purvis, a Scottish manufacturer, who had trained in textiles at art school but had taken the unusual step of setting up his own CMT operation and then later a small factory outside Glasgow, commented on this situation in an interview in March 1994:

> There is a shocking ignorance on the basics of production among design graduates. It's laughable how little they know. For example, they have no idea that the point at which the profit is made is at the layout of the fabric stage. It's all about fabric and cut. This means that pattern cutting is an art. The designers don't see that and they lose a lot through not paying attention to how the clothes are made up. There is a huge hidden economy in fabric in CMT, for instance, in fabric ripped off from the designers who can't be bothered to follow up how much is actually needed to make up the orders.

Instead of being involved in every stage of the costing process, the designers paid little attention to the sort of issues raised by Purvis, nor did they ask any questions about how much the women employed further down the sub-contracting chain as outworkers or homeworkers were being paid. Perhaps it was in their interest not to ask any questions about who was actually doing the sewing, since this might have implicated them in a chain of illegal or semi-legal employment practices: people working for very low wages, 'off the cards', or employed on a cash in hand basis in the knowledge that they were also signing on (Phizacklea 1990). The designers tended to stick to what they considered their professional brief which focused on the quality of the final product. The rigid division of labour operating in the field of fashion separated the designers at the top from the women at the bottom end of the chain of production who did the making up. For all the reasons relating to their education and training as well as their creative identities as professional designers, they were able to relegate production to a field outside their own expertise. But they still had to have people working for them or with them in producing orders. The forms of employment relied on by the designers were combinations of the following modes of fashion design production.

Students on work experience

When first interviewed, Yvette M. and Lisa R. could not afford to pay sample machinists at all, even though they had won substantial orders following good media coverage, both in the fashion magazines and also in the quality press. Instead, they were reliant upon unpaid student labour. This was possible through the work experience programmes which fashion students were encouraged to take.

I can't sew. We have students from the college working for us – we can't afford to pay them but it's good experience for them and they can put it on their CVs. They do the making up and the sewing and also some of the pattern cutting, and we also send them up to the West End to scout around for finishings and that's good experience for them too.

(Lisa R.)

Lisa's comment about her own inability to sew supports what I suggested earlier was a typical fashion design graduate's repudiation of the 'dressmaking' tradition in fashion. However, there seems to be a degree of 'wilful forgetting' in some of these claims. Even if what they learn about sewing remains rudimentary, most fashion design students appear to gain some knowledge in this area. There is a degree of unlearning of these low status skills. As we saw in the comments made by Lagerfeld and Yamamoto, it is only when designers reach the top that they are confident enough to rediscover and acknowledge the skills of sewing – they can 'come out' again as dressmakers. But for those still struggling to succeed in the fashion business, doing design means getting other people to do the sewing. Yvette and Lisa employed a pattern cutter and, once they had raised the necessary loans from their banks and were at the stage of putting the orders into production, they were able to use one of the small companies which combined some in-house manufacturing in the sort of small unit described by Phizacklea (1990) with sub-contractual work involving Asian and Turkish Cypriot women based in North East London. However, having students on work experience meant that the small details of finishing or sewing work could be done by them on the premises. All the other designers were also able to make good use of students on work placement schemes. Indeed, there seemed to be something of an apprenticeship system in operation. The students did finishing and hand sewing. In some cases they constituted more than half the production team. For example, one designer described her workforce as follows: 'I have three people help with the sewing up of garments, a woman round the corner and two students on placement.' The students did the work which the designers did not consider doing themselves and which was not the job of the sample machinist either. This was considered a vital part of the students' training and indicates that they did have knowledge and experience of some sewing work. Rachel F. explained that she always took at least a couple of BTEC students on a work experience basis and that this helped cut her costs because it meant she only had to pay a sample machinist on a one day a week basis to do the work which the students did not get through or which was too difficult for them.

Several of the young designers had themselves gone through work experience programmes in which it was generally accepted that they did all the dogsbody work including the finishing of the garments and even the handing up of pins. All the design studios visited in the course of my research had students working on this basis, a few being paid a token amount, while others had their travel and lunch costs covered. They were also expected to do other kinds of work including

119

writing press material, being on reception and running errands. A few designers also had students working on their stalls or units at Hyper Hyper or Camden Lock. Work experience programmes, or even informal arrangements, provided the designers with valuable unpaid labour power and this included making up designs to samples, sewing and production, as well as all the other work involved in running a studio. This whole system was summed up in a comment made by a student to her tutor on completing her placement. She said that in lieu of payment she had been given 'two suits from Bella Freud'. The question might be raised, who covers the living expenses of these young people on 'work experience'? Are those who work for nothing signing on at the same time, which means that the dole is in effect a training agency? Do parents provide support, once again on the basis that this unpaid work will pay off in the future, or do the young designers pay their own way for unpaid work by taking evening jobs or other casual work? No doubt all three of these suggestions provide a patchwork of funding, which is in itself a sign of the new piecemeal way in which jobs and livelihoods are now being constructed.

Employing a machinist/pattern cutter on a freelance basis

As we have seen earlier in this chapter many of the designers had to rely on freelance services rather than actually taking on full-time employees. Even the relatively well-known designers found it hard to cover all the employment costs entailed in having full-time employees and got round this by taking on part-time workers. The sample machinist working on this basis would typically be found locally and would be paid in the region of £5 an hour. Paula S. described her employees as follows: 'Everybody in the business is freelance, the pattern cutter, the machinist, and then we use a CMT firm with outworkers for the complete collections and a factory if it's jackets, so we have no employees as such.' Celia M. had an equally small team:

> I have one outdoor machinist who does the bulk of the sewing and an assistant who finishes. She is employed on a part-time basis and I usually have a student attached as well. There are production teams round London that, depending on their availability, can be used when necessary. But I try to rely on them as little as possible as I have experienced the horrors of late arrivals and hundreds of wrongly-made garments.

Most designers could only afford to employ people in a flexible and freelance capacity. This was the only way they could have people on the books (or off the books as it happens) and stay in business. Some designers had started off with full-time employees but were forced to re-employ them as freelancers. This suggests that flexible, part-time and freelance working practices were increasingly prevalent right across the skill range in the fashion industry, from the designers

120

at the top, to the sample machinist at the bottom. As we see in the following section, there are relatively few direct employees. These are very small businesses, a sprawling network of urban-based cottage industries, where the owner-director is, in reality, a self-employed person, and where her staff are also self-employed.

Full-time employees

The designers who were more established and running relatively successful businesses would have at least one sample machinist on their full-time staff, sometimes two. These women worked closely with the designer, often in the corner of the design studio, and their talents were heavily relied upon as this (somewhat patronising) comment from Helen Storey shows:

> There should be a Sharlot in every workroom. In the best fashion houses they are bred from generation to generation – they weft to our warp as designers. When they are silent, but most often over chatter, one can glimpse their effortless skill. The years of perfection in any couture house can be seen in the rheumatoid knuckles of women. . . . In Sharlot's hand chiffon will obey, can follow a course of miles, never is the suffering transported to the edge. The work that flows behind has stitched in it a mother's love.
>
> (Storey 1996: 93–4)

All eight of the well-known designers interviewed for this book employed sample machinists and pattern cutters on a full-time basis. These were core workers for the design process and reliable and highly-skilled workers in these areas were valued even though they were not necessarily earning wages that reflected these skills. At the time of writing the average annual pay for a skilled pattern cutter working for a London based designer was £15,000, while a skilled sample machinist could only expect in the region of £12,000. By European standards these salaries are low, a reflection of the fact that the pattern cutter in the United Kingdom is perceived as a skilled worker despite the new educational qualifications and the various training progammes. Paul Smith sees this as symptomatic of the poor state of the United Kingdom fashion industry:

> Pattern cutters wear white coats in Italy, they are highly-skilled workers and very well paid for what they do. We (at Paul Smith) would do that here but the profile of the pattern cutter is so low. When we advertise for pattern cutters in The Guardian, Time Out, the Drapers Record, or Fashion Weekly, all we ever get is 'I'm working in a pub right now but I've done a course at college.' There is a low level of enthusiasm about this kind of work yet it's the most important part of the job.
>
> (Paul Smith in discussion December 1995)

Cut, make and trim

The designers all made use of the CMT system of production as soon as they had an order which went beyond the kind of output they could possibly produce themselves. For them the most important issue was quality and, as Celia M.'s comment above shows, being able to ensure that the work would not have to be returned. None of the designers enjoyed this side of the work especially when it involved having to bargain for the lowest price for an order. Many of them wanted to be rid of it altogether, either by remaining small and overseeing the production side in-house as Celia preferred, or by delegating this work to a business manager. They were also aware of the problems in getting small batches done, since although the local units specialised in this kind of work they still preferred bigger orders of simpler, less complex items. The CMT men knew how unstable the cash-flows of the young designers were and demanded payment, in cash, upfront on delivery of the order. For these reasons most of the designers, if they did not already have a business manager, said how much they needed one. For those who worked as a couple or a husband and wife team, one partner would look after the 'outwork' of production, quality control and delivery, leaving the other to do the design work, organise the fabric and textiles and also run the studio.

Discounting Paul Smith who is a retailer first and a designer second, none of the designers themselves professed to having visited a factory or workshop where their designs were made up. Obviously the more established designers employed their production manager or business manager to liaise with the manufacturers and they would have the opportunity to make such a visit if required, but this element never arose naturally in the course of the interviews. Even when it was clear that their orders were being produced barely a couple of miles away, there seemed very little need on the part of the designers to make any contact with the women who were doing their making up. The production manager of J. who was in regular contact with the suppliers, put this clearly in an interview by Rana in 1995:

> From a sociological point of view, you can work in a studio in the West End and within twenty minutes you are in a factory in Hackney. It's cheap labour, the people at the top take all the glory, but behind it it's not like that . . . the people in the factories have no concept of what all this is about, they never come up here.

Most of the designers interviewed had some experience of using these small and dispersed production teams. It was widely recognised that this was how fashion production was organised within the design sector. The successful companies such as Whistles, Ally Capellino and Jones used these local CMT firms and also made use of a number of factories located either in the north of England or in Scotland. Caroline Coates of Coates and Storey describes their manufacturing strategy as follows:

122

> We do most of our manufacturing in London with the CMT companies. Coates Viyella have recently been helping us out with the manufacturing of our winter jackets. For the heavier work we need small factories with all the equipment. Some are based in London but a few are located up north. We desperately need a good database with fabric suppliers and manufacturers, especially factories that will do between twenty and two hundred garments. There is still a real problem finding that kind of outfit.

There is, therefore, a manufacturing curve through which the designers move from relying on their own and also the unpaid labour of students (and friends) to the freelance employment of a machinist and pattern cutter, to the full-time employment of these workers, to the use of CMT firms who subcontract the work out to smaller production units and small factories. This is largely United Kingdom, home-based production. The designers were aware of the problems and the costs of outsourcing and relied on the local labour market of very flexible workers.

The designers omitted to mention in interview those points in their careers where they had done their own sewing. Some might have been bad sewers, others might simply have hated the tedium of sewing and been pleased to pass it on to somebody else, but there is no doubt that this activity played some significant role in the small scale production involved in setting up as a designer. They did not want to mention this because, again, it brought them too near to the image of the dressmaker and they saw this as a threat to their skills as designers. If they did one, they didn't do the other. And yet they had all been through the apprenticeship system of work experience or had compiled their own collections by doing some of the sewing work themselves, and several of them had produced or were still producing for a stall or unit by relying on their own skills from design right through to production, so there was an element of disingenuousness here. Their training and education and their aspiration to be creative artists forced them to overlook or forget the manufacturing side of things – even the sewing they had themselves done as teenagers as a way of keeping up with fashion and of setting new fashion trends. In many ways it was this activity which led them to study fashion in the first place. In many cases this disavowal backfired in that it meant the designers did not have a clear idea of what happened once the CMT man went off with the orders. This failure is as much the outcome of a rigid, class-based and hierarchical division of labour as it is the fault of the young designers. The importance placed on this specific division of labour is, as we have seen, a product of the history of class and gender in the art school. Adherence to this makes their failing in business almost inevitable. It appears then that the designers can sew. They need to be convinced that this disavowal serves no useful function, indeed it only exacerbates the problems they face in production.

'NICE LITTLE EARNERS'

The designers can sew, but they keep quiet about it. One young woman work-ing freelance mentioned as an aside that she made clothes for her family and, in particular, her mother and sisters back home in Northern Ireland. She quickly ran them up after she had finished work in the studio. She even managed to use some of the fabric left over from the orders she was doing for a big fashion company, so it cost her nothing. She said she had been doing this ever since she started at college. Nor was she alone in this respect as many of the fashion students sup-plemented their grants by taking orders from friends. Another young woman interviewed for this book said that she already had an order book by the time she left college. The young designers producing clothes for stall and units in markets were almost certainly doing most of the sewing themselves, but many of them were reluctant to admit this. The most vivid example of the fact that designers can sew comes from a newspaper article by Sally Brampton following the tragic death of John Flett, a young designer who had graduated at the same time as those interviewed for this study and who had been considered as talented as John Galliano. Brampton quotes Galliano remembering his friend: 'At college . . . he used to go out and buy a metre of fabric and run up a dress for one of the girls in his lunch hour. That gave him the money to go out that night. He made a frock a day' (Brampton 1991: 9). Similarly, in a profile on the American designer Ben de Lisi (in The *Independent on Sunday*) the journalist describes how de Lisi was brought up by his grandmother who was a seamstress. He went on to study paint-ing and sculpture but, following graduation, turned his hand to fashion with the help of his grandmother and began supplying small collections to the big New York department stores: 'These were nice little earners that Grandma and I did together. I would design them and we would both sew them, she taught me how to sew' (Barbieri 1995: 8–9). De Lisi came to London in 1982 and began to make clothes in his partner's restaurant after hours: 'I'd put all the tables of the restau-rant together and cut, and then bring all the pieces upstairs and sew them together. I did it all myself' (ibid.). In a short time de Lisi had orders worth £30,000 from Liberty on the basis of this one-man production line.

How then could United Kingdom designers work more profitably by over-coming their professional disdain for sewing? Steven Purvis, interviewed in March 1994, made the following suggestion:

> The thing is that if art students could not afford to go into design themselves they actually could go into production if they knew how to. There is a need for small scale quality production. They could do it because it also does require design knowledge which is, of course, what most manufacturers don't have. The problem is at present, they come to manufacturing with the most unrealistic of expectations. They come for an interview and they have their portfolios and it's all very interesting and then I ask them how much they are expecting as a salary and they

say about £15,000, and I have to laugh. That's about £5,000 a year more than the average manufacturer takes home after he has paid all his overheads . . . So they have no alternative but to set up for themselves but what I'm saying is that they're not taught to do that properly. And I'm talking as somebody who knows about fashion. There is not a major name in London that I've not produced for.

Val Baker, merchandising manager at Hyper Hyper, made a similar point in interview in August 1994:

My strategy recently has been to get the designers who aren't doing so well to take on some production work for those who are. They can do it better if they put themselves to it, and cheaper, and it gets them through a rough patch when they are not managing to sell their own stock or when things have just slowed down. This also gets round the problems of the CMT firms who won't do the very short runs. Even the ones who are doing OK, often they are not able to produce at the right kind of price. For example, they need a pattern cutter or a grader and he or she charges £190 for the work. That's far too much. They would be much better learning how to do it for themselves. What I've been doing is getting the designers going through a flat period to go off and do a tailoring course or a pattern cutting course at night school and then they can produce for somebody like Terry Nordel who is doing well just now but needs to be able to bring his prices down.

The disavowal of sewing is one dimension of fashion's own identity crisis. It is indicative of both the low status and the low skill level of those employed in production. However, I am arguing here that the gap between the young designers and the women at the bottom of the chain of production is not quite as vast as it appears. Both groups of workers are emerging out of a culture of unemployment; they are also part of the new low pay economy which has crept into British working life by stealth during and after the Thatcher years; they tend to be urban-based; they work extraordinary long hours; and they are working in a labour market which traditionally has been gender segregated, with all that entails. They are separated by education and generation, but in all other respects this labour force shares a common cause for improvement and change in the industry as a whole.

FINDING A MARKET

In the same way as the designer's image as creative artist influences the way he or she disavows production, so also it shapes how he or she would like to disavow consumption. Just as a sculptor does not produce works with a clear market

in mind, neither would the designers if they could get away with it. Ideally, they would like their clothes to be seen as 'pieces', small works of art for which consumers were willing to pay substantial amounts. In reality, they were reconciled to thinking more objectively about the market and this tended to focus around three identifiable groups: the young fashionable and club-oriented consumers; more mature and professional women with enough money to spend on fairly expensive clothes; and the 'celebrity' market including pop stars, actresses, and also consumers from the fashion world itself, in particular fashion journalists and editors. However, these specific groups take second place to the fact that primarily the designers are creating clothes and collections not so much for real sales as for imagined consumption, that is, for the fashion media, for the image industry. It is the national and international press, as well as *Vogue, Elle, Marie Claire* or *Just Seventeen* which they have in mind when they see their clothes go down the runway. This is the first port of call for the aspirant designer and, to the extent that the media makes them names, indeed household names, even though they may still be signing on and working from their kitchen tables, it could be argued that the 'media-as-market' adds a further twist to the peculiar economics of British fashion design. This is a market of audiences and viewers rather than consumers and this raises the possibility which is explored in greater depth in the following section that the image is 'the thing' and that the widespread consumption of the image bears no direct relation to the often tiny trickle of sales. This is the problem for United Kingdom fashion design in a nutshell. There is a vast audience for the images of the work and a much smaller number of customers. Before attempting to tackle the enormity of this problem, the way in which the different markets are more concretely envisaged by a number of the designers shows clearly the extent to which part of the labour process of 'independent' fashion design is to shape up the consumer in such a way as to encourage them to buy these particular kinds of clothes (Du Gay 1996). The target market is brought into being by the meanings associated with the clothes, and with the retail environment in which they are found, as well as in the marketing or publicity material. The challenge is a big one – to create a market outside those markets sought by the powerful chain retailers and also the large fashion companies who have huge budgets at their disposal to do this kind of 'shaping up' work. The designers have to insert themselves into the retail world by producing distinctive meanings which are then embodied in the various items of clothing.

How is this done? Celia M.'s market reflects her own identity as a fashion 'pop artist':

> I still design for me, that's what it's all about. I wear them out to clubs, and I love seeing young girls in clubs and on the street wearing my clothes. They want things cheap and, like me, they love popular culture. My clothes have got that pop feeling. They're very much a part of me, I suppose.

Celia's notion of the market may be personally led and creatively driven but it is also informed by the existence and success of youth cultures and, in particular, the club cultures of the late 1980s and 1990s. She draws on her own involvement in and experience of these to confirm her place in the market. By concentrating on her two retail outlets, a stall at Hyper Hyper and a small shop in Soho, she is able to keep a close eye on how quickly the stock moves and what sort of people buy her clothes. While also producing orders for a variety of stockists both in the United Kingdom and the US she was, at the time of the interview, producing images for an influential niche market of young 'taste-makers' including the editors and journalists of the style press. That is, she was giving them 'good copy'; her clothes made a good fashion story. The 'pop feeling' is also a 'pop art' feeling and this is reflected in the kind of coverage she receives in the style magazines where her work is seen as shocking, taboo breaking, sexually explicit and avant-garde, while also (in the Mary Quant tradition) being relatively cheap. She treats fashion design with the same seriousness she would a fine art, but she rids it of its élitism and draws on and quotes pop imagery (from the world of pornography, pop music history, and youth subcultures) in much the same way artists such as David Hockney did in the 1960s. 'I extended the 'Psychedelic' into the 'Hippie' collection for the winter', she says in i-D (no. 89 1990). Celia M. stands firmly in the populist tradition of British fashion design – like Mary Quant in the late 1950s and early 1960s, she rejects *haute couture*, embraces pop while at the same time bringing a strongly fine art sensibility to bear on her work. Indeed she is one of the most adamantly artistic of the designers interviewed for this study.

Celia's market comprises young girls, clubbers and 'trendsetters' with a sprinkling of pop stars who not only bring in valuable revenue, but can also be mentioned as customers in press material and thus serve a double function. These stars include Cher, Siobhan Fahey (of Bananarama and Shakespear's Sister) and also Debbie Harry. The purchase of a few items by celebrity figures does not create a thriving business in itself, but these names bestow both an aura and an image on the designer and her clothes so they function as much in cultural or symbolic terms as they do in economic terms. They can be used on the publicity circuits upon which the designer is reliant. For the designer the press attention, the celebrity shopper and the coverage provided by a few shots in a range of fashion or style magazines and gossip columns work as a kind of symbolic capital. To have sold to a celebrity is a mark of success which can be profitably traded on. The market is therefore another image, in this case the image or representation of the pop celebrity who brings his or her own distinctive iconic value to the clothes, further extending and accentuating their meaning and value.[2] This exchange taps into some of the most complicated aspects of the culture of fashion design in Britain today. It demonstrates the existence of a double circuit in operation: the fashion garment as real product, bought by a real person, and the fashion garment as image (usually photographic), purchased and worn by somebody also 'known' as an image (again usually photographic).

Celebrity consumers play a role for most designers as part of an ideal 'image

market'. Who the designers sell to becomes a mark of their success. Commenting on the work of English Eccentrics, one journalist described their market success as follows: 'Their customers are high profile. Mick Jagger likes their shirts, as does Prince. Paul McCartney and Pamela Stephenson wear them. . . . Their base now is an old warehouse in Shoreditch, from which they sell direct to prominent retailers such as Liberty, Harrods and Harvey Nichols' (McHugh 1993: 37). Anna T., one of the young designers, said that her first important sale was to 'the wife of a famous Hollywood film director who bought a jacket and a coat.' And Rachel F. said: 'I've sold a few things to the fashion editor of the *Evening Standard*. She rang me up to say how much she liked my stuff. She came to the studio to have a look round and after that she also told several of her friends about my work, on a word of mouth basis. That was very useful.' The 'added value' of celebrity customers is summed up in the final words of one of the longer interviews with Gillian P. She says, with a hint of nostalgia for the days when she was working as an independent designer: 'I had the interest of the Design Council and Madonna bought one of my sweaters.' The role of the image market and the image industries will be pursued at greater length in chapter 10. In the meantime their role for the designers tells us something important about the practice of fashion design.

The more established United Kingdom designers (described by one young designer as the 'sensible girls'), who have a more serious and realistic image of their customers, focus less on the ideal celebrity customer and more on the process of 'shaping up' the ideal woman who will buy their clothes. This work is carried out through the activities of the press and publicity offices. The press packs produced by Ally Capellino, Whistles and Betty Jackson envisage a certain type of woman. 'She' is too busy to spend a lot of time on clothes; 'she' wants to be comfortable as well as stylish; 'she' might not even be the perfect shape typically assumed by male designers.[3] Ally Capellino's personal assistant explained:

> Our market has evolved over the years. We have grown with our market and we aim to sell to women who want to look good but don't have a great deal of time to spend on it. We want things to be easier for them and our clothes are designed to take the stress out of fashion. Our customers feel comfortable in our clothes and that's why we have built up customer loyalty. Perhaps our biggest competition is from Betty Jackson although I don't know how they are doing right now. Possibly about the same as us. However, the home market has really picked up for us in the last couple of years. It's because we have this really strong image and it's developed now into a family image. We design here for real people and we appreciate that women have different figures and so, even in the Tunbridge Wells department store where we did a show last month, we had very different types of women snapping the stuff up. And that's the feedback we get from the other retail outlets we supply to, up north, in Manchester and Glasgow and also in Nottingham and Yorkshire. There is a home market if you search it out.

However, both in-house and out-of-house publicity is expensive. Young designers can rarely afford to employ a publicist and so they are reliant on the fashion media to pick up their work and give it exposure either within the fashion news slots or more often in the fashion pages themselves. Some of the designers actually described their market in these terms, for example: 'I feel as though the work I'm doing here is for the *Just Seventeen* reader or for *More!* and what I'd really like to be doing is producing clothes for the *Elle* market or even for *Marie Claire*' (Nana F.). In this way the market finds definition not through concrete sales but through the targeting of media space and, in particular, the fashion spreads in the magazines. All the designers recognised the importance of publicity. They had as many unpaid students working on the press release material for the collections as they had doing the hand finishing. And fashion promotion now occupies a key place in the designers' business strategy, even if they have to rely on the unpaid labour of friends and students to do this work. Publicity and promotion are the means by which design reaches out to make connection with its second great pillar of support, the magazine and media industries (the more precise nature of this relationship is explored in the following section). If the designers have established some kind of contact with fashion editors and journalists, this 'social capital' can be used to help them find a market in retail, so that they actually have a sales outlet for their work. This is how Yvette M. and Lisa R. found their first stockist. They wanted to show their work during London Fashion Week but could not afford the costs of putting on a big collection, so they decided to show the work with friends modelling it, in their own studio (fortunately close to the bigger shows). However, the question was how to get the buyers to attend. Invites had to be designed, produced, printed and sent out. The designers were reliant on students and friends doing this kind of work for them for free. It wasn't the buyers who turned up, however, but the fashion journalists and editors who came to the studio, and it was they who gave the designers the break they needed.

> The fashion world is very small and the way we got started was that the fashion editor at *Vogue* loved one piece that we did. Browns had already placed an order and that allowed us to send out a press release with the waistcoat to *Vogue*, mentioning Browns as the stockist. . . . However, Browns cancelled the order a couple of weeks later which meant that we had no orders and no stockist. *Vogue* could only use the picture of the waistcoat if we had a stockist, so there and then, on the spot, Sarah (from *Vogue*) phoned up Whistles and said how lovely it was and how she wanted to use it for a picture and would Whistles consider placing an order? They said yes as long as it meant one in each size to begin with. So, in fact, the order meant three items of clothing. And for them of course there was the mention of Whistles in *Vogue* so they got that out of it, we got a tiny order and *Vogue* got the picture. And that, in turn, was what triggered off all the other interest. We were immediately

approached by all the other magazines and also by the British Fashion Council asking us if we wanted to be sponsored! That's how the whole thing works. We know that at present we are only interesting to a tiny number of media and fashion types. Somebody will buy one of our pieces for a special event, a big media do, a premiere, a dinner party, a reception.

This example is useful because it vividly highlights the reliance on publicity and on the mass media to actually set in motion the selling of the products. Having a unit at Hyper Hyper also worked in this way for many of the other designers. The high cost of renting a space could be offset against the general publicity which this retail unit as a whole attracted. So in this case we can see marketing working in the opposite direction from that described above. There the press brought the goods to the retailer, in this case the retailer showcases the goods and brings them to the attention of the press. Celebrity stores such as Hyper Hyper or Harvey Nichols are in themselves publicity for the clothes. If such a store stocks them they must be good.

Hyper Hyper gets huge amounts of press coverage, from the *Evening Standard*, *Elle*, from i-D and *The Face* to *Vogue* and also *Time Out*. So we get people coming in all the time looking for something they've seen in one of the magazines. It's a tourist trade and it's the girls who read the magazines.

(Val Baker interviewed August 1994)

This interrelationship between the retailer and the media comprises the basis for finding a market for the young designers, a point put clearly in a comment by leading fashion publicist Marysia Woroniecka:

It's the fashion pages that make or break a young designer. How else can they get publicity? Most cannot afford an agent, and they certainly can't buy the kind of advertorial spaces that the big fashion houses like Maxmara, Escada or Armani can. So they are desperate to have their pieces shown, and there are a lot more opportunities now than a few years ago. But what it does mean is that so much of the designers' time is taken up chasing the fashion stylists and the editors. And then some bigger companies have literally been rescued by magazines. Laura Ashley has got a lot to thank *Marie Claire* for.

In short, the market is heavily mediated by the fashion press. It is socially constructed in that it is 'imaged' (Nixon 1996) as much as it is also 'imagined'. The idea of the consumer is created discursively through the fashion stories which are the centrefolds of the glossy fashion magazines. Whether the consumer is young and clubby, or more mature and working in a professional field (real women),

her existence is brought into being by these fictional devices which are the professional tools of the fashion promotion intermediaries. However, these marketing images, these fictional devices, cannot guarantee sales. They might be enjoyed by readers without ever encouraging them to purchase a single item. Are we talking then about two quite separate circuits of consumption, that of viewing images and that of purchasing goods? If so, this has quite profound consequences for fashion as a culture industry, suggesting that it actually comprises two separate activities, producing real clothes and producing clothes to be turned into images. And if, as seems to be the case, there is a profound mismatch between enthusiasm for consuming images and reluctance to buy clothes, how can the designers resolve this seemingly impossible dilemma? How can they serve both these markets and succeed in business?

BALANCING THE BOOKS

As we have seen, the fashion market has a weak existence in the professional imagination of designers. It marks a point of doubt and uncertainty. Once again this is hardly surprising given the designers' preferred self images as creative artists. The market indicates the presence of a commercial rather than a creative dynamic and the alarm bells start ringing. This is not how the designers want to be seen. So, in interview, questions about turnover and volume of sales and capital investment and even their own salaries were not always responded to with the same openness and enthusiasm that questions about design direction or inspiration prompted. Many of the designers appeared to live on a hand-to-mouth basis. They were either earning a 'pittance' or else they said they were hardly able to pay themselves a wage from the business. So there was a reluctance to talk about money, and any attempt to produce a clear overall account of the performances of these small companies as businesses was made more difficult by the fast rate of change and movement in and across the sector as a whole. One minute they would be in business with a studio and a book of orders, the next they would be freelancing from home.

As we have already seen, what emerged as the most stable of careers was that of the flexible freelancer working for at least two companies at the same time, and combining this with some part-time teaching while also harbouring ideas of getting back to her 'own label' work. So, not only is it difficult to get a clear picture of the economics of each one of the stages in the cycle of fashion employment (and self-employment) but the picture changes so quickly, and the fortunes rise and fall so rapidly, that anything other than a set of individual economic profiles would be unreliable. At any rate, the rapid change of employment in the sector makes it difficult to present an overall account of how it functions as an economy. From the data and material which follow, the United Kingdom fashion design industry seems more like a micro-economy, comprising a strata of small-scale producers whose activities are closer to a 'cottage industry', than a sector which is in

fact a key part of the clothing industry and which remains Britain's fifth biggest industry.

The fashion and clothing industry was always volatile, wages were always low, and companies were regularly going into liquidation, so it is not an industry which was once stable and well organised. The 'new kind of rag trade' which I have argued has emerged since the early 1980s is a peculiar hybrid of past, present and seemingly future features of work in an increasingly deindustrialised society. It is the cottage industry elements of the designers' practice, including not just the small scale of the economies but also the emphasis on hand finishing and on craft, which make the art-school trained design sector appear deeply anachronistic and traditional, but this is then balanced by those features which make it also a product of the 1980s and 1990s. These include the whole range of changes in consumer culture, in particular the emergence of high quality differentiated goods produced in small batches for 'niche markets'. The British fashion designers can be seen in one sense as the new professionals who service the needs of this segmented market. But if only it were as easy as this. The designers find themselves in sharp competition with much more powerful sectors of the fashion industry, in particular the fashion retail chains which are in an infinitely stronger position to implement the strategies of what are usually referred to as Post-Fordist techniques of production to bring higher quality, more differentiated fashion ranges to the customers.

These companies (from Next to Kookai, from Warehouse to Jigsaw) can 'interpret' the shapes and styles from the designer ranges and, through the access they have to both economies of scale and of scope, they can have them on the rails at competitive prices within less than a month of the designer shows. From the mid-1980s to the mid-1990s the competition for the young designers trying to assert a place for themselves in the fashion market has increasingly come from these retailers. As we have seen, a few, like Whistles, have bought collections from the young designers and displayed this work on the rails alongside their own in-house label. Otherwise the designers are dependent upon sales from retailers and from department stores who are known to specialise in designer collections, such as Harvey Nichols, Liberty and Selfridges. Alternatively, they have their own small outlets. But in some respects these are in a similar position to corner shops facing competition from supermarkets. Those who survive seem to do so against the odds.

The additional feature, which is also a reflection of Britain in the 1980s and 1990s, is the flexible and relatively cheap (as well as local) labour markets which form the manufacturing base for both the small scale designers and also for a substantial part of the bigger retailers' output. So there is competition here too. From the point of view of the CMT men an order from Jigsaw is inevitably more appealing than one from a much smaller one-woman label. The cash flow will be more reliable, the work possibly easier and thus requiring a lower level of skill, and the fabric less delicate. In this respect, too, the designers find themselves at a disadvantage. These difficulties clearly demonstrate the need for a sharper and

more developed analysis of the sector as a whole. So far, as we have seen, commentaries have been rather piecemeal. The designers' experiences are reflective of those emergent features of work which are as yet uncharted and, consequently, mostly unknown. One of the aims of these chapters has been to describe and analyse how the designers make a living and how this creative work functions within an economy which is increasingly concerned with cultural production. The key relation appears to be the interplay between fashion as an image industry and fashion as a concrete practice which involves designing, making and selling clothes. The extraordinary vitality of the former (the visual spectacle) overshadows and conceals the difficulties of the latter (the garments themselves).

SALES AND SALARIES

Celia M. who, as noted earlier, had two outlets at the peak of her business activity (a shop in Soho and a unit at Hyper Hyper) and who also featured in numerous television programmes, press interviews and in a range of magazines at home and abroad, none the less rarely had a turnover of more than £200,000 per annum. With orders from big New York department stores, as well as United Kingdom stockists across the country, her output still remained relatively small. Most of her employees were working on a casual or part-time basis, she relied on students and friends to 'help out' in the business, and otherwise depended on a single machinist and pattern cutter to help with the production. As we have already seen, the small CMT firms she used for manufacture were a constant source of dissatisfaction and anxiety. A designer like this is working virtually on a self-employed basis. She will have an accountant to look after the books, and from time to time somebody will step in as a business manager. Otherwise the business itself remains almost solely in the hands of the designer. According to Celia, after payment of her overheads her take-home salary was in the region of £15,000.

This corresponds almost exactly with another of the small-scale independent producers, Paula S. Like Celia M., her studio was at home and her employees were all working for her on a freelance basis. She had the additional support of her sister who looked after the production side, ensuring that orders were produced in time and that the quality of the finished goods was right. However, whereas for Celia the fears were of being let down by the CMT producers, for Paula S., who was supplying to a range of small, independent, high fashion stockists across the country, the problem was in getting payment from the shops in time to maintain the cash-flow she needed. She was aware of the lengths to which some stockists would go in order to avoid paying for the clothes:

> Shops will often return goods with an excuse out of the blue, just before you know they are going to place another order. They have got you hooked. They know you are desperate for the order. You know that

the so-called faults in the clothes they have had on their rails for three months are a way of returning them to you without having to pay for them, and so they cut their losses on things they haven't managed to sell by suddenly inventing flaws. The small shops are terribly bad at paying – you can be left waiting for months even though you know they sold the whole collection ages ago.

Problems with non-payment for orders puts tremendous strains on the designers, frequently pushing them out of business altogether. Paula S. had become more used to the stresses of working in such an insecure field by keeping her overheads low and by being able to rely on her husband for the mortgage repayments. But given the long hours she worked and the high level of her own skills and expertise, her salary was, she estimated, a meagre £15,000 on a turnover of approximately £100,000.

Yvette M. and Lisa R. were also living on next to nothing:

> Almost everything goes back into the business, so it's a matter of juggling several things at once. We have to think about paying for the next season's fabric while we are still waiting for the returns from the retailers. There are so many uncertainties and it fluctuates so much. We have to charge over £300 for a jacket to cover all the costs, but let's say right now we can just about live, although that is partly because Yvette's father owns the flat and is letting us live and work in it for nothing right now.

Two years later, with a healthy order book but with debts of more than £50,000, these young designers realised that they could not raise the finance to produce the orders. Lisa said, 'I had had enough and wanted to pull out. We were still only on £50 a week and I had stopped enjoying it. There were moments of glory; I loved the collection but the production was a living nightmare.' In October 1995 they realised they were not able to produce the summer collection for 1996 and were forced to call in the receivers. So in this case the two designers who in many ways are emblematic of so many of the themes in this book, were declared bankrupt at the same time as they were enjoying huge amounts of media attention. At no point during their short careers as celebrity designers did they have a turnover of more than £200,000 despite sales to Barneys in New York and Harvey Nichols in London. Nor did they ever have a staff as such, and it seems they were living virtually on pocket money of £50 a week from the business.

It was precisely in reaction to this kind of situation that the designers who, after a few years as independents, ended up working as freelancer designers, expressed some relief that 'at least you get paid when you are freelance.' Once again, it is difficult to get a clear or accurate picture of exactly how much the freelance designers were earning – some were on retainers to one or two companies at the same time, while others were being paid for each job. It seems that £20,000 a

year was considered a reasonable and realistic income from this kind of work. For the designers still working as independents with a unit at Hyper Hyper it was more a matter of breaking even and managing to survive on tiny incomes once the overheads had been covered. There were also a number of young designers relying on the hidden economy to allow them to attempt to move from being on the dole to working as designers in a more legitimate capacity. For them £100 a week was considered as manageable. By making clothes for friends, or by providing a small number of clothes for sale in a street market or designer stall or unit, the payments for this work supplemented unemployment benefit. However, they pointed out that they still had to buy the fabric to make the clothes and they also had to have the facilities (space, sewing machines, overlockers, access to a part-time sample machinist, and so on) to produce for this market, so the money they got was not so much 'hidden economy' income as it was cash to cover the costs of production.

So far what we have seen gives the impression of fashion design as a kind of chaotic or disorganised micro-economy comprising a number of talented and hard working young designers practising their trade against the odds but in the hope that eventually their talent and creativity will be rewarded. Even the most viable of these working practices, the freelance economy, requires enormous expenditure of time and labour for relatively modest returns and with the added uncertainty and insecurity of being employed on a one-off basis, and therefore not knowing where the next order is coming from. In this context the designers were also responsible for their own national insurance payments and, as self-employed people, they could not rely on maternity pay, sickness pay or pension contributions since they were not employees. Those who were married or in stable partnerships were reliant upon their partners to cover these costs. Only four of the designers interviewed for this study had children, and all of these women had husbands either working in the business alongside them or able to support them independently of the business. A more general question raised by this kind of highly insecure work in the creative economy is the extent to which women are further disadvantaged by self-employment when it comes to maternity and childcare. Being forced to put off the possibility of motherhood because of these difficult working conditions is in itself a great sacrifice. In these circumstances women are almost being forced to choose between a creative career and motherhood. How widespread this kind of choice will become as the flexible economy of self-employed workers grows, raises a number of important political questions. Another way of putting this is to say that the shift towards flexible, freelance work in the creative fields will almost certainly have consequences for women which might well make it more difficult (rather than less difficult, as the pro-flexibility argument has it) to combine motherhood with a career. This book reveals such a low level of returns and such a high level of financial insecurity that the possibility of embarking on motherhood is literally unthinkable for many of the respondents.

STRATEGIES FOR SURVIVAL

What kind of businesses were the more successful fashion design companies? If we discount the two bigger retailer designers (Paul Smith and Whistles) on the grounds that both companies define themselves as retailers first and designers second, we are left in the context of this book, with the chosen examples of Ally Capellino, Coates and Storey and English Eccentrics. If we add to them comparable companies such as Betty Jackson and if we also include Vivienne Westwood (whose fortunes have also vacillated during the period covered by this study) we can develop a slightly clearer picture of how companies like these operate.

Betty Jackson and Ally Capellino have each been helped by contracts and support from larger organisations. Both designers have produced ranges for Marks & Spencer bringing them additional funding on a freelance basis. They have also won support from Coates Viyella (Ally Capellino) and Courtaulds (Betty Jackson). They each produce for the home market and also for the overseas market, but are well aware of the fragility of the fashion market and the number of companies which have gone bankrupt in recent years. Vivienne Westwood's work has taken a different turn in the last few years. After many years of barely making a living despite being one of Britain's most famous designers (she continued to live in a council flat in Brixton right up until 1994), Westwood has benefited from the resurgence of international interest in avant-garde British fashion from the early 1990s. As a result, her business has moved onto a different level of success altogether with sales to Japan at £3 million a year and lucrative licensing deals bringing her company up to £10 million a year. Westwood, too, was forced to recognise the value of freelance contracts and in effect bailed out her business in the late 1980s with a series of contracts for mass market catalogue companies like Littlewoods, and Freemans, while also producing ranges for the underwear company Knickerbox. This has put her at the top of the design hierarchy both for innovation and also for capital returns. However, this kind of success is dependent upon the highly distinctive and controversial image which Westwood has fostered. Her own ranges are, as she puts it, 'almost *haute couture*'. This means that alongside Galliano and Katharine Hamnett, Westwood is on the brink of relinquishing the United Kingdom in favour of the French fashion houses who are now eager to employ the stars of British fashion. Perhaps the relevant point here, however, is that Westwood barely survived as a designer until she picked up the contracts from the big mass market companies. They manufactured and retailed goods bearing her name and she in return was able to fund the catwalk shows which in recent years have won her great acclaim and given rise to speculation about a move to Paris.

In contrast to this, Betty Jackson and Ally Capellino have aimed at the professional female market also sought by Nicole Farhi. Their clothes are all expensive, 'classic' but with a distinctive design signature: Ally Capellino specialises in linens and fine wool tweeds; Nicole Farhi produces clothes which bear the traces of current design inflections, for example, 1950s style swing coats, translating or

'editing' these into more functional outfits; and Betty Jackson has won praise for her textile designs and for the use of dramatic abstract prints as the basis for her collections. Although superficially similar, these companies are not really comparable with Nicole Farhi who, with the biggest turnover and the largest number of shops and concession areas, is independently run but underwritten by the more middle market and younger fashion chain French Connection, with both companies managed and co-owned by Farhi's ex husband, fashion entrepreneur, Stephen Marks. Ally Capellino, as we have already seen, brings in an annual turnover of approximately £3 million, with sales overseas of £1.5 million. This is a similar profile to Betty Jackson. Both companies have relatively small full-time staff (Ally Capellino employs seventeen full-time workers at the Butler's Wharf studio, while Betty Jackson has only twelve employees based in her Tottenham Court Road headquarters). In short, these remain fairly small businesses. As several of the respondents pointed out, the key issue for designers like these was breaking in successfully and holding onto the foreign market. For Coates and Storey, interviewed eighteen months before they were forced into liquidation, this was the important issue. Although at their peak they were selling to twenty-six different countries with Belgium and the USA accounting for the greatest volume of sales, selling abroad was beset by difficulties, particularly those of finding reliable agents who would manage the foreign market.

But could they raise the capital investment to make this transition into the international fashion design market? And if they couldn't how long could they rely on the United Kingdom market to produce sufficient returns to remain competitive? What would happen if they went out of fashion? In the United Kingdom in the late 1990s only Paul Smith, Whistles, Katharine Hamnett and Vivienne Westwood have successfully made this transition. For the others the reality has been to maintain and build steadily on a turnover of between £2 and £4 million per annum. To achieve this requires working on cheaper diffusion ranges and also taking on freelance contracts or consultancy for high street fashion retailers. This raises the more general and important question of how representative this small and partial account of British fashion design is. To what extent can this present analysis of primarily small-scale producers, many of whom are continually hovering on the borderline of big time success (on the basis of extensive media coverage) and dismal failure (on the basis of bankruptcies), be understood as typical of the British fashion industry? By considering the portrait of a cultural and creative industry provided here in comparison with a piece of funded research on small scale fashion producers commissioned by the British Fashion Council, it is argued in the following chapter that this book offers an accurate and realistic account.

Despite the difficulties this book also argues that the distinctive contours of this new kind of rag trade ought not to be dismissed as marginal and economically unviable. As part of the significant shift to a flexible, freelance and culturally-driven urban economy it is more the case that this kind of working practice in fashion is at the forefront of change and needs much better understanding and support than it has so far received. The fashion design industry requires more

planning and organisation and needs better forms of management. The United Kingdom fashion industry has sprung into being through the 1980s with high quality training and educational provision producing the designers, and with the support and publicity of media industries hungry for its visual images. But between these two pillars of support is a thin, skimpy and underfunded network of activities. Social scientists ought not to wipe their hands of this apparently chaotic design sector as a further sign of the 'end of organised capitalism' and its replacement by a new even more exploitative stage, the professional equivalent to the 'return of the sweatshop' (Piore 1997). As a sign of things to come, this kind of creative work requires more sociological analysis and political debate. The question is not just if there is a space in the market for small scale independent design, (which I would argue there is) but whether the social relations of work and employment for the designers (and also the producers) match in livelihoods, the time, energy and skills invested in the design process.

9

A NEW KIND OF RAG TRADE?

THE FUTURE OF WORK?

Recent writing on the sociology of work has suggested that so rapid are the changes taking place in Western European societies that there is an element of opaqueness or simple uncertainty about how working life is going to develop in the coming years. Ulrich Beck, for example, talks about 'abnormal work' whose 'unpredictable and erratic' rhythms are becoming the norm for an increasing number of people today (Beck 1997). He has recently spoken on the idea of 'capital without jobs', and of 'work being threatened with extinction' (ibid.). These useful, if rather polemical, epithets touch on issues that have been central to this current work. This study certainly charts the growth of 'jobs without capital' but emphasises not so much the extinction of work, as the determination to create work against the odds. We have seen young designers create jobs more or less out of nothing, on the strength of £1,000, usually loaned by parents, to put in a bank account in order to qualify for the EAS. This has provided the basis for setting up in business. By getting hold of remnants of fabric and with a minimum of equipment (sewing machine and press) most of the young designers in this book were able to insert themselves into the fashion economy and maintain a presence in the do-it-yourself sector of the urban street markets, stalls, units, and small shops, creating employment out of unemployment, making careers out of culture and pursuing these careers with a commitment far beyond what might be expected were they simply looking for paid employment. I conclude this section on the working practices of the designers by further exploring the scale of their economies and the sustainability of this kind of creative work.

Of course, it might be argued that my study is small, that this is a marginal field of (self-) employment and that its micro-economies are unreflective of British 'designer fashion'. In fact, there is only one study from which any useful comparison can be drawn. In 1991 the results of a survey commissioned by the British Fashion Council and carried out by Kurt Salmon Associates were published (Salmon 1991). The Survey of the United Kingdom Fashion Designer Industry based its findings on the data provided by a questionnaire sent to 150 design companies. With a high return rate from the questionnaires, the authors were

confident that their survey provided an accurate image of the industry. They wanted to gain information on the 'structure, employment and output' of the sector. They also sought to 'analyse output by value, volume and garment type . . . to review the supply network . . . to measure the size of the main markets . . . and to predict future trends' (ibid.: 1). The companies they polled were similar to the small designer-led companies which have been the focus of attention here. Indeed, all of the well-known designers interviewed for this current study also participated in the Salmon survey as did six of the eighteen younger designers. Since one of the criteria for inclusion in the survey was that the design companies should 'regularly participate in designer shows both in the United Kingdom and abroad', this would disqualify at least half of my own sample who were either unable to afford the costs of producing collections for the shows, or were, at the time of the interview, no longer working in an independent design capacity. So, in this respect, the six who did take part and the full participation of the more established designers demonstrate that, to a considerable extent, both studies are talking about the same kind of people.

One of the most important things that the Salmon study revealed was the volume of sales. Twenty per cent of the companies polled accounted for eighty per cent of the annual sales, showing concentration of sales in a small sector of the field as a whole. Overall, thirty of the 150 companies accounted for four-fifths of all designer sales. The study also showed that sixty per cent of the companies had annual sales of less than £500,000, and that eighty per cent shared between them a measly twenty per cent of all designer sales, an average volume of annual sales of £100,000. Overall, then, the great majority of the firms had sales around the £100,000 mark with a smaller number managing to achieve a turnover of up to £500,000 per annum. Already we can see that this bears a close resemblance to the kinds of figures which the designers in this current study mentioned in relation to their own turnover. Rachel F. put her one-woman business turnover at £70,000 a year, based upon her designing and supplying between twelve and twenty items a week to the unit she shared at Hyper Hyper and, in addition, taking on individual orders from customers. Several of the other young designers reported annual turnover figures within a range of between £100,000 and £200,000. Paula S., for example, stabilised at £100,000, while Celia M. had managed up to the £300,000 mark. When she was doing well Jasmine S. had broken through to almost £1 million of sales.

The Salmon study does not convert its own figures into this kind of company average and therefore fails to confront the fact that a turnover of £100,000 means, in practice, a tiny take home pay for the designer once he or she has covered overheads, in particular the cost of renting premises like a unit at Hyper Hyper, as well as the labour costs involved in manufacturing the clothes. In this respect, the findings of the Salmon study steer clear of pinpointing the general economic fragility and precariousness of this sector and the very poor rate of returns to individual designers. Instead they add a rejoinder that the growth of the design sector between 1987 and 1989 should not be relied on as a steady trend,

particularly in the light of the recession of the early 1990s. How true! It is not just that the designers can barely make a living, but that so many of them are forced out of business altogether.

However, if we look in more depth at my study in comparison with the Salmon survey and consider the case of Rachel F.'s turnover of £70,000, we can deduce that what she is actually living on is a very small salary. She is paying £11,000 in rent to Hyper Hyper, in addition to which, although subsidised by the local authority, there is the cost of renting her studio, thus adding at least another £5,000 a year for premises. On top of this are the costs of fabrics, equipment and other raw materials, VAT, tax, and, finally, the cost of paying the part-time machinists who work for her. It's easy to see why she is not in a position to employ anybody for more than a few hours a week. And as we have already seen she is heavily reliant on the unpaid labour of students on work experience. However, she has stayed in business and that in itself is an achievement. The question of how long she is able to continue on this basis, and what the possibilities for real growth and expansion are is difficult to predict. Rachel offers a good example of what Giddens claims are the 'unknowable futures' of current forms of work and employment (Giddens 1997). But how can careers like this become more knowable? Grand social theory tends to avoid asking questions of a more mundane nature, such as how we can make work in the new culture industries, fluid as it is, less opaque?

Rachel F.'s work is characterised by a high degree of insecurity. A few weeks of illness would knock her completely off course. Holidays, as she herself said, are out of the question. At least she is paying her national insurance contributions (unlike several of the other young designers who really are working on a hand to mouth basis) and she also has a council tenancy. However, the decision to have children would place her in a relationship of total economic dependency on a partner, and the costs of paying for childcare would wipe out her take home pay in a stroke. A decision to expand with the aim of extending the range of her clothes and bringing in more people to help her with production, combined with taking on some freelance work, would be the most likely course for her to pursue, but she would also need to develop a more active marketing strategy so that her name is better known. This would also cost her in both time and money. She would need to raise capital and embark on the riskier business of turning her company into more than a unit of self-employment. Her turnover of £70,000 is 'reasonable', according to her bank manager, and a relatively stable figure for designers working in this way but it is difficult to see how realistically she could expand without substantial financial backing, particularly with the hefty rents she has to pay for her unit at Hyper Hyper.

The Salmon survey also shows that twenty per cent of the companies (thirty in total) accounted for £48 million of annual sales. However, an additional £15 million could be added to this as income through licensed sales (which ran to £125 million per annum). This means that thirty companies were generating £63 million of sales, on average just over £2 million per company. This, then, is the

second key point, that the 'successful' companies polled by Salmon indicate more or less the same level of average sales as five of the six 'successful' companies I have considered here. Coates and Storey, Betty Jackson, Ally Capellino and English Eccentrics all hovered between the £1 million and £3 million mark. At her peak, Jasmine S. met the £1 million target. Celia M., despite being very well-known and extremely influential in the field, had annual sales of around £300,000. So the profile of economic performance revealed in the Salmon study parallels that of the much smaller group of companies around which this current research has been based. These are low sales for what are regarded as successful companies. Ally Capellino and Coates and Storey were, at the time of the interview, each employing approximately seventeen people and had three retail outlets in central London between them. The costs of their in-house staff would run at approximately half a million pounds and the rent for studio and shop space would have run to possibly another half a million. This makes the annual sales figures look far from healthy. This again confirms the scenario I have described of Coates and Storey going into liquidation in 1995, and Ally Capellino coming near to the brink and being more or less rescued by the Coates Viyella contract. There have also been some comments in the fashion press that the last few years have not been as stable and successful for English Eccentrics, as they had hoped. They are reported as having to slim down the company and narrow their ranges.[1]

The Salmon study estimates that only 1,200 people are employed nationally in manufacturing for the designer sector. It acknowledges the difficulty in getting accurate figures because of the nature of the long and anonymous production chain. It relies only on the reported direct employees from the companies polled so presumably this figure refers only to sample machinists working on the premises and a few other direct employees in production. This leaves aside the important question of how many people are employed in the long manufacturing chains. Available figures do not differentiate between people working in a CMT capacity for the low end of the market making the cheap mass fashion items, and those producing for the designer ranges. This is anyway very difficult since in many cases the women work for both ends of the market simultaneously. Zeitlin suggests this high- and low-end production accounted for one third of the 480,000 employed in fashion and clothing production in 1986 (Zeitlin 1988). Taking into account the overall loss of employment of approximately 30,000 jobs in the sector and the relative growth of the local units of production revealed by Phizacklea in 1990, we could estimate that somewhere in the region of 150,000 people were working in 1996–7 in the small production units making up both cheap and quality fashion garments.[2] Unfortunately this figure cannot be verified or broken down any further since no study has yet followed designer activity through from conception to manufacture. Annie Phizacklea points to the substantial increase in employment particularly in homeworking in the late 1980s in this sector: 'It is estimated that at least 20,000 new jobs have been created in small clothing firms in the (West Midlands) area since 1979' (Phizacklea 1990: 80). Once again, however, there is no way of knowing the ratio

of high quality work to cheap standardised women's fashionwear. Phizacklea does provide some indicators that the quality end in London at least, accounts for a more substantial proportion of the thirty per cent attributed to both high- and low-end production by Zeitlin. She suggests that contrary to the usual assumption that this is mainly low skill work, many of the women workers are doing highly-skilled work and seeing items through from start to finish. She also describes the relatively low take up of high-tech and CADCAM equipment in the small manu-facturing units which have sprung up over the last fifteen years, not only because of the cost involved but because of the primary need for individual skills includ-ing sewing and hand-finishing.

Phizacklea points to a substantial sector of production workers based in London and also the West Midlands. But this does not show up in the Salmon study for the same reason that the designers I interviewed more or less disclaimed knowl-edge of, or involvement in, this aspect of the design process. This inattention, I have already argued, is a basic feature of the ethos of 'artistic' design which sep-arates creative work from production. But, to some extent, it also accounts for the failings, or at least the weaknesses, of the design sector. Both myself and Phizacklea agree that small scale designers have emerged virtually at the same time as United Kingdom manufacture has been scaled down and replaced by the tiny production units (of less than ten employees) positioned close enough to the designers to provide a fast service as well as a cheap one. While the Salmon study recognises that this kind of pattern is distinctive to British fashion design culture ('The United Kingdom industry is composed of smaller organisations than USA or Europe' and 'The United Kingdom industry operates more independently of big business than USA or Europe, because it contains more owners/designers/man-agers' (Salmon 1991: 17)) it does not follow through the connection between the growth of these relatively new production units and the designer culture itself.

Other findings by Salmon also correspond with my own smaller study. For example the volume of foreign sales shows the USA and Japan to be the single biggest foreign markets. Even here these are mostly all licensed sales which bring in only a small proportion of returns to the United Kingdom designers (Salmon suggests that £125 million of licensed sales brings in only £15 million). Writing now, in 1997, it is quite clear that these two markets, particularly Japan, have continued to show this interest in United Kingdom designers. Paul Smith, as we have seen, now has an enormous market in Japan. Whistles also have three of their own outlets there and several of the other designers who participated in the Salmon study moved towards producing primarily for Japan in the early 1990s when the United Kingdom market went into recession (for example, Workers For Freedom, Vivienne Westwood and Katharine Hamnett). In the Salmon study only thirty five per cent of all sales were to the home market (making the United Kingdom the single biggest market). But in my study carried out only a few years later, the designers sold primarily to United Kingdom consumers, and managed their foreign sales on what could only be described as a haphazard basis. An order would be placed by a buyer at a big American department store which then had

to be produced and delivered to a strict deadline. This whole transaction was con-
ducted primarily by the designers themselves. At the peak of their success, as we
have already seen, Coates and Storey had three agents working for them in dif-
ferent countries, but this part of the work proved by far the most difficult to
coordinate, especially in terms of keeping track of and being paid for foreign sales.
The administration and paperwork involved, as well as the initial capital required
to employ agents and to actually produce orders to the high standard expected of
European and American outlets, meant that throughout the time that these design-
ers were working in an independent 'own label' capacity, the most difficult thing
was to produce for the foreign market and to their requirements. Because of this
they preferred to focus their attention on the home market and to liaise with the
fashion editors and journalists to attract the kind of publicity they needed.

Overall, the findings of Salmon led them to conclude that the United Kingdom
designer fashion industry is a cottage industry. It remains under-capitalised and
consequently unable to compete successfully on the international market. While
design standards are considered to be high, the perceived quality of production
makes foreign retailers and wholesalers less enthusiastic. Future growth requires
better international sales. At the same time, United Kingdom manufacturing will
continue to decline, forcing United Kingdom designers to consider sourcing
abroad. Likewise, the poor quality of United Kingdom textiles and fabrics already
means that most designers use foreign suppliers for fabrics. Finally, the authors
also recognise the high turnover in firms, pointing out (euphemistically) that
many of the companies surveyed may not exist in the same form over the next
few years and that many of these were in practice one-person businesses rather
than fully fledged companies.

Two of these conclusions are borne out in the present study. The designer
industry needs to exert itself more successfully in the foreign market (this has hap-
pened to an extent with the recent success of Paul Smith and Vivienne
Westwood), and British designers do indeed rely on foreign produced textiles,
with the exception of Paul Smith who has single-handedly encouraged fabric
manufacturers based in the United Kingdom to attempt production of more high
quality textiles. Sourcing abroad for fabric increases the price of designer items
and also takes the decline of home-based textile production as a fait accompli, some-
thing which Smith himself would dispute. The overall description of this sector
as a cottage industry also corresponds with my own account – if anything the
returns of the designers I interviewed were a good deal less than those surveyed
by Kurt Salmon. They make no mention of how regularly these small businesses
disappear and cease trading, although they do say that there is a high turnover of
firms. The disparity between their account and my own is that through more
detailed description and analysis of the situation on the ground I have sought to
show just how perilous and unstable these small companies are. Indeed, casting
a brief glance at the 150 companies who participated in the Salmon survey, I esti-
mate that over fifty per cent no longer exist in the same form in which they
existed in 1990 when the survey was carried out.[3] A good proportion of these

will presumably have re-formed or the designer will be working in a freelance capacity.

It is certainly the case that there has been an enormous change in the design industry since 1991. This corresponds, too, with my suggestion that the most regular feature of this sector is its instability. Since the early 1990s I suggest that this has intensified and that there is even greater fluidity. The companies which were contacted by Salmon in 1990 have largely been replaced by other, even smaller, ones. In this context it is highly unlikely that they will compete in the foreign market with any real force, since to do so would require better quality of both textiles and 'finish', access to capital for investment in more up-to-date equipment and to computer technology and sufficient capital in reserve to tide them over during the periods between the orders being delivered and payment being received. Caroline Coates said in interview that to build up foreign sales on a properly managed basis would have required an injection of over £1 million and even this would neither guarantee survival nor allow the company to employ more than another twenty workers.

The encouragement to focus primarily on the foreign market is therefore premature, given the difficulties the designers have staying in business and creating relatively reliable home markets. The more urgent question is how to turn these 'everyday experiments' in work into an industry with a long term rather than an opaque future (Giddens 1997). Already this current study has provided some (admittedly sketchy) ideas about how this could be achieved. While concrete policy proposals are well beyond the scope of this study it is relevant to point to the geographical proximity between the low skilled and very low paid women working in the CMT economy and the designers themselves who at present have little knowledge of the operations of these chains of production, never mind the women who actually do the sewing. It is not impossible to envisage these two sides entering into a more productive partnership by cutting out the CMT contractors who take such a hefty cut of the profits at present, and with the support of new legislation including a minimum wage and other incentives such as better childcare facilities, the homeworkers could be brought into the workplace rather than kept out of it.

Annie Phizacklea points to the entrapment of many Asian women in the prevailing kinds of exploited labour by virtue of their place and role in the family. In these cases, the middlemen are also 'ethnic entrepreneurs' to whom they are culturally and familially bound, as well as economically dependent. However, this situation need not remain quite so fixed in the future. Local authorities have in the past shown themselves capable of providing community facilities, education, training and support grants to encourage unqualified people and ethnic minorities into better paid work. On the few occasions that this kind of initiative has been pursued in relation to the fashion and clothing industry, the focus has been on the small manufacturers and the producers and not at all on the designers. Although described as a 'fashion centre', the Hackney scheme supported by the Greater London Council, catered almost entirely for the low quality clothing sector

and did not attempt to involve designers.[4] The involvement of designers in the sort of scheme being suggested here would be part of a broader attempt to break down the division of labour which restricts machinists and home workers in low skill work and which keeps the designers from knowing about and playing an active role in the production of their orders. The drive to increase exports is similarly dependent on quality goods and this too would require the presence and participation of the designers. The historic location of the fashion industry in and around London's East End, and the more recent revival of local fashion industries in the West and East Midlands, are good examples of where these kinds of initiatives could quite easily be developed. Subsidised studio space for designers with access to shared high technology equipment, as well as reduced rate schemes for new businesses willing to employ local workers on a direct rather than a sub-contractual basis, would encourage the designers to participate in such schemes.

CONCLUSION

It could be argued that the designers who participated in this study, instead of fully surrendering to the Thatcherite rhetoric of the enterprise culture of the 1980s which they grew up with, have actually made good use of it according to their needs. They have rearticulated it, so that it fits more closely with the principles of what Schwengell labels, in the German context, *Kulturgesellschaft* – Culture-Society – (Schwengell 1991). As a model for overseeing some aspects of the transition to a post-industrial economy, this is a public sector-led practice rather than private sector trend, as its United Kingdom equivalent has been. British enterprise culture is consequently a more free market-led version of the German concept of culture as a regenerative force dominated by 'the public sector . . . and the liberal establishment'(Schwengell 1991: 139). However, as we have seen, British fashion design is in fact heavily dependent upon and uniquely supported by the State in terms of training and education, and this stands as something of a counterpoint (as well, of course, as a support) to the small business culture into which the young designers rapidly move once leaving college. Schwengell also argues that this interest in the 'culture-society' in Germany has a Utopian element, 'but also an empirical hypothesis that, in the choices between different sets of goods and services, culture as the permanent examination of preferences will become a key factor' (Schwengell 1991: 137). Fashion design would thus be understood as part of what Hartwig, writing about the German experience, labels the 'longing for art', in this case, for producers and consumers alike (Hartwig 1993). It would rely on public sector support in the form of grants and subsidies and it would also have the support of the art schools and the fashion academics. Schwengell also argues that the *Kulturgesellschaft* marks a rejection of 'classic élitist modernism – that cultural experimentalism can only be experienced by a minority' (Schwengell 1991: 141.) This, in turn, is suggestive of a greater degree of access to culture and its democratisation, a point also made by Lash and Urry as

one of the unexpected outcomes of the shift to an image-dominated and cultur-
ally saturated economy (Lash and Urry 1994). Once again the usefulness of this
conceptualisation in regard to fashion is that it offers the possibility for under-
standing fashion design's existence as both a cultural phenomenon and a set of
commercial enterprises.

The popularisation of fashion design through the 1980s is indicative of a
widening interest in its aesthetics (although, as we shall see in the following chap-
ter, this is not unproblematic for the designers, since it often means an interest in
fashion design exclusively as a visual image, meaning people know about fashion
by looking at the images without buying a single item). While fashion per se has
been a traditional feminine interest, what marks the broadening out of this in the
1980s, is the visibility and confidence of fashion design as a key force in British
cultural life. To envisage fashion as part of the Culture Society rather than simply
the 'enterprise culture' touches on its symbolic existence and on the place it has
won for itself as an art practice in the postmodern context where the strict divi-
sions of high and low culture have given way to a flood of art and art-related
activities often set alongside commercial practice. The most obvious example of
this is the art–fashion mix found in a number of high street department stores.
Jigsaw, for example, regularly 'exhibits' prize winning pieces of sculpture from
the degree shows in its front windows.

But my interest here is on the producer side of 'cultural experimentalism', and
how careers and livelihoods have been created by young and mostly female
fashion graduates, from a wide range of social and ethnic backgrounds. This also
connects with Schwengell's recognition that the culturalisation of society also
emerges out of 'real change in work patterns, family, community and social habits
and so on'(Schwengell: 142). As I have argued throughout this book, it is easy
and dangerous to simply write off these urban micro-economies of culture as
dismal failures, or else to say that the real talent will pull through, leaving the
weaker designers by the wayside. In fact, the reverse of this is the case judging
by the success of Galliano and McQueen, neither of whom could survive as inde-
pendents in Britain and both of whom have been rescued by French haute couture
and have consequently moved to Paris. Nor is it useful to see the enterprises I
have described as so small as to be insignificant. It is both the smallness and the
enormous cultural visibility of these practices which is indicative of their impor-
tance. Located in what were once the historic sites of the nineteenth century
garment industry, in the 'lace market' in Nottingham, in the Shoreditch area of
London where so many of the designers have their studios, in the old 'jewellery
quarter' in Birmingham (and also in the 'fashion quarter' in New York), these
enterprises reflect all the fluidity and unpredictability and sheer inventiveness of
work in a postmodern Kulturgesellscaft.

At the heart of Lash and Urry's argument in Economies of Signs and Spaces is the idea
that the shift to a cultural economy brings into being a new popular awareness of
aesthetics, an aesthetic reflexivity (Lash and Urry 1994). This coincides with the
stronger structures in society and the older attachments of class and age and

community declining and being replaced by those of a more openly individual-ist nature. The weakened structures now operate by virtually forcing people to be free, to take responsibility for a whole range of aspects of their lives, including in this case the creation of the source of their livelihoods in culture. According to Lash and Urry this need not be seen as an entirely negative phenomenon. They do not spell out how or why, and it might be argued that women stand to gain most from this new individualisation if it means financial independence for them through access to the labour market. But, taking this as a given and drawing on the analysis I have presented here, I would suggest, that the individualisation of which they and other contemporary theorists including Beck and Giddens speak, can actually encourage in the longer term the need for new forms of association. Recognition of the problems arising from having to 'fend for yourself' will even-tually produce more active and dynamic attempts to organise working conditions along more collaborative lines. What is missing at present is the kind of political vocabulary which would spell out the advantages of such new forms of associa-tion.

While all the turmoil of a do-it-yourself labour market doubtless creates very uncertain futures, the possibility of making work a source of self-actualisation, as we have seen the fashion designers do, also marks a difference from the days when work was, for the majority of people, just a job. I argue that the memory of work as a life of drudgery is passed on from parents to their children and pro-duces a 'historically-informed' discourse which fuels the expectation on the part of the younger generation of a more rewarding working life. In addition, as Du Gay has recently reminded us, debates about the decline of the 'industrial worker' have to be accompanied by a recognition that many groups of workers including women and members of ethnic minorities were typically excluded from this cat-egory (Du Gay 1996). If, as we see here, young women who do not come from privileged backgrounds and who are now emphasising the importance of a work identity for themselves in fashion design, as well as holding out for a working life which fits in with their personal aspirations, even their fantasies, can sociologists only interpret this as a further feature of social regulation and one which is umbil-ically connected to an ethos of individualism as a condition of its existence? After all, these young people do want to work; and they do so, in this particular field, against the odds. If governmental rationalities were working so well these young workers would presumably be heading for something which actually fitted more successfully, and certainly more profitably, with the goals of enterprise! This leads me to counter, not just the 'over-regulationist' approach of the neo-Foucauldians or the speculative theorising of Giddens and Beck, inspired though this may be, but to question the arguments of the more conventional Marxist-influenced writ-ers like Inge Bates who seems to see the desire on the part of young girls for an exciting job in fashion as a kind of 'false consciousness'. She dismisses as girlish fantasies these ambitions to be a designer and to work in a studio and says they would be better off looking for office work (Bates 1993). But on what grounds does she base this suggestion?

What is marked in this current study is the determination of the young designers to stay in fashion and to make good use of their talent and their training. However, what they lack is an overall perspective, a kind of map of the field in which they work and, in the absence of such an analytical framework, they find it difficult to move out of or beyond the individualising vocabularies which they have learnt as art students. As we have already seen, the attachment to work on the part of the designers is overwhelming. It is a crucial and profound part of their identities, something which for women who, in general terms, no longer expect to be dependent upon a male income for their livelihoods, is also a relatively new phenomenon. And these are not a tiny and highly privileged sector of the population, they are not 'artists' in the traditional and élitist sense; they are drawn from a range of different backgrounds, they are overwhelmingly female and they have aspirations to have a home, family and children and also to pursue a career. So, in this sense, they are very ordinary people. They are not 'artists in berets' starving in garrets and indulging themselves in the pub or 'salon'. Their values and desires are important for the simple reason that they are not exceptional or deviant or even simply eccentric. Indeed, their ambitions have become almost the norm for cultural and creative workers. What the fashion designer looks for in work, is not unlike what the independent television producer or the freelance journalist also wants.

While it is tempting to interpret the frenzied activities of the young designers as a sign that the self-disciplining model of work, embellished with the promise of creativity has brutally misled them into a spiral of self-exploitation and an intensification of their own labour well beyond any conceivable legal limit were they in conventional employment, if we want to understand this as a social phenomenon we also have to at least take into account the other side of this scenario of effort. We have to listen to their own accounts of their working practices. I have already pointed to a number of important features in this respect. For example, they prefer to do the kind of creative work over which they have some degree of control and where they can see the fruits of their own labour rather than take work, if it is available, for the high street market ('seeing 1,000 blouses into production at Marks & Spencer' as one fashion academic put it). There is good sense in this decision. The culture of creativity in which they have been trained, requires that 'talent' is nurtured early on, and also values more highly the notion of youth. So if the designers have any chance at all of making it and being successful, the few years after graduation is the time to pursue this goal. After living on a grant they can perhaps risk another few years of hardship and low incomes, especially when many of their counterparts will either be on the dole or else doing 'filling in' jobs before embarking on a real career.

There is also common sense in taking the option of trying to work for yourself by supplying a unit or stall at a city market because, in many cases, the alternative for art and design graduates is unemployment, or taking casual work in an entirely different field. The decision to put what has been learnt into practice immediately, and being willing to work long hours to make a very modest

living, is not just a form of self-deception. Small businesses of any sort frequently demand this input of time. There is also the question of the qualitative experience of time. The long hours worked through the night (which we academics also do ourselves) are different from being on the night shift in a factory or even working late in the office. There are interruptions of coffee, there is invariably music and even videos or television in the background, and there is a whole studio environment, so that the 'place' of work as well as the 'time' of work are also aestheticised, as a prop to counter the often mundane or repetitive activities, or simply to get through the long hours.

The designers are taking a risk in setting up in this kind of business, but they are doing so not because they are foolishly romantic and self-deluding but actually because self-employment and freelancing is part of the way in which work is rapidly developing in society, and as young workers they are participating in a kind of giant experiment. Can they, and all the other freelancers and self-employed young workers in the various cultural fields, carve out a sustainable future for themselves? Will the culture industries prove themselves sufficiently expansive to provide enough opportunities to keep so many people in some kind of gainful activity? Can British fashion design find ways of resolving the seemingly intractable problem of creating a more stable relation between producers and consumers, or is it destined to remain a disintegrated sector, one into which eager newcomers flood each year and old timers anxiously move around, offering a bit of this and a bit of that in a patchwork of creative employment? This book suggets that fashion design is not quite as ragged, romantic and irrational as it appears. Instead, it is a hybrid of old and new, a rag trade and an art world, a field of economic activity where the participants are inventing careers for themselves. The value of a sociological analysis of fashion design ought to be that it offers a more socialised account of a field of activity typically understood in highly individualistic and creative terms. The challenge for the future is to outline the potential of new social connections which might emerge out of this individualisation and to envisage the role of government and policy in such a changed world of work.

10

FASHION AND THE IMAGE INDUSTRIES

THE FLUID FIELD OF FASHION JOURNALISM

By providing a display window for United Kingdom fashion design, the fashion media does indeed function as a pillar of support for the industry. Had it not been for the appearance of *The Face* magazine in 1980 and i-D in the same year, British *Elle* magazine in 1985, and the British edition of *Marie Claire* in 1988, the boom in United Kingdom designer fashion through the 1980s and into the 1990s could hardly have happened. However, the magazines did not provide this support in an unconditional, unmediated or uncomplicated way. The fashion media 'represents' fashion and in so doing adds its own gloss, its own frame of meaning to the fashion items which serve as its raw material. The support it offers, and the role it plays, are limited by the various traditions and conventions which have defined fashion journalism as a specialist field, shaping what can be said, and in what kind of format. And so the initial and most significant difficulty faced in exploring the relations between these two sectors is that the fashion media exists within a set of institutions and organisations whose working practices are entirely different from those of fashion design. We are entering the world of journalism as soon as we step foot inside the offices of *Marie Claire* magazine, or *Elle*, or the *Guardian* newspaper. It is the professional codes of journalism which dictate the way in which fashion is packaged and presented on their various pages. The fashion media is therefore as separate and as autonomous from the world of design as the fashion departments in the art schools are from the working lives of the designers. We are talking about an entirely different institutional environment.

The work of the editors and journalists as well as the other creative practitioners including photographers and stylists, is driven by a different set of logics from that of the fashion designers. These are the logics of creative and editorial reputation, circulation figures, competition from rival publications and advertising revenue. These considerations play a key role in influencing the way in which fashion appears within these different media. But one of the significant features of fashion journalism is that it is set apart from other forms of journalism. The fashion media finds itself more closely linked with the fashion industry than would be the case in other journalistic fields. The low status of fashion writing

within the hierarchical field of print journalism pushes those who work in fashion closer together. The writers, photographers, fashion assistants and contributing editors share the same 'fashion world' as the designers, the company directors, the press officers and publicity personnel. This is a narrow, even closed, world which perceives itself to be trivialised and associated with a kind of stupidity, for example, Linda Grant in the *Guardian* 15 April 1997 writes, 'the brain of a supermodel isn't much, and so it was that Naomi Campbell came late to understanding that the fashion industry is in the business of selling and that what sells are blonde haired, blue eyed girls' (Grant 1997: 8). Likewise, in the aftermath of the murder of Gianni Versace another journalist wrote in the *Guardian*, 'Why all the bother, sceptics ask, over a preening victim of fashion, who belongs to the fashion press, not to Fleet Street?' (Glancey 1997: 19). As a result, fashion journalism does not have the security and confidence of other media worlds. Tunstall argues that because specialist fields in journalism associated with consumer-based activities are advertising-revenue led, they inevitably have a closer relationship with the industry which manufactures and promotes the product, since this is both the source of 'news' and of revenue (Tunstall 1971). Fashion, because of its feminine status, is something of a special case in this respect. It has a presence in both the women's magazine market and in the daily press. Where the readership for the women's magazines can be assumed to be interested in fashion, there is less of an emphasis on fashion having to prove itself. But in the daily press, where the staff journalists are predominantly male, even in the context of appearing within the remit of the 'women's page', fashion is more unsure of its status. This often produces a shrill, often overblown, language so that the reader is reminded once too often of the creative genius of John Galliano or Vivienne Westwood, triggering a counter-reaction exactly like that expressed in the wake of Versace's death in the *Daily Telegraph*, where a headline ran 'Was Versace Really A Genius?' and the journalist added, 'Nothing wrong with being vulgar. Versace had a very good idea. It's just that it seems odd to treat it as high art' (Johnson 1997: 21).

The limitations of the role played by the media in supporting the fashion sector stems from the conservatism and timidity of fashion journalism and its genres. This in turn is the product of the ethos of 'keeping the advertisers and the readers happy' which is particularly strong in the magazines. In practice, references to 'the readers' are typically a means of gatekeeping or controlling the flow of copy so that the advertisers are indeed kept happy in the knowledge that their product is being seen by huge numbers of the right kind of people. This knowledge of the readership gained, according to the editors through polls and market research, is actually a useful fiction, a means by which the power of the editor is deployed. It is a crucial part of his or her professional language. It is also one of the means by which all editorial decisions are justified – 'Our readers wouldn't like it' is a familiar response. But resistance to change couched in these terms produces a strangely old fashioned and unchanging feel to the fashion writing and reporting in magazines. The reliance on 'tried and tested' formulae pushes fashion out on a limb in an otherwise rapidly changing and innovative media world.

The images might be designed to shock, but the text remains culturally reassuring. On these pages fashion reporting and writing conform to a pattern wherein no real offence is ever spoken and no rules appear to be broken. The 'shock of the new' remains carefully contained within the legitimate avant-gardism of fashion photography (for example, the 'dirty realism' of grunge) and the fashion media regulates itself with a system of informal censorship. Of all forms of the consumer culture, fashion seems to be the least open to self scrutiny and political debate. This is because the editors deem that fashion must steer well clear of politics, and fashion journalists are expected to go along with this. With *Vogue* acting more or less as a universal benchmark of quality, fashion-as-politics is only conceivable as a catchy idea for a 'fashion story'.

Fashion reportage is almost the same now in the 1990s as it was in 1967 when Barthes it was turned his attention to fashion writing and found on the pages of the French fashion magazines a kind of rhetoric which was always anxious to reassure the young female reader that there was nothing out there in the world that was anything other than pleasurable or at least enjoyable. Barthes wrote 'Fashion's *bon ton*, which forbids it to offer anything aesthetically or morally displeasing, no doubt unites here with maternal language: it is the language of a mother who "preserves" her daughter from all contact with evil' (Barthes 1967, 1983: 261). The world existed to give these young women excuses for luxury holidays and romantic reveries ('a weekend in the country', 'visiting his chateau', 'a Bermuda break'). What Barthes described, still more or less prevails today with the provision of an occasional ironic, postmodern gloss on such stories. The rules on fashion reportage, the conventions which define the field of fashion representation, also set the fashion world apart from the rest of the media by virtue of this very conservatism. It seems that the overwhelming emphasis on images, indicating that the magazines are primarily 'to-be-looked-at', somehow relegates the role of text to accessory, to banal commentary, to a poetics of mood, to simple information, caption, headline, 'statement', or else it conforms to the tradition of superlatives in fashion writing.[1] Even the more radical youth culture-oriented magazines such as *The Face* and *i-D* abide by these rules to an extent. Although they have pioneered new styles of fashion photography which sometimes suggest that the world is not such a pleasant place, (for example, fashion as a poverty aesthetic as promoted by *The Face* and *i-D* in the early 1990s) this remains a visual genre with an artistic signature. It is 'just' a style. And, as Dick Hebdige has forcibly argued in relation to *The Face*, where everything is on the surface, laid out as a style, there can be no place for serious discussion, there are only superficial skirmishes or 'style wars' (Hebdige 1988). An article about manufacturing for Hussein Chalayan, or about graduates working for free? Forget it. In this context sociological analysis or political debate are either simply not the 'house style' or are 1970s' 'retro' phenomena and thus a bit of a joke.

There are some important points of difference between the smaller, more independent press and the large circulation glossies. *i-D* retains a focus on ordinary young, black and working-class, men and women as the source of most

153

fashion ideas. In interview the fashion editor, Edward Enninful, argued that fashion designers look to the magazine for their inspiration: 'Designers use the magazine as a reference. It's a question of what's up, what's going on? It's a visual thing'. By claiming that fashion ideas come from youth cultures, i-D provides a more open and accessible version of fashion culture, certainly a counter to the *haute couture* approach. But this, too, has its limits if we also take into account what cannot be said or shown in i-D and what is ruled out by its own editorial commitment to promoting fashion and style while ignoring completely its existence as a place of work and a space of livelihoods. *The Face* also offers an important forum for cultural and creative workers from a whole range of fields to have their work seen and commented on. *The Face* unproblematically sets fashion design alongside painting, sculpture, music and cinema without subjecting it to the old high and low culture divide. This might be seen as one of the redeeming features of its postmodern ethos, to break down that distinction. But these magazines also draw their own boundaries which exclude any detailed or serious discussion of the social processes or economic relations which underpin fashion as a cultural activity. Instead they construct style and fashion as insider knowledge, possessed by young, urban taste makers whose seemingly innate sense of 'what's going on' sets them apart from the masses and puts them in the lead in terms of what Thornton argues is a kind of 'subcultural capital' (Thornton 1996). This insight and expertise is then recorded, re-worked and translated into the language of the magazine as a series of distinctive taste cultures by the editors, art directors, photographers and stylists. The problem then is that as these firm up as genres of reportage which in turn become a set feature of the style magazines, the apparent openness of this media in fact becomes more closed.

Why has the fashion media developed in this way? To begin to answer this question we need to know how it works, including who does which job, and how key decisions are reached. This is a more difficult task than might be imagined. Just as we have seen an extraordinary amount of job mobility within the field of fashion design, with many designers doing two jobs at once, so also when we look towards the fashion media we are confronted with occupational fluidity which makes it difficult, if not impossible, to actually define and specify different jobs and the people who do them. This is partly because fashion journalism and many of its associated activities, in particular fashion publicity, has grown enormously throughout the 1980s. Until then, there were a limited number of outlets. The quality newspapers each had a fashion editor and a weekly slot, usually a single page, and apart from this there were only the fashion and women's magazines. But since the 1980s the scale of coverage given to fashion has expanded into television and across all the new magazine publications, as well as commanding more space on the daily newspapers. Fashion has become a subject of interest to a much wider section of the population. This can be seen most clearly in the family magazine programmes on daytime television. Not only do the programmes have daily fashion reports, they also have the immensely popular

fashion make-overs where couples of all ages come forward to have themselves restyled from head to foot by a team of experts.

This attention to fashion is part of the general expansion of the media and, more broadly, of visual culture and it also connects with the new attention to personal image and style led by the fashion retailers throughout the 1980s. A key dilemma for the fashion industry is that while millions enjoy looking at these images on the page or on the screen, there is no direct relation between looking and actually consuming. The availability of cheaper full colour print technology, the celebrity value of the fashion 'supermodels' and the sales appeal of having a glamorous model on the front page of all the newspapers has given fashion a more prominent position as a cultural phenomenon. One consequence of this is that a lot more people are employed in producing these fashion images and in writing about fashion. As in other similar areas of recent expansion (pop videos, for example), specific jobs often emerge in the process of somebody doing one job and seeing gaps and opportunities existing in related areas which have as yet no formal title. This indeterminacy, which Tunstall and Elliott both argue are characteristics common to media occupations in general, gives rise to both high degrees of labour mobility and to the creation of new job titles almost overnight (Tunstall 1971, Elliott 1977). For example, a fashion manageress at a key department store will meet with buyers, fashion agents, designers and merchandisers, as well as with the fashion press, on an almost daily basis. With this kind of experience and with such a wide range of contacts, a shift into being a fashion agent, doing fashion public relations and sales, or even setting up an agency for photographers, models, stylists and others, is not at all an unusual step to take. In effect these are media jobs, especially when we consider how reliant journalists now are on pre-written press release material for their own copy. Two respondents in this present study followed this kind of pathway. One young woman, Naihala Lasharie, started as a sales assistant at Harvey Nichols. She moved to a well-known fashion public relations company, worked for nothing for a few months and was then put on the payroll. After a year she began to build up her own list of clients. Now working for herself, her clients included the Italian label, Alberta Ferretti. As she says: 'Mrs Ferretti was a good story. I got full page coverage for her in Vogue, Elle and The Independent.' Naihala then moved full time to promote the cult shoe designer Patrick Cox (whose Wannabe loafers became an international brand) and looked after the shops, sales and public relations. At the time of the interview Naihala had left Patrick Cox to set up once again on her own in public relations and sales with twelve clients, her own office and a small staff.

Paul Davies also began his career in the mid-1980s in sales:

> After two years at Harvey Nichols as senior sales assistant where I was liaising with buyers, merchandisers, floor controllers and suppliers, and then a further two years at Jones with responsibility for visual merchandising, I set up a Press Office for the group which at that time had five stores on the Kings Road and at Covent Garden. After that I went out

on my own with the Z Agency for models, hair and make-up artists, stylists and photographers. I was primarily a photographers' agent which involved trips to Germany to introduce the photographic side to the fashion magazines in Munich, and the same thing elsewhere.

(Paul Davies interviewed July 1995)

A third respondent, Marysia Woroniecka, was, at the time of this interview, London's best-known fashion PR. She, too, had created her job on the basis of experience in retail and getting to know key people:

I started aged eighteen working in retail. Then I moved into wholesaling 'own collections' which I presented to the fashion editors. I went to parties and got to know more of the fashion people and then went to work in an advertising agency which I hated. From there I went to Jean Bennett PR who had ten clients and I had lots of freedom and learnt about the whole fashion business. By the age of twenty two I had my own company. There were fewer fashion magazines then, and a different kind of fashion press. It was a lot more limited. One of my jobs was advising clients (that is, the designers) which editors to contact and try and get to come to the shows, even what clothes to highlight. So I was also advising them on their collections. I knew what the media would go for. The bubble burst at the end of the 1980s. There was a different, much more demanding fashion media and the designers often couldn't come up with the quality or the finish. You could have 800 people turn up for a show, but if the quality of the product wasn't up to scratch, it could all become a complete disaster. The publicity could be top notch, but that still couldn't solve the production problems which the designers at the time all seemed to have. It was costing me more to have them on my books so I eventually had to lose them and concentrate on my two main clients, Benetton and Jigsaw.

(Marysia Woroniecka interviewed June 1995)

As well as indicating the limits to the kind of support given to designer clients by their press and publicity agent, while also acknowledging the weaknesses in production, both of the above comments not only tell us something about the flexibility of the career structures opened up with the expansion of fashion culture and the growth of the fashion media through the 1980s, they also describe a high degree of integration and overlap between different sectors of the industry. Individuals can move from being shop assistants to setting up their own media companies within the space of less than three years. Marysia Woroniecka, has now, at the time of writing, moved to New York and works as a fashion journalist setting up web site magazines.

Harriet Quick, who at the time of the interview was fashion editor for the *Guardian*, described her career moves as follows:

I have worked for five years as a journalist, after completing the one year postgraduate course at City University. I started in design journalism first, on the *World of Interiors* magazine for six months. Then I went to *Fashion Weekly* as menswear editor. I was there for two years. In 1992 I was free-lance and won the Jackie Moore Award in the *Vogue* writing competition. I went back to *Fashion Weekly* which was superb training for the whole fashion industry, and while I was there I was also freelancing for *Elle* and *Vogue*, and also doing some designer interviews for *i-D*. I started doing some bits for Louise Chunn who was then fashion editor at the *Guardian* and then I took over from her when she left to go to *Vogue*.

(Harriet Quick interviewed July 1995)

This demonstrates both the high degree of mobility within a specialist field such as fashion journalism, and also describes ways of working which Philip Elliott has argued are standard practice in media journalism, for example, doing several jobs at once, and doing low pay or no pay work as a means of getting, and remaining, known (Harriet would have worked unpaid for *i-D*). Again, this is not unique to fashion but is, argues Elliott, a way for journalists to maintain a more creative profile or of having some outlet for writing pieces which would not find a home within the more commercial sector (Elliott 1977). More specifically, the degree of to-ing and fro-ing between journalism and public relations encourages a kind of professional dialogue which makes it difficult for those involved to draw hard and fast lines around where reporting finishes and advertising begins, a task made even more difficult with the rise of lucrative, sponsored advertising features which have come to be known as 'advertorials'.

It is the rise of the stylist which is the most significant development for the way in which fashion design finds itself represented in the media. The stylist operates within the space between the design work itself and the creation of a broader environment or setting for that work. He or she does this by bringing those items into a particular and 'styled' relationship with other pieces of clothing. Located midway between assistant to the fashion editor and photographer's assistant, styling became a recognised job as these various assistants (often with an art school training in fine art or photography) began to realise their own creative input into the fashion pages and the freelance potential of their work. They planned and then put the whole image on the page together, including the combination of clothes (usually from a range of different designers) the look of the model, including hair and make up, the props needed for the narrative or non-narrative setting, the lighting and the overall 'look' of the image or series of images. Starting off as assistants who ran errands and went out scouring the second-hand markets for props, the stylists were increasingly given more of a free hand by imaginative editors (such as Sally Brampton at *Elle*) and soon a number of them began to develop a distinctive 'style' of 'styling', to the point that other editors could put a name to a page without looking at the credits. From this a new creative occupation was born. The stylist's services were suddenly in demand

across the fashion media, but also and more lucratively they were brought in to 'style' individual pop stars (like Kylie Minogue, for example) and to work on pop promotional videos and advertisements. This career developed out of the smaller independent magazines like *The Face* and *i-D* which were at the forefront of what came to be known as the 'designer decade'. Spurning the need for advertising revenue the editors allowed the stylists to experiment with fashion on the page. When it was launched in 1985, *Elle* magazine also relied on the work of key stylists such as Melanie Ward and Debbie Mason to give its fashion a look which was quite distinctive and different from *Vogue*, its main competitor. However, it was *The Face* and *i-D* which helped to create the stylist as a new strata of media professionals. People such as Judy Blame, Venetia Scott, Melanie Ward and Anna Cockburn all worked for nothing for these magazines, but it paid off in the longer term since the readership included art directors from international companies, advertising account managers and key people from the music industry. The magazines therefore provided an ideal venue for this kind of 'art work' and also helped to create these new jobs in the media industries.

Anna Cockburn described in interview how she became a stylist:

I did two years of fine art at Central St Martins, but I knew I wasn't going to paint. I was much more interested in making images, so I left and worked as an assistant to a fashion photographer, knowing nothing much about fashion. For six months it was a bit of a nightmare. Then I got a job at Joseph (the designer fashion retailer) and it was interesting to me because of the contact with customers. I became more conscious of clothes and the personal thing of helping the customer to choose. At that stage I didn't know what a stylist was. But I wanted a change and heard there was possibly some work at *Harpers and Queen*, assistant to the fashion editor, and I got the job. During this time I was also working in a pub during the evening to pay my bills. At *Harpers* I found myself with six pages and whether it was a collection I saw, a film or a dream, or a painting, it was the idea that was important. . . . The stylist and the photographer can both be mavericks and it works. I got promoted to Junior Fashion Editor in 1988/9 and then the recession hit and it all became more commercial, you were forced to be less creative. I went to *Elle* and I was on Best Buys with cheaper clothes and of course I tried to make it good with the best photographers, but there was a lot of pressure and I didn't really settle down. I then spent a year in America on various projects, came back as contributing fashion editor at *Vogue* . . . it was a bit disappointing because everything had to be agreed and approved, from the models to the photographers it was all done at the level of 'house style'. Since then I have been completely freelance. The agent, Camilla Lowther, calls me up and says there is a job here or there. At the same time, right through this whole period I have worked for *The Face* and *i-D* who don't pay but it is exposure and it's advertising for people like

myself and the photographers who I've worked with for them. I ring them up when I have an idea of something I'd like to do for them. It always costs me, but it's worth it for the freedom, the exposure and the space. They are also generous with the credits which are more visible and bold.

This comment is worth quoting at length for the detail it provides on this emergent occupational category of the stylist and the insight it offers on a number of themes which are directly relevant to this and the following chapter. These are, first, the idea of 'making images' as creative work; second, the opportunity of movement in this field from working as a shop assistant to being a fashion editor on a glossy magazine; third, the way in which creativity conflicts more directly with commerce in the magazine environment when the industry goes into a recession; and, finally, the extraordinary working schedule of this young woman who has, throughout the entire period of paid work, also done unpaid work for the style press in order to keep her own creative profile visible. It has been suggested that this kind of pattern of working is by no means unusual in media occupations (Tunstall 1971, Elliott 1977). But the move towards working on a permanent, freelance basis is much more marked in the 1990s than it was in the 1970s. Not only are the culture industries more crowded than before, with the growth of the service sector and the impact of privatisation and deregulation, but the expansion in self-employment and freelance working has been enormous. This is a way of 'capital' unburdening itself of responsibility for 'workers'. In a high unemployment labour market the very idea of working for no pay or on spec becomes more acceptable as young people are increasingly desperate to get their foot in the door.

It is not, I think, coincidental that the final destination of the fashion designers who participated in this study was to work in an entirely freelance capacity. With the same drift in fashion journalism we can reasonably ask, how sustainable are these micro-economies, these self-employed careers? How long, for example, can somebody like Anna Cockburn carry on at this level of activity? What would happen to her career and her personal livelihood if she was ill for even a short period, or if she took time off to have a child? Is she a valuable asset because of her talent or is this as crowded and as competitive as the other media occupations? The growth in this kind of work has been more than matched by the number of young people keen to work in the fashion media. It is an area of work brimming over with graduates from universities and art schools including prospective writers, photographers, graphic designers, and art directors (Garnham 1987), to the extent that the Prime Minister himself, writing in the *Guardian*, claimed there to be over 300,000 people now employed in Britain in the design sector (Blair 1997: 18). As Anna Cockburn's career indicates, most of the work in this field is of a freelance character. This is highly advantageous to the employers. It also creates more competition and almost certainly results in the undercutting of set rates of pay. Even the biggest circulation magazines like *Marie Claire* now operate with a

tiny full-time staff and a whole range of different kinds of contracts for different kinds of work, for example, contributing fashion editor, associate editor, contributing features editor, and so on.

This freelance culture produces new social relations in work. A stylist commissioned to put a series of pages together needs to know that she can pull in the photographer and the models and also get hold of the clothes she needs, all to a tight deadline. The informal team-work and even sub-contracting which comes into being around this new freelance economy has been barely documented in academic writing or in the media. Often it emerges from friendship groups which go back to art school or university, or a stylist will develop a 'feel' for working with a particular photographer and they in turn might have contacts with a couple of models and a new fashion design graduate – and they will all pull their resources together and do a number of 'tests' (a fashion story) which they will then present 'on spec' to magazines such as The Face or i-D. A number of international careers have been launched on this basis (the model Kate Moss teamed up with 'model-turned-photographer' Corinne Day for Vogue in 1993, having already done a number of trial shots or 'tests' for i-D). The magazines and newspapers are inundated with these presentations of work and many have now adopted a commission only policy. Harriet Quick of the Guardian reported receiving up to five portfolios per week. Recognition of the value of exposure has also given rise to new glossy publications like Dazed and Confused and Don't Tell It (again non-paying) setting up in competition with The Face and i-D. The entire copy for these magazines is in effect 'donated' in the hope that it will be seen by big budget magazine editors and advertising companies looking to recruit new talent.

Keeping track of the economics of this kind of work is difficult, if not impossible. Only by interviewing individual participants in the field can we develop any sense of how it functions and what kind of living these people actually make. To be able to get some picture of the kind of division of labour which exists in fashion journalism what is needed is a thorough documentation of the field. It seems however, that the only practical methodology is indeed the individual interview. People move about so quickly and there are so many short term contracts or part-time jobs that it is difficult to keep abreast of these changes. It is not at all unusual, indeed it is increasingly the norm, for a fashion editor to be employed for just three days a week in order to put her pages together on a major monthly fashion magazine or even a daily newspaper, leaving the rest of the week 'free' to freelance elsewhere (though not on a similar title) as a way of making up a full-time wage. At the same time, full-time magazine staff also freelance or 'moonlight' for other slots, particularly on television or radio. A highly paid full-time fashion editor may also be filing copy for a foreign newspaper or working with a new cable channel or consulting for a design company. Editors regularly move on. Some, like Glenda Bailey of Marie Claire, move to take up lucrative posts in New York while others, like Sally Brampton, go on to combine teaching fashion journalism with freelance writing. Nor is it uncommon for well-known fashion editors to work for the big fashion companies such as Armani, usually in

the press and publicity departments. Crossing the boundaries in this world is also common. For example, the German designer, Jil Sander, employed Anna Cockburn to add her distinctive 'styling' talents to Sander's original collection. This involved designing the catwalk show (make-up, set, logo, lights, music, etc) and then also styling the models with the clothes for a series of advertisements and an in-house brochure. This shows how, in the world of the image industries, fashion design recognises the need for additional skills in the transition from three dimensional fashion to the one dimensional page, or from the art of fashion to the art work of the page.

Fashion is not the only field to have so many ill-defined jobs and such high degrees of job mobility. This is a mark of the creative sector as a whole although the nearest comparison is the music industry where, as Negus has argued, the creative ethos produces occupational fluidity unheard of elsewhere (Negus 1992). Artists can move into production, even a shift into journalism is not uncommon, while journalists are often aspiring musicians waiting for a break. In the fashion world it is uncommon but not altogether exceptional for designers to move into journalism (Helen Storey has recently made such a move). And while several editors or journalists may have started out with ambitions to be a designer (Glenda Bailey, editor of British *Marie Claire* from 1988–95, studied fashion design before moving into journalism) most of the journalists have simply combined an interest in fashion and style with writing and reporting. However, like the music industry, this is a small and close-knit community where everybody seems to know everybody else. It is also a precarious world in terms of both jobs and income and this means that individuals are continually thinking and projecting into the future for contacts, new work or consultancies or similar offers. As we have seen, there is also a high degree of mobility between press office work and journalism and together these factors produce a culture of consensus in the magazines and the fashion press. It is simply not worth upsetting those who occupy positions of power. Journalists quickly learn the rules of the game and this means knowing what kind of story not to offer.

The relatively closed world of fashion makes it more difficult to untangle the relationship between fashion design and the fashion media. We are not able to simply place the designers in one corner and the editors and journalists in the other. There is so much mediation between the two (through public relations departments, press offices and agents) that the very idea of looking at how the fashion media 'represents' fashion design is immediately more complicated than it might seem. Each separate magazine, newspaper or television programme has its own particular 'house style', its own image of itself and of its audience or readership. Different media favour different kinds of fashion. We therefore need to tackle a further set of relations between actual, rather than imagined, readers and consumers and their fashion preferences (fantasy or otherwise) in order to chart the connection between editorial policy and the choice of clothes featured on the pages.

'IT'S NOT A *MARIE CLAIRE* STORY'

There are hard and fast rules which govern the field of fashion journalism and magazine production and which set it apart from other areas. I have already argued that these have remained in place over a longer period of time than might be expected. The conservatism which characterises fashion journalism is also the product of its marginal and feminine status. It has managed to safeguard its own tradition, one which perceives itself to be quite separate from the world of mainstream journalism. There is, for example, a reliance upon a set of conventions, and a generic structure, for dealing with fashion which date back to the 1920s heyday of *Vogue* magazine and its commitment to fashion as art and as luxury consumption for upper-middle-class women. This is the dominant tradition of fashion journalism. Despite the various popularising forms of fashion media (like the BBC's *The Clothes Show*) the *Vogue* model retains a strong influence over the practitioners. The old élitist image of fashion lingers among the professionals, in particular in their respect for the litany of *Vogue* editors whose snobbishness and tyrannical ways of working are mythologised as part of fashion history. Figures such as Diana Vreeland, one of the most influential of *Vogue* editors for over thirty years, and currently Suzy Menkes of the *International Herald Tribune*, embody this fiercesome, flamboyant and immensely respected image on the basis of their knowledge of fashion and their writing about it. Students are encouraged to emulate their style of writing, with its eagle eye for detail combined with sweeping judgements and dramatic proclamations as in the famous statement by Freeland, 'Pink is the navy blue of India' (quoted by Billen 1996: 7). Because these editors see fashion as an extension of high culture, a branch of the fine arts which has been neglected, while at the same time being part of a luxury consumer culture, the last thing in the world they are going to draw attention to is pay and conditions. They might express concern when designers go out of business, or they might ocassionally write about the economic state of the industry as a whole (although this is unusual), but they do not see this as in any way a priority. Their typical response is that this is not what readers want to hear about – 'It's not a *Marie Claire* story.' Instead the editors deal in a world of fashion images and fashion fantasies, and fashion imagery as part of the wider popular culture works at the level of fantasy or enjoyment. The emphasis on looking, with function and information being reduced to the merest hint of a new seasonal look, means that editors can indulge all their own fantasies and show clothes which are well beyond the financial reach of the readership. The logic of the fashion image on the page is not primarily to stimulate immediate consumption – the reader need not feel any obligation to buy, this is not a selling strategy, nor is it an advertisement – instead it is a journalistic strategy. For example, in one issue of the *Guardian* (4 April 1997) the clothes by the designer Alberta Ferretti shown on the three page spread included a chiffon dress at £1,010, a kimono coat at £1,467 and a chiffon skirt at £601. This article comprised a profile of the woman and her work and described her success in business and her high-tech factory in

northern Italy. Ferretti's clothes are extraordinarily expensive and so the point of running such a feature is to say something to the readers about Ferretti as some-body they ought to know about, and to show the work so that it evokes a certain mood or fantasy about beauty, wealth and 'lifestyle', as well as about female sex-uality. The abstract and sexually evocative way in which the pictures are shot (in one picture the model is absent-mindedly touching herself, as though aroused simply by what she is wearing) appeal to the features of taste and distinction by which particular readers are addressed as a means of confirming their class, status and cultural capital (Bourdieu 1984). Readers of the Guardian are expected not to be shocked precisely because these are clothes which carry an art value. They are 'pieces' to be admired. This determines how they are presented on the page and how they are to be written about. As long as the editor is confident that the Guardian readers will not be put off by such a feature (although a few might write to complain about the prices as in this case, 'I mean £1,010 for a tarted up bit of net curtain – as I say, disgusting and obscene' the Guardian Weekend 12 April 1997) and that they will consume the images at the level of art, fantasy and enjoyment, then she can be satisfied that she has made the right choice. The fash-ion copy creates both a particular kind of readership and flatters it with its good taste. Harriet Quick explained her editorial strategy at the Guardian in the follow-ing terms:

> With the weekend supplement we are in the fortunate position of being able to be adventurous. There is a good deal of forward thinking, a mix of literature, art, music, culture. Newspapers are obviously different from magazines, we don't have to be cutting edge and we take fewer risks visually. We have to make fashion communicable and accessible. The writing has to balance detail with the visual side, information with the conceptual angle.

This comment locates fashion within a triple framework of the arts and culture, lifestyle and leisure interests and, as we have seen, less directly with consumer cul-ture. With such a broad remit it might be expected that other issues which relate more to the fashion industry as a whole, such as sales, turnover, export and import, might also be covered. But this is very rarely the case. There are as fixed a set of genres of fashion writing as there are of fashion imagery. These do not include the business or economics of fashion, or its existence as a sector of employment. While newspapers like the Guardian will run the occasional story on the success of Marks & Spencer, or a profile on a key retailer such as Jigsaw or Whistles, there is little serious attention given to how clothes are produced and exactly who consumes them. Fashion journalism and fashion photography are unique in the field of mass communications. The fashion pages show clothes available for consumption and list the stockists or they talk about designers and retailers and report on the new collections, but these pages do not have to sell the clothes.

Because they are neither advertisements nor reviews in the traditional sense, nor simply consumer information, they occupy a vague and indeterminate visual space. It is precisely this that licenses the move into the field of fantasy and sexuality. The photographers and stylists welcome the creative freedom provided on the fashion pages. For them it is a unique opportunity to show off their talent. The magazine page functions like the gallery wall. For the editors and the creative teams the art work of the page takes precedence over the clothes that are being featured. Sometimes they can barely be seen or they fade into the background. Edward Enninful, fashion editor of i-D described the fashion pages in the following terms: 'The magazine itself is art. The main thing about the work here is that it is creative. i-D isn't fashion, it's ahead of fashion.' Sheryl Garrett, editor of The Face took this even further when she said that the art directors sometimes commissioned designers to create specific fashion pieces to go with the pages:

> Fashion-wise we are pushing back the barriers, it's not a question of simply presenting clothes. Often we commission clothes to be designed to go with the overall art idea. It's more of an art direction approach to fashion. And, because of this, the best fashion photographers and stylists will work for us for free. The Face is a career ladder, a huge opportunity for creative professionals to get attention and to show their work.

What these statements show is that the style magazines promote their own art work and their own overall look or image. They are much less concerned about showing the work of designers. Fashion fits into the vision of the editors, photographers and the stylists but it does not define what they do. So in this sense even the style press, so committed to fashion, cannot be said to be supporting it or promoting it in any direct and unmediated way. The art work is the means by which the style press 'advertises' its own creative talent, offering valuable exposure for photographers, stylists and also models. Sheryl Garrett said in interview that if one of the supermodels wants to change her image, or liven up a slightly flagging reputation, she will offer to do a cover shot and fashion spread with her favourite creative team at The Face, again for no fee. There is in this transaction, wherein virtually no money passes through anybody's hands, a multiple trade-off between the model and her image, the magazine and its status and identity as being at the leading edge of fashion, the photographer who takes the picture and, finally, the person who designs the clothes which the model is wearing. Indeed everybody is in it for 'image'.

The style press encourage their freelance creative teams to produce images which break boundaries and attract a lot of attention. Sheryl Garrett described how this happened with a fashion spread in The Face which featured models splattered in blood: 'Most of the magazines followed up Tarantino images with the men in suits, they played around with that. What we did was the blood issue, the fashion with blood story.' Controversial images like these also mean publicity for the

photographers and stylists and for the magazine itself. It is by giving the creative teams a free hand with the fashion pages that the work ends up being shown in exhibitions and gaining the approval of the art critics. If newspapers like the *Guardian* provide readers with cultural capital through their fashion coverage, and thus also 'cultivate' the readership, the style press participates in a similar process through its embodiment and distribution of 'subcultural capital' (Thornton 1996). But unlike art magazines and journals, magazines such as *The Face* or i-D which are by no means simply visual publications and do carry written text do not, however, run any serious or critical commentaries on the sort of work they promote and feature on their own pages. As Hebdige points out, there is only the catchy title, the witty caption, or the ironic few lines of commentary. This precludes the possibility of dialogue or critique or even judgement. As Hebdige says, it simply puts everything on the surface (Hebdige 1988).

The art directors and graphic designers also relegate fashion to second place in this visual field. The photographers and stylists see this as their space and do with it as they please – they compose the page and have no obligation to fashion designers, they merely use their work where it suits. It could be argued that it is none the less by this means that fashion has achieved the status it has craved, it is turned into an aesthetic image *because* there is no text, no reviews and thus no procedures or criteria for judgement (as there is in film criticism or music). Fashion remains a 'spread' and its values are simply stated or asserted. There is no substantial and accompanying discourse which debates questions of value or which casts judgement on the basis of agreed criteria. A number of reputations get made by this means, photographers end up having their work exhibited in art galleries and designers become household names. Nobody requires that the fashion journalists defend or even explain the basis of their judgements. It seems to be enough that the work which is shown, and the image itself, are recognised as important. Of course, Bourdieu would argue that this is the traditional means by which the 'creator is created'. Cultural outsiders are excluded from understanding how such decisions are arrived at, precisely as a strategy of power and as a means of protecting already existing cultural hierarchies. In such a context it hardly matters that the old divide between high art and popular culture has been broken down because, even in this more flattened world where fashion is treated as art, it is still subject to these traditional patterns of representation.

In addition to this process of aesthetic transformation, the fashion item itself need hardly exist as an object for sale in the shops because its existence is more concrete, more assured and much more widely seen on the page. The style press and other magazines have contributed to the visibility and popularity of fashion culture, but the truly postmodern dilemma for the fashion designers is that fashion has a more substantial and a more popular existence as an image on the page than it has as a set of clothes on the rail. As an economy of images operating in the field of magazine and newspaper publishing it works effectively – the pictures on the front pages sell more copies – while the economy of fashion, the dresses

themselves rather than the images of the dresses on the page, tells a different story altogether.

The fashion pages are also increasingly art or exhibition spaces. The same photographers work for the glossy, more commercial magazines as for *The Face* and i-D and they bring similar values to both, even if they are forced to make some compromises with their own creativity for *Marie Claire*, *Elle* or even *Vogue* (although *Vogue* has always championed strong art direction). Whether these are narrative features where the pictures tell a story and create a particular visual effect, or whether the emphasis is on the relation of text to image as news or information, the aim is to create an aesthetic effect. A fashion feature centres around the visual image and it is this surplus of visuality, 'spreading' out all over the pages, which has attracted the critical attention of feminist cultural theorists who have seen these spaces also as sites for fantasy and female visual pleasure (Evans and Thornton 1989, Griggers 1990, Fuss 1994). This is important, usually psychoanalytically informed work. But its exclusive focus on the fashion spectacle reinforces the wider cultural emphasis on the image. The sexual politics of the page produce a kind of sociological amnesia as if nobody was employed to produce the pages or to create the clothes.

THE POWER OF THE EDITORS

I have argued that fashion journalism is a peculiarly unchanging kind of practice. The forms or 'slots' for fashion coverage are narrow and restricted. Fashion stories tend to fit one of the following types: first, the designer or company profile or interview; second, the reports from the collections; third, the fashion spread or 'centrefold'; fourth, the consumer-oriented feature (for example, *Marie Claire*'s influential '100 Best Buys'); and, fifth, the single item feature (the 'new' fitted silk shirt). These genres regulate the flow of fashion knowledge and also create a relatively self-contained world of image where text is a subordinate feature. It is on this basis that fashion meanings are constructed. It was *Vogue* magazine which in the early years of the century established these rules of fashion reporting. Other magazines followed suit and also provided advertisers with the wider readership they required. The key figures in this world were the fashion editors, both feared and adulated, with dominating personalities who ruled the world of fashion and were also patrons to both the designers and the photographers. The history of fashion magazines is full of such legendary characters. The spectacular figure of Diana Vreeland, dramatically configured in old age with raven black hair cut into a bob and scarlet lipstick, and contributor to and editor of American *Vogue* from 1940–71, was the most influential of these figures and fashion editors since then have almost inevitably acknowledged the importance of her editorial style and sought to emulate the avant garde aspects of this style in their own practice. In particular, they have inherited the *Vogue* rhetoric which simply asserts the overwhelming importance of fashion as an unquestionable truth and, with this,

women's love of luxury as the embodiment of femininity. As Billen has recently said: '*Vogue* delivers such an elevated version of an already elevated lifestyle. . . .' (Billen 1996: 7).

This image of the fashion editor as a powerful and influential figure, an icon of glamour and a patron of the arts, continues to influence the practice of fashion journalism today. The emphasis on status and hierarchy is important as the editors have to fight to be taken seriously outside their own territory. Women's magazines and glossy fashion magazines have always been quite separate from the broader field of journalism. As a place of employment this is a woman's world, in the same way that fashion education in the art schools has also been dominated by a series of strong and influential women. And, for all these reasons, women's magazine journalism, including fashion journalism, occupies a much lower status than many other forms of journalism. Most male journalists consider it lightweight, trivial, entertainment, domestic and consumer-based and, as a result, it is hard for journalists working in this area to move outwards into other fields, particularly news or feature writing for the press or for television. This induces a sense of isolation and inferiority which makes the fashion world all the more brittle and defensive, more self-contained and concerned with its own status and importance than might otherwise be the case. It is not surprising that everybody knows everybody else and although there is a high degree of labour mobility it is very much within the same field. Lacking the broad cultural capital of the Oxbridge-educated journalist, few fashion journalists ever find themselves moving across different specialisms on a newspaper as staff journalists are still expected to do. No fashion editor ever moves to a general editorship in the press or television, and it is rare for a beauty editor to move away from her field. While many of the journalists who write features for the new men's magazines also cross over into the wider media (Tony Parsons is a critic for *The Late Review* on BBC2, for example), this is primarily because what makes the men's magazine market different is the coverage of a wider range of material than their female counterparts. Sports, politics, music, even literature, all command more space in *FHM*, *GQ* and *Arena* than they do in *Marie Claire*, *Elle* or *Vogue*. 'But we are fashion' is how the editors would respond to this point. Yet because they are too concerned with fashion images and too little concerned with the fashion industry, it is actually qualified support that the fashion editors provide for the fashion industry. What they do is much narrower. They set the agendas for the look that will be promoted each season. They go to the shows and sift through all the work shown on the catwalk and presented to them in the smaller studios to decide which designers to feature and which looks to promote. This conforms with the gatekeeping role of editors across the different forms of media. They have the power to select one story and veto others. In fashion the editors play a hands-on role. Glenda Bailey, editor of *Marie Claire*, said in interview that she always had the final say on the fashion pages because, as she put it, they were so central to the image of the magazine as a whole:

We sit round after the collections, with the team, and have an ideas

session. We've already done our predictions and our own forecasting. That's where the training comes in. We have this sense of what the designers are going to be doing and usually we're right. Good fashion fits with the way society is going, and that's what we also pick up on. It's my decision in the end. I have to take that responsibility and thank goodness it's worked so well. We do our own research through the magazine twice a year and ask the readers to give comments on every article, including all the fashion features, and there is often no surprise – I find that my theories are the same as what the research shows.

Glenda Bailey also described her commitment to showing the work of British designers:

The great thing about Britain and the art schools is that they do encourage eccentricity and individuality. It's all so connected with youth culture and working-class life and the greyness of Manchester and that kind of thing. It's also because we encourage people to fight against things. In my first year at Kingston, John Richmond and Helen Storey were my hero and heroine. They fought against all the rules and discipline.

These are the terms in which the editors express their support for British fashion. It's a championing role and one which also emphasises, as Glenda Bailey does here, the 'eccentricity' of the British designers. But this merely confirms the image of the designers who must be bad at business if they are good at design. We have already seen how one editor arranged for a stockist to take a few items from the collection of Yvette M. and Lisa R. so that she could feature them in her magazine. If an editor really believes in an up and coming designer she will often go to great lengths to help them gain a foothold in the industry. This can also extend to the role of 'patron'. It is widely recognised that for all the right reasons the ex-editor of British *Vogue*, Anna Wintour, acted in this role on behalf of John Galliano. She took him to parties and introduced him to businessmen who might be potential 'backers', she advised him and supported him as a friend and gave him space in *Vogue*. Inevitably this helped him gain the post he now holds as chief designer for Dior in Paris.

This kind of support then sets a whole set of gendered relations in motion where Galliano becomes the editors' favourite and, as we have already seen, gets more coverage than all the other United Kingdom designers put together. This form of patronage is quite unique to fashion and is very much the product of it being an enclosed, culturally anxious and virtually self-regulating world where notions of objectivity and impartiality do not have the same impact as they do elsewhere in journalism. Indeed, because they adhere to traditional 'high culture' values the editors would possibly see this role as patron of the arts as a kind of philanthropy, a way of helping the poor, starving artist to achieve the success which he deserves. This is another sign of how old fashioned and conservative

fashion editors are. This role of patron is, in fact, far removed from the way in which contemporary artists define their own role. Most of them would angrily reject the idea of patron as a throwback to the eighteenth century. Anna Wintour's patronage of John Galliano reveals the extent to which fashion imagines itself to be following the rules of high culture, while in fact it is quite out of touch with the contemporary politics of art. While this might work as a kind of camp comedy, a means by which fashion gently pokes fun at itself, this is also one of the ways by which the mostly gay 'fashion boys' find themselves the darlings of the editors and journalists. In the emotionally charged world of the catwalk shows, the passionate relations between the gay, male designers and their female journalist followers (recently parodied in BBC television's *Absolutely Fabulous*) finds the female designers squeezed out of this particular fashion circuit.

Bourdieu provides an interesting account of this positioning of critics and commentators close to the artist. He argues that as a cultural practice develops, its commentators position themselves more and more closely with the creative figures at the centre, in this case the designers. The writing and reporting is often produced more for them than it is for the readers or for the public, while at the same time this activity in effect writes the creator into being, almost bringing him or her to life. As he puts it, they 'create the creators' (Bourdieu 1993b: 78). By this means, the critics also feel as if they can share something of the aura of the artist – they have earned their place in the sun and they can bask in the warm light. In this respect 'the discourse about the work is not mere accompaniment, but a stage in the production of the work' (ibid.: 111). Bourdieu also says 'Words, names, schools . . . are so important only because they make things' (ibid.: 106). This process clearly happens in the world of fashion where a few key figures can shape the career of an equally tiny number of designers to begin a snowball effect, so that within some period of time the artist, designer or whoever it is at the centre, becomes a household name. This is exactly what happened with John Galliano, less so with Westwood and McQueen, but still enough to make this threesome now representative of the summation of British talent. My point here is that although Bourdieu is right and this process occurs across the artistic field, the art critic does painting and fine art the service of writing seriously about it. The analysis and commentary, directed as it may be at the artist, performs a role in producing criticism. This is an altogether different activity from being a fashion editor/patron and simply enthusing about or publicising certain designers.

If we take into account this individualising process which produces the designers as simultaneously eccentric artists and also part of the celebrity world of popular culture, we can see the dangers as fashion becomes more and more reliant upon media hype and whatever is new or up and coming, including the designers themselves. As Sally Brampton said in June 1994, unusually for an editor, 'the irresponsible thing is that the fashion press has a voracious appetite for novelty.' This means that the editors and journalists have priorities which appear to promote United Kingdom fashion but which in fact also contribute to its

problems. The instant negation of the recent past ('say goodbye to this summer's chiffon frills and move into something much sharper'), the forgetfulness about last year's successful designers, as well as the increasing pace of fashion coverage set by the global media which means that the designers themselves have to run to keep up, are not necessarily good news for the stars of last year or the previous year, nor is it much help to the designers who cannot afford to put on a show or to pay a good public relations company. Like the music industry, a good deal of journalism is increasingly PR driven. Just as the record company will jet out a planeful of journalists to Los Angeles to meet Meat Loaf, wining and dining them in the process in the expectation of a good review, the big fashion companies have huge budgets for the launch of a new line or even simply a new collection. The opening of a 'flagship' store will result in editors and journalists being inundated with invites and the promise of interviews. Indeed, it is just this kind of promotion (including a glittering party) which resulted in the feature described earlier on Alberta Ferretti. The article coincided with the opening of a new and exclusive store on Sloane Street in London.

The smallness of the world I have just described and the feeling of being marginalised from other fields lessens the possibility of a more open and critical form of journalism. Where a new book or film, or a new record or play can be panned by the critics, it is very different in fashion. It is not unusual for editors who have published even mildly critical reports about a new collection (along the lines of 'Lacroix was disappointing') to find themselves barred from entrance and deprived of an invitation the following season. The shows are where the editors do their groundwork and they have to be able to see these one-off events. If filing poor copy means that they won't be invited back, this at least influences what they say. The designers can get away with it because, after all, they are 'artists' and they can be as temperamental as they like. This reliance upon keeping 'in' with the designers means that editors back down from covering even a news item which might cast the designer in a poor light. I was told by the fashion editor of a daily broadsheet that it would be 'more than my job is worth' to cover a story which suggested that one of the leading American designers was using cheap, exploited labour to manufacture her clothes, even though this story came from reliable sources and had already surfaced in the American press. The response was similar when I suggested a story myself about what happens when United Kingdom designers are forced out of business. The reason given for the first issue was that this editor might at some point in the future need to do an interview with the American designer and would not want to find herself refused and, for the second issue of designers going out of business, she did not want to be seen giving poor publicity to the British fashion industry!

There are other factors which shape the nature of fashion coverage. The growth of the star system and its connections with the wider world of show business and entertainment means that editors focus more on international fashion and on *haute couture* because it is where the good stories (including expensive press packs, luxury lunches, flagship opening parties) are. Their commitment to promoting

British fashion needs then to be set alongside the competition from the big brand names such as Calvin Klein, Donna Karan and the Italian designers, all of whom can afford the kind of publicity stunts and perks which are beyond the wildest dreams of any single British designer. As this trend begins to set the pace for fashion coverage, and as the *haute couture* collections begin to show at different times across the year (rather than on the traditional seasonal basis) the British designers find themselves squeezed into the London Fashion Week or into the low seasons or quiet times for the fashion press (for example, mid-summer or mid-winter). The increasing prominence of the brand names also has the effect of isolating and marginalising the United Kingdom designers. International designer clothes might well be beyond the reach of most consumers but they also provide images which will surface on the high street soon after the shows. There is no longer the long wait for the high street versions to eventually arrive in shops as high street retailers can now make use of high technology batch production, or simply the proximity of the local labour market, to rapidly produce cheaper copies – so that what is on the catwalk one week can be in Miss Selfridge a few weeks later. The fashion media play a role in orchestrating this connection through their high profile reports on all the shows. In- house designers at Kookai, Warehouse or French Connection only have to read the papers to see what they should be concentrating on over the next few weeks. With all the power and resources of international *haute couture* on the one hand, and the high street on the other, the British designers begin to look less exciting. They cannot command the same kind of attention unless they themselves have moved into this international fashion circuit. The cottage industry of United Kingdom design finds itself in competition with multinational companies and huge corporations such as Donna Karan and Calvin Klein. The small scale designers fade away from the spotlight and the catwalk, and it is the European houses (all subsidiaries of giant corpora-tions) which hand pick one or two people a year to provide a frisson of celebrity; for example, Stella McCartney's move to Chloé in Paris to replace Karl Lagerfeld, 16 April 1997; novelty (McQueen at Givenchy) or glamour and eccentricity (Westwood).

CONCLUSION

The relation between fashion design and the fashion media is one of dislocation and unevenness. The media might be a pillar of support but this does not mean that the gossamer slips and the silky summer dresses won't slide to a crumpled heap on the ground every so often. This is not the fault of the fashion media – it is after all an image industry – and for the editors the priority is not the design-ers but their own consumers, the readers who buy the magazines. While the editors claim that their readers are the type of people who want to buy the clothes found on their pages, they are not really thinking about actual sales. These clothes play a symbolic role in the fantasies and aspirations of the reader. The

fashion pages are fantasy spaces through which the reader is free to wander, but there is nothing there that pushes her in the direction of the shops. Instead, the images and the meanings attributed to them, produce taste groups within the over-arching concept of the readership. The taste groups are also produced for the benefit of the advertisers. So, as Sean Nixon writing on the growth of the new men's magazines argues, the fashion magazines serve a double function of providing advertisers with the right kind of visual and textual environment for their products (in the case of the fashion magazines, a luxury, 'glossy' environment, rather like an upmarket department store) and they also create for the advertisers a 'shaped up' group of consumers (Nixon 1996). Nixon shows how effective this has been in the promotion of a range of male products including jeans and male toiletries.

However, this model does not have the same direct applicability when we look at the women's fashion media and fashion design. There is no one-to-one relationship because the fashion spreads are not advertisements and the designers cannot afford to advertise themselves. Even with a good public relations company, when and where the designers clothes get featured is something of a hit and miss affair. Neither is there any guarantee that coverage will generate sales, especially if the item can barely be seen. In short, this is not how women's magazines work. Fashion on the page is there to be looked at and a whole range of activities intervene before this process of looking leads to the concrete act of purchasing. There is no necessary relation between the play of pleasure, tension and anxiety in looking and the very different social relations of consumption.

The fashion magazines and the fashion press operate within an economy of looking. They also produce distinct cultural values which feed directly into the formation of taste groups for the broader consumer culture. The editors provide the advertisers with an appropriate visual environment within which they can insert their own copy. So the visual pleasures of the fashion pages are actually used indirectly to sell other products such as perfume, make up, shoes, bags, in fact all the goods whose market size allows them to pay for expensive advertising space. And, once again, the fashion industry, particularly the small, independent British fashion design industry comes off worse. As far as fashion is concerned it is difficult to avoid coming to a Baudrillardian conclusion about the economy of the image replacing and even negating the economy of the actual product (Baudrillard 1988: 166). But the apparent imbalance which exists between the success of British fashion as an image industry, and fashion design as a straggling, crisis-ridden sector, can also be explained in more sociological terms. There are two interlocking economic circuits in operation in this field, one belongs to the ever expanding world of the image and of visual culture, to which vast numbers of people have access at relatively little cost, while the other belongs to the world of making things and selling them within a highly competitive market, where small producers (that is, the designers) find it almost impossible to sell their clothes cheap enough to attract a wider section of the market (because of the power of the big retailers and the numerous agents in the fashion chain who each take their

cut). The balance is tilted in favour of the fashion media which is not just a pub-
licity machine for the designers (a selective one at that) but also, in effect, a
market in its own right, a first port of call for up-and-coming designers. This pic-
ture is complicated further by the role of the image industries as a *de facto* market
for the designers, anxious to establish a name for themselves independent of, or
prior to sales.

However, with all these advantages the fashion media remain none the less
unadventurous and trapped in a format which came into being when fashion was
an exclusively female and 'society', or upper-class, interest. The history of *Vogue*
magazine reveals a lineage of *grande dame* editors most of whom were unashamedly
élitist in their desire to create a luxury magazine for well-to-do readers. These edi-
tors did a great deal to bring fashion design into prominence as an art. They
achieved this partly by treating key fashion designers as creative geniuses; they
also provided the space in which fashion photography was able to establish itself
and this, too, was celebrated as a branch of modern art. Since then this tradition
has been taken as the canon of fashion journalism. The editor of *Vogue* magazine
occupies the best seat at all the shows and her power and influence are undis-
puted. Because fashion feels itself to occupy an inferior place in high culture and
also in the world of serious journalism, and because it does not really want to be
associated with mass culture, (in just the same way as it does it utmost to disso-
ciate itself from mass production), this creates an inward-looking and culturally
isolated group of fashion media professionals who seem to belong to a time when
politics did not intrude upon the world of fashion and when fashion people had
no need to dirty their hands with what went on in the outside world. There are
residues of this kind of thinking across the fashion media, in particular an insis-
tence on the irrelevance of social or political issues. This is expressed in different
ways according to the different media. For example, while I am sure that Sheryl
Garrett, the editor of *The Face*, would recognise the importance of sexual politics
in fashion, (including those which involve work and employment), and while
Edward Enninful of i-D as a young Ghanaian living in Britain, would, like
Garrett, want to bring to bear some elements of contemporary political reality on
the magazines, these can only be conceived of as gestures of style and they can
never take the form of a social analysis. Everything within these magazines has to
be translated into a kind of secret, insider knowledge about what is 'cool' and
'hip' to which only they, as editors and journalists, have access and which they
can then sell to the big companies in exchange for valuable advertising revenue
by providing them with knowledge of 'the street' and of black youth culture and
urban life.

In the more mainstream women's fashion magazines there is an even stronger
reliance upon tradition. Fashion writing is informative or celebratory, it is never
critical, only mildly ironical. Nowhere does it ever touch upon some of the most
important dynamics in contemporary British fashion which hinge around fashion
as a place of work and as a space of livelihoods. The editors and journalists rarely
break ranks and produce more engaged and challenging writing on this subject.

This, in turn, keeps them isolated and away from those policy makers and politicians who are anxious to see the fashion industry become more stable and more profitable and give a better return on the investment made in education and training. The fashion media thus secures the marginalised, trivial image of fashion as though it cannot be bothered to take itself seriously or to consider its own conditions of existence. The excuse is invariably that this kind of material frightens both readers and advertisers. Yet, as women and girls become more highly educated and as the fashion sector is increasingly recognised as an important part of the national economy, this seems like an increasingly ill-considered stance. It only serves to keep fashion journalism in the ghetto of femininity, whilst in almost every other sector of public life femininity and gender issues are increasingly coming to occupy the political centre stage.

11

LIVELIHOODS IN FASHION

'MERELY EMPIRICAL'?

It has been difficult to find a single, over-arching, theoretical framework from within existing scholarship which would comfortably contain this current study of work and livelihoods in fashion. Creative labour has been overlooked in media and cultural studies in recent years to the point that almost everything but work has been the subject of extensive attention. One exception to this is Garnham's study of the culture industries, where he briefly considers that aspect of the culture industry labour market which has figured most prominently here – the freelance, 'independent', creative young workers willing to work long hours for low, sometimes no, pay (Garnham 1987). Deploying a conventional Marxist vocabulary, he sees this phenomenon as the ultimate sign of the triumph of contemporary capitalism which is able to milk the talent of young people, getting them to shoulder all the risks without even offering them a proper job or contract: 'Often labour is not waged at all, but labour power is rented out for a royalty'. He continues: '. . . the workers willingly themselves don this yoke in the name of freedom' (Garnham 1987: 33). While Garnham is absolutely right to see this no pay economy as a product of deregulation and sub-contracting in the increasingly competitive culture industries, where capital manages to unburden itself of everything except a minimum responsibility to labour, my emphasis here is in examining these types of working practice in more detail. With references being made to the idea of working unpaid for 'experience' and for 'exposure' at almost every point in the fashion field, I question why this happens. What Garnham sees as a regrettable feature of the inexorable processes of capitalism, I consider as an integral, emergent (if also regrettable) but by now, in the late 1990s, an almost predictable feature of the working practices of cultural capitalism. If Fredric Jameson has examined at length the products of such a system, the flickering images dispatched across the globe, one of the aims here has been to untangle some of the complicated features of the labour and production processes which underpin this creative economy(Jameson 1984).

When we look at contemporary sociological writing, very little attention is paid to the kind of work I have examined here. At the same time, all the major social

theorists indicate how changes in work and employment are among the most sig-
nificant features of the current social transformation. I have already drawn on
some of this work – from Beck's notion of 'risk work' and Giddens' account of
'uncertain futures', from Lash and Urry's 'aesthetic reflexivity' to Giddens' (again)
'reflexive modernity'. These conceptions have, in the absence of more concrete
studies, at least assured me that the field of activity with which I have been con-
cerned corresponds in some respects to broader social movements. However, there
are problems with the fact that these debates about whether we are in a state of
late modernity, reflexive modernity or postmodernity, are typically pitched at such
a general level. As David Morley has recently argued, quoting Doreen Massey, the
effect of such large scale, macro-social analysis is that it implicitly locates the local,
case study or the detailed field work study as 'merely empirical' (Morley 1997:
126). This raises questions for the current study. What is its theoretical status?
What can be drawn from a small-scale case study of a strata of creative workers
in one particular corner of the fashion industry? Can we legitimately move from
the frame of the case study to the bigger frame marking the field of cultural pro-
duction? Or do the sheer peculiarities of fashion in Britain restrict such a move?
Is fashion exemplary or exceptional? It depends of course on what we are com-
paring it with, which in turn raises the question of the relationship, if any,
between the various component parts of the culture industries. If, as I would
argue, it is more exceptional than exemplary then this inevitably accounts for
some of the difficulties entailed in moving outwards to other fields for compar-
ative purposes. But this too might be a telling feature of the new culture
industries; can we really compare advertising with fashion or independent televi-
sion production? Likewise, many commentators might say the same thing about
the music industry; that it is so peculiar, so talent-driven, so fragmented and
casual, that it would be virtually impossible to compare it with other culture
industries and, as a result, it is typically considered sociologically, as a separate
thing (Negus 1992).

A second problem with current social and cultural theory is that the concern is
with totalities, with grand social and epochal shifts. Even Foucauldian accounts,
which tend to be interested in more detailed or micro-political practices, tend to
focus on the broad convergence of particular discourses and how these add up to
an accumulation of power and regulation through 'subjectivising processes'. In
both cases, this 'heavy analysis' leads to a weightiness of even weak structures and
consequently a sense of the sheer difficulty of opposing or countering such
processes. This, in turn, produces a rhetoric of pessimism or, with writers like
Giddens, a sense of wonder and suspension of judgement at the energy and speed
of the new knowledge-based and skill-intensive systems of 'reflexive accumula-
tion'. This produces a perceived need for political realignment which, in the
context of 'uncertain futures' is appropriately 'beyond left and right' (Giddens
1995).

The aim of this current study of the British fashion industry is to attempt, on
a modest scale, to eliminate some of this uncertainty through sociological inves-

tigation by showing how working futures are currently being made in this sector. However, the advantages of detailed analysis of a sector such as this is that it offers the opportunity to observe just how peculiar it is and the extent to which it does not fit within existing sociological accounts of work. This form of *cultural capitalism* is led by art school trained designer-entrepreneurs who, by and large express little, if any, real interest in the dynamics of wealth creation and business. They work according to a different set of principles which are about artistic integrity, creative success, recognition, approval by the art establishment and then, also almost as an afterthought, sales and markets. This raises more questions than it is possible to answer here – for example, are these workers between capital and labour or virtually beyond capital and labour in so far as that duality cannot really account for their position and their activities. In the past we might have said they were simply artists, but as I have already indicated, there are a lot more of them than there used to be and, as other jobs decline, art work becomes less the exception and more the norm, which in itself requires some degree of reconceptualisation.

To an extent this book follows David Harvey who, recognising the problems of assuming a wholesale shift in working practices, none the less argues that, 'it is equally dangerous to pretend that nothing has changed, when the facts of deindustrialisation . . . of more flexible manning practices and labour markets, of automation and product innovation, stare most workers in the face' (Harvey 1989: 191). I would add to this that for first time entrants into the labour market, such as the designers I interviewed, two important factors must be taken into account: first, that they have nothing with which to compare their experience in fashion design, apart from their 'work experience' placements, so their taste of a working life is actually being forged along new lines where they are actually being expected to make a job for themselves; and second, that this marrying of youth and flexibility in the name of 'independence', 'art' and 'enterprise' represents a crucial feature of the process of deindustrialisation, to a generation who will have known nothing other than this kind of work.

Is this a postmodern cultural economy to the extent that it cavalierly combines old and new, in particular pre-modern, practices in the form of knitting and sewing, along with the very modern idea of the creative artist who, following Raymond Williams, rejects industrialism in favour of romanticism (Williams 1958)? And if both these features are then incorporated within a field in which there is 'a prodigious expansion of culture throughout the social realm' so that culture 'cleaves almost too close to the skin of the economic to be stripped off' (Jameson, quoted by Kumar 1995: 116), then could it be argued that the concept of postmodernity as defined here by Jameson does indeed have a role to play in this account? This dimension in the fashion industry is most evident in the dominance of the fashion image over its object. The voracious appetite of the image industry means that while the fashion media plays an important role in shaping and fuelling demand, there is also a sense in which they exist and function quite independently of the world of fashion consumption. For the magazines

it is enough that people consume the images. So great is the disparity between the rapid circulation of images and the much slower volume of sales of the clothes themselves, that sometimes it seems that the clothes need hardly exist in reality. They are more 'real' as images on the page than as items of clothing in the wardrobe. Almost inevitably this gives rise to the kind of scenario described by Baudrillard in which the economy of the image exists independently of the economy of the objects represented by the images (Baudrillard 1988: 166). As regards fashion, it seems that Baudrillard's prognosis may well be right – there is an enormous chasm between looking and consuming, with what is purchased bearing little relation to the consumption of the image. This means in a nutshell that fashion culture is as much about looking as it is about wearing and this is nowhere better demonstrated than in the existence of the two separate but interlocking circuits of the image and the object.

In labour markets, too, we see signs of the kinds of shift described by David Harvey and attributed by him to the emergence of a postmodern condition. In the world of fashion journalism as well as in design the same casual, short term and freelance patterns of work are dominant. The journalists and image makers as well as the designers all survive within a series of urban-based cottage industries whose characters might also be described as postmodern, precisely in the ununiform, mixed modes of production which are distinctive in combining old sweatshop or rag trade elements (Grub Street for the journalists) with what Harvey has described as 'new survival strategies for the unemployed', with the added factor that the unemployed in this case are graduates from a diversity of social backgrounds (Harvey 1989: 153). Working in fashion comprises a series of 'temporary contracts' and as this becomes the norm it gives rise to a number of social consequences including financial insecurity, under-insurance and an enormous potential for self-exploitation.

More concretely the focus in this book is on a particular set of social and economic relationships which achieved visibility and importance in Britain in the 1980s and into the 1990s. These are the product of the expansion in the training and education of fashion designers in the British art school system, and their subsequent entrance into a United Kingdom labour market, which was itself undergoing dramatic transformations before and during this period. Of key significance was the increasing 'new right' emphasis by the Thatcher government on enterprise culture and on the virtue of self reliance in a world where traditional 'jobs for life' were fast disappearing to be replaced by new kinds of jobs and, equally important, new social relations of work. Self-employment of the type and on the scale I describe effects a number of transformations in one sweeping movement: it 'individuates' the experience of work, by uncoupling it from the everyday vocabulary of trade union membership or other forms of collective organisation or representation. However, as we have seen, this movement is significantly tempered or offset by the connotations of art and creativity which are now less exclusively attached to the working practices of fine artists and have spread more widely to include those working in a spectrum of design and related

fields on a self-employed, freelance or fully employed basis. (Even hairdressers these days are keen to promote their own creative identities by holding exhibitions of contemporary art on the premises, with the work mounted alongside the washbasins.) So the desocialising impetus of self-employment is accompanied in this case by an additional current of change which brings art work within the realms of possibility for more than just a tiny élite. At the same time the attractive image of marrying paid work with personal creativity is also seen as a type of hidden or invisible labour disciplining. By remaining freelance or self-employed, the designers who might be working most of the time for some of the large fashion companies can none the less be assured that they have not completely sold out, they are still 'independent' while, in practice, they are part of a growing army of contracted-out workers. Art thus serves a double function. It both protects them against failure when times are hard as Bourdieu has shown, and it gives them the incentive to work even harder, in an unambiguously commercial capacity, on the basis that what they are doing now counts as creative work. These are simply some of the complexities which arise when what was once a narrowly privileged and charismatic field of culture enters into the mainstream of society and begins to shape its labour markets.

One way of seeing this is as part of a wider process described as the 'aestheticisation of everyday life' (Lash and Urry 1994). Although this general trend is widely recognised by social and cultural theorists, the extent to which it has also penetrated the world of work has been overlooked. But work too has become 'aesthetic' and through this it becomes an anticipated source of pleasure and self-realisation. While most sociologists have considered this aestheticising process from the viewpoint of consumers, I have considered it here exclusively from the perspectives of the producers. The image of the romantic artist now underlies the practice of a wide range of cultural professionals, from the art directors of the advertising world juggling million pound budgets, to the independent fashion designers whose micro-economies are much closer to that of the traditional image of the 'starving artist'. None the less, both these types of cultural workers share an urban, and possibly London-based working environment, they each consider themselves highly creative and they frequently connect through the various chains of communication which find, for example, a designer like Rachel F. providing one of her dresses as an accessory for an expensive advertising shoot and the resulting exposure of the dress in the advertisement creating an increase in her orders by a hundredfold.

In such a seemingly disorganised creative economy, contingency and even serendipity provide unexpected windfalls and opportunities as well as subjecting the workforce to stress and anxiety through the sheer fickleness of fortunes. The young designer will help out a photographer doing a test shoot in the hope of gaining regular work, by providing a number of fashion pieces and by helping him or her organise the shoot for free. It may or may not pay off in other ways. If the test series is published the rewards are potentially high, the designer might find herself 'known' as a name or a label virtually overnight. If it is not used, it

is time and money invested to no effect. These kinds of associations have been described as 'transaction-rich networks of firms' by writers who have looked at the post-Fordist small producers of the so-called Third Italy (quoted in Lash and Urry 1994: 114). In the specific context of the London designers it conforms more to what Lash and Urry describe as a 'transaction rich nexus of individuals' (ibid.: 115).

The extensiveness of this kind of work is suggestive of a new, urban, postindustrial system. On the basis of the study conducted here it is impossible to state with precision just how exemplary fashion is in the new economy of culture, and how extensive this new economy is more generally. However, we can draw out some elements of working in fashion design which appear to have a wider currency in the culture industries as a whole. As we have seen, the freelance or self-employed status of most of these cultural workers, while based on the traditional principles of artistic individualism, also gives rise to new forms of team-based work. Informal relations of dependency and reciprocity emerge both within specific sectors (designers often form partnerships as 'design duos') or across different parts of the cultural field (stylists often team up with photographers, models and fashion designers). Self-employment agencies of the type mentioned earlier (the Z Agency, for example, managed by Paul Davies) are a further example of how this kind of work generates new employment opportunities as well as new ways of working. 'Creative labour' is not quite as isolated as it might seem but there is as yet no theoretical or political analysis which would provide the basis for a more effective structure for co-operation and collaboration.

The most significant and, indeed, I would argue the dominant features of 'creative labour' in fashion are: first, the frenetic level of movement; second, the 'mixed economy' where, as a norm, the designers actually do two or three jobs at once; third, the peculiar mix of not just old and new, but pre-modern, modern and postmodern features of production coexisting in the same shared space and time of the urban 'studio-workshop'; and, fourth, the persistent downgrading of the skills of making and sewing. Just as few of the designers originally interviewed for this book would be doing exactly the same kind of work if I were to track them down today, just two or three years later, so almost all the magazine and media personnel have moved on since they were interviewed. Inquiries made on both fronts before writing this conclusion revealed an increasing shift towards freelance work for both designers and journalists alike. This may indicate that the small businesses which most of the designers had set up and run at some point in their brief careers were, in fact, transitional structures, (not unusual in the culture industries according to Lash and Urry – small television production companies frequently only last as long as a couple of features). Far from being outright failures we might view them instead as playing a central role in establishing fashion design skills and reputations. They were largely unsustainable because the designers found it difficult to raise the bank loans necessary to avoid cash-flow problems. But this means that the structures of the new fashion industry, the one-woman businesses, are also temporary 'portacabins'. The 'mixed

economy' represents a second stage whereby 'freelancing around' the designers could, ironically perhaps, achieve some degree of financial stability while at the same time planning to relaunch their 'own label'. And finally, despite their protestations, in their day-to-day practice they were in fact practising the most traditional of feminine pursuits (hand knitting and sewing) under the label of being artists, in the more contemporary context of being career-oriented young women, not untouched by feminism, and determined to make a living for themselves in a way they found enjoyable.

THREE SITES IN THE CIRCUIT OF FASHION

Let me recap. My analysis of the place of fashion design in the British art school system reveals a downgraded status as a result of a double stigma. Historically its associations were and have been with a trade or dressmaking tradition and also with a field designated as women's work. Fashion design attempts to undo these associations by defining itself as more than a branch of the decorative arts and more than a lesser form of sketching and drawing. Institutionally, this struggle was conducted in the fashion departments of the art schools by a number of women pioneers in fashion design education who persevered in attempting to convince the rigid and male-dominated hierarchies about the fine art value of their creative practice. This is achieved unevenly and uncertainly but through these various strategies fashion design does eventually find itself established and validated as a degree level subject in almost every art school throughout the country. This achievement provides the foundation for the distinctive character of British fashion design. Unlike the *haute couture* tradition in Europe which is based in the commercially run but exclusively marketed 'houses' of Paris or Milan, where a traditional apprenticeship system remains in place, British fashion design carries all the high cultural capital of the art academy. Its graduates are educated within a system which considers itself to have élite status and which emphasises the necessary integration of fine art and design. Although in recent years this has been expanded to encompass business and marketing components, it is the traditional image of the artist which remains the most visible sign of an art education.

However, this ethos creates a lasting tension for British fashion designers. To achieve the status it required within the academy it was necessary for fashion design to separate itself, not just from dressmaking and the rag trade, but also from the world of what was first known as mass culture but which later came to be referred to as popular culture. As Huyssen argued, it was part of the project of modernism in the arts to repudiate the debased and 'feminine' nature of mass culture (Huyssen 1986). This movement was seen in the British art schools as they embraced the principles of artistic modernism and, in so doing, denounced the 'fashion girls'. From the fashion departments it could be argued that the fashion girls, with nothing to lose, did some of the groundwork of early

postmodernism by going out and making links with the burgeoning pop culture of the 1960s. British fashion design is, as a result, more indebted to figures such as Mary Quant, Biba and the late Ossie Clark than it is to the fine art professors who eventually and often reluctantly recognised its value. And yet, despite this fruitful, indeed historic, relationship between art school-trained graduates in fashion design and the more commercial world of popular culture, fashion academics have themselves held back in acknowledging this important relationship. This is because their own status in the art schools hinges upon their adhering to and endorsing the dominant values of artistic modernism which still prevail in these institutions.

In this context, postmodernism has a recognised existence not in the sense that it marks the breaking down of the 'old divide' between high art and mass culture but as an art movement which picks upon and references the world of popular culture by integrating it into otherwise contained contemporary works of art. In other words, the outside world of everyday life and popular culture can only be brought into the art school as a conceptual category, a point of reference, a 'sign of the street'. This leaves more or less intact the professional and modernist-inspired vocabularies of fashion education whose proponents still feel themselves too close to the street (a synonym here for popular culture, for femininity and, of course, for trade) to be able to fully welcome this presence in any form other than a quoted reference in a self-contained work (or collection). This is understandable from the point of view of those who have struggled so long for fashion to be recognised as a legitimate branch of art and design, but my argument in this book has been to suggest that this now needs to be revised. Fashion in the art school could benefit not only from the critique of modernism, but also from the sociological 'defence' of postmodernism as a popularising, feminine, boundary-breaking practice.

Fashion design in Britain exists in a milieu largely defined by the values of popular, rather than high, culture. The image industries which give fashion design its main exposure may still rely on the traditionally élitist values of *Vogue* magazine in terms of emulating its focus on luxury consumption, but the magazines and other fashion media (including the immensely successful BBC television's *The Clothes Show* programme) are aimed at attracting as wide an audience as possible and all present fashion as part of the broad span of popular culture which includes pop music and entertainment as well as the more traditional field of female leisure interests. Even when fashion achieves an existence within the arts, as illustrated in the London Weekend Television programme *The South Bank Show* devoted to the work of John Galliano (LWT 1996), this is not because the senior echelons of the art academy and the art establishment have fully and unequivocally pronounced fashion design as equal to and an honoured part of the fine art tradition, but rather because of the mixing and blurring of boundaries which has occured outside these hallowed halls in other much less privileged and often commercial social sites and spaces including those inhabited by young people. As I have already said, there remains a degree of vagueness about the precise institu-

tional and historical underpinnings of the so-called 'aestheticisation of culture' (Jameson 1984) or the 'aestheticisation of everyday life' (Featherstone 1991; Lash and Urry 1994) and the way in which this has entailed a breaking down of the old distinctions between high culture and popular culture, but fashion has arguably played a key role in this process. As the arts institutions, including galleries and museums, have been forced to open themselves up more fully to market forces and attract wider audiences, so the more stuffy world of the high arts has been challenged from a variety of fronts. The expansion of the media has provided more space for arts and culture pages and programmes and alongside this there has been enormous growth in both the production and the consumption of various forms of culture. Fashion design fits into these developments in a number of different ways: the history of fashion, as well as the history of fashion photography, now finds itself the subject of gallery exhibitions and retrospectives; the young designers showing their work at degree shows are treated by the press and television companies in the same respectful tones as their counterparts in fine art; and knowledge of, and familiarity with, fashion design culture has entered into a more popular vernacular and has become something that almost everybody knows something about. It is the stuff of television news bulletins (such as stories like 'Alexander McQueen's "bumster" trousers cause a stir in Paris'), celebrity designers appear in the gossip columns at the same time as their work is described as the work of genius, and the talent of Britain's fashion designers becomes a source of national pride as the Prime Minister recently wrote in the *Guardian* (Blair 1997: 17).

All these characteristics can be seen as part of this process by which the categories of art and culture become mixed through a combination of commercial and other factors (including niche strategies of taste and distinction) and as the 'feminine' is revalued in response to feminist pressure and as 'women' represent an increasingly significant market for these forms of cultural or symbolic consumption. While the young designers who are at the mercy of the commercial world in order to earn a living are reliant on this popularising process, the art academics hold back, as though such processes in some way threaten the field of their own expertise. In contrast to this approach, I suggest that fashion education would benefit its students by addressing fashion's existence more fully not just as an art and design practice but as a place of many people's livelihoods, a place of sewing as well as sketching, and as a new kind of rag trade whose rhythms and dynamics rely upon the expansive fields of youth culture and popular culture.

In chapters 5 to 9, I describe a distinct and even idiosyncratic micro-economy of fashion design. Its influence is formidable and its failure to capitalise on this influence is all the more disappointing. Many of the fashion themes and currents which inform the big European *haute couture* collections quite blatantly borrow or 'steal' ideas first seen in the small London outlets of British fashion designers. Many European designers openly admit that they send their fashion scouts to scour the London stalls, shops and clubs for new ideas. There is little doubt that it is in the experimental 'funhouse' of the British youth culture and club culture

scene, in and around the art schools, in young graduates' studios and in the small units, shops and stall-type outlets which they supply, that the creative work which influences major fashion trends emerge. Not only does this activity put Britain at the forefront of fashion design in much the same way as pop music and advertising are also recognised as world leaders in their 'design intensivity' (as Lash and Urry (1994) put it), but, as I have argued elsewhere, this group activity points to a social, collective or perhaps subcultural base for what is at a later stage attributed by the press and media to individual designers (McRobbie 1989, 1994).

A political economy of fashion design suggests that it is within these informal micro-economies that the experimental groundwork is done at little or no cost to the bigger companies, for whom the bankruptcies and business failures of these small fish are of no concern. In this book I have attempted both to analyse the working practices of these small-scale producers and to find ways of securing their place in the new cultural economy. These are, after all, forms of 'job creation' and while it is explicitly not my intention to reduce these to the idea of talent ('This is where the talent is' as the British dominance in pop music was explained to Lash and Urry), simple choice, or unconstrained agency on the part of the designers (in the 'Just Do It' style of Nike advertisements), but rather as the product of a strategy of government, none the less the process of creating jobs out of very little ('jobs without capital') is of some sociological significance. It is both planned through 'enterprise culture' and completely unplanned in its cultural outcome, the signs of which stretch across the urban landscape, bringing colour and vitality to run down, deindustrialised sites and spaces. Despite the wider political interest in 'job creation' it is remarkable how little attention has been paid by sociologists to these practices and how they can be made more stable – how they can find a stronger economic foundation.

Whilst I have argued that the precise contours of the market for clothes produced by British designers and sold in various national and international outlets raise a number of difficulties (as illustrated in chapter 9), there is no suggestion that there is no market. Distribution and cash-flow are recurrent problems across the cultural sector and fashion is no exception. In fashion, late payment or the late delivery of an order from the producers can see the designers plunge into debt beyond the point at which the banks will continue to underwrite their borrowing. They have to serve too many masters at one time and as young and relatively inexperienced graduates they are frequently not able to manage these demands. However, there is little evidence to suggest that not enough people want to buy their clothes. Customers may be few but they are not the primary problem. Likewise, if we look across the range of designers interviewed for this book, none indicated that they were forced out of business because of poor sales. While pricing policies may have played some role in the problems faced by Yvette M. and Lisa R. they were none the less rarely left with unsold stock. Instead they faced disaster with wrongly made up orders which had to be returned. It seems then that it is neither the design work itself nor the absence of customers which is the

problem and, consequently, it cannot be claimed that the problems in the industry lie in the unrealistically creative work of the designers. Instead, we must look at the other weaknesses in the chains which connect the designers with both their suppliers and their consumers. These difficulties might, for example, be overcome by the designers working more closely with producers and employing machinists and others on a direct, rather than a subcontractual, basis. With some input from government funding, designers could pool their resources and turn the informal networks which exist between them into a more fully socialised field embracing every stage from design and production to marketing, promotion and even to (relatively cheaper) sales.

In chapter 10 I argue that the role played by the press and the magazine industry was, on first impressions, supportive of British fashion design in so far as these publications promoted the sector by displaying the work and by subscribing to a broadly promotional vocabulary. However, on closer inspection, a number of more problematic features reveal themselves and these are detrimental to the more successful development of British fashion design. Some involve the distinctive forms and codes of fashion journalism and its photographic conventions and also the broader political economy of the magazines. Briefly put, given their commitment to innovation, these media have the space and the opportunity to break some of these 'rules', but instead they continue to present fashion design as a cultural phenomenon which is somehow trapped in its own traditions. It therefore remains framed on the page and, ironically, frozen in time. As a visual field it is as aloof and distant from the messy business of earning a living as the expressions on the faces of the models on the pages. The magazine editors could be more adventurous and include regular documentation on fashion as a place of work and employment and, more broadly, on the politics of fashion and clothing, gaining recognition from the rest of the 'quality' media and acquiring more readers in the process. But the deeper problem lies in the fashion media working to a rhythm other than that dictated by fashion sales. It is their own sales and circulation figures which really matter and this means that fashion items, indeed fashion culture, is image-driven rather than object-driven. The clothes which they decide to use for the pages are virtually props for their own creative labour and recognition of this fact forces some revision of my original proposition that the media is a pillar of support for fashion design. It indicates that this model works, but only to an extent. The designers need the fashion media, but the fashion media does not need every single one of them. Once again this relation of dislocation is in the order of complexity that we might expect when two such worlds, that of localised design practice and that of global media corporations, exist in close proximity to each other.

'I WAS KNITTING AWAY NIGHT AND DAY': CREATIVE LABOUR AND THE CHANGING WORLD OF WORK

This book, like the fashion industry it describes, bears traces of theories past, present and future, in its attempt to make sense and draw some conclusions about a place of work, which somehow stands at the very cusp of social change. It offers no single argument but instead a 'tapestry' of argumentation. I also want to defend the theoretical eclecticism as an appropriate intellectual strategy in the context of a study which has been in many ways exploratory. The emphasis in recent cultural and social theory has gone so far in the direction of mapping global totalities and movements and charting discursive convergences in the creation of new forms of selfhood, 'self steering mechanisms' as Rose (1997) has recently described these, that it is hard to see any kind of easy fit between 'top down' theory and 'ground up' documentation and analysis which does not explain the latter in terms of the former. If anything, I use the 'ground up' analysis to qualify some of the certainties proposed in theoretical work, and to note the kind of slippages and small changes which, over a period of time, at least interrupt the passages of power and the apparently smooth processes of 'self management'. And so it is on a note of openness and uncertainty, with a glance in the direction of policy and intervention, that I wish to conclude this book.

Past theories, which some might argue are now past their sell-by date, remain a haunting presence throughout this book. Inevitably, perhaps, the legacy of Marxism makes a necessary and valuable contribution. It will not have escaped us that the very idea of revealing the productive base and the 'hidden hands' which remain a vital part of the fashion process, but which the world of consumer culture is anxious to conceal, takes us right back to the very premises of historical materialism; the exploitative relation between labour and capital, hidden by the laws of the market and overshadowed by the seductive presence of the commodity. But whether the commodity is a fashion object or a fashion image, this book shows similar conditions of labour prevailing. These are all casual workers, part of the same creative workforce and sharing the same perilous conditions. It is surprising that amongst the most significant contributions to the post-Marxist debates on culture, none, from Baudrillard to Jameson, asks the question, who makes the images? Bourdieu does, but slots his art workers into a cultural map which simply does not fit with the fluidity and cultural crossovers of working life in contemporary Britain. He sees the 'cultural intermediaries' as members of the sunken middle classes eking out a living for themselves by discovering a kind of creative niche, as yet relatively undesignated, into which they can bring their own personal skills and social capital. While he comments upon the flow of women into this category, gender remains only a sub-category of his overall picture of class hierarchies. Whilst the precise class position of the designers considered here is beyond the scope of this book, it is wrong to see them as fitting unproblematically into this rather rigid petit bour-

geois strata. And yet their occupational identities, and the fact that they are all graduates with the quasi-professional status of the designer, mean that they disregarded or disavowed those skills associated with the more menial side of fashion, manufacture and production so, to an extent, they reproduce some of the most traditional of class divides in their own working practice. They want to believe that they are above manual labour. Against this I argue for the dressmaking dimension to be retrieved, revalued and recognised in fashion culture, and also for these new 'rag trade' characteristics to be introduced into debates on the future of the fashion industry.

The 'memory' of Marxism is also apparent in the desire, on my part, to see the determination of young women fashion designers to transform the world of work into something more than a life of drudgery and routine, as more than an index of the success of the 'subjectivising discourses' of new governmental rationalities of labour discipline. There is a history in this Utopian repudiation of what used to be known as the 'factory clock', and it is not inconceivable that these discursive fragments, more possibly those of William Morris (described by Williams as searching for 'delight in work') than Jacques Ranciere ('proletarian nights'), have found their way into the field of references which construct the new space of practice for creative labour (Morris, quoted in Williams 1958: 154, Ranciere 1981: 10–13). There is also that appropriation of entitlement to privileges and rewards such as pleasure in work which in the past has been the prerogative, indeed the considered right, of the few. The fashion designers whose work I describe are from a range of social backgrounds, working class and middle class, black, white and mixed race. Their occupational identities are, yes, in part the product of the expansion of post-war British education provision, which has seen, at least in recent years, some movement of young people from a range of different backgrounds into the art schools (often through the BTEC route), and they are also newly arrived professionals whose work emerges from a backdrop of unemployment and is in itself a form of 'job creation'. So this work bears the traces of much of the history of post-war British society, the history of girls' education in the art schools, popular culture, Mrs Thatcher's enterprise culture, punk's do-it-yourself job creation schemes and finally the determination of young women to find work which is satisfying to them. Despite their disavowal of the production elements of fashion, their 'dream of social flying', as Bourdieu puts it, does not put them, once and for all, on the other side of the fence from traditional 'labour'. This is not the traditional, class-disloyal petit bourgeois fraction of French society described by Bourdieu, whose conservatism plays some role in his pessimistic and over rigid analysis. These young women actually seem far removed from the cultural intermediaries described by Bourdieu. If their mothers were denied access in the past to work of their choice, they are now pushing their way into a labour market by creating their own. As one girl said, 'My mother has always had to take jobs she didn't enjoy, and she's the one who has encouraged me. . . . They (her parents) even extended the loft at home so I could have it as a studio' (Gaby T.). This suggests not so much a dream of escaping into

the middle classes as a reproduction of a dislocated and fluid working-class family value system.

So here we have a further 'memory of Marxism' in my analysis which posits that, throughout the long years of Thatcherism in Britain, her enterprising rhetoric and her transformative programme did not exist and were not implemented uncontested and in isolation. Nor were they as internally consistent and coherent as they might have appeared at the time. They were unevenly implemented and possibly also subverted in the process, continually 'turned around' by social and historical 'subjects' who had some capacity to re-deflect or redesignate or simply bring to bear other elements (including those of their own families and communities) on their cultural practice. In this respect '(G)overnment is a congenitally failing operation' (to quote Du Gay drawing on Miller and Rose again (Du Gay 1991: 58). It is a mark of this 'failure' (or at least ambivalent outcome) that enterprise culture has produced a series of unanticipated consequences, subjects who are not the champions of the 'free enterprise' favoured by Mrs Thatcher, but as far as this book is concerned, Left-leaning young women who are more likely to look to the politics of New Labour.

Two further points must be made, one which connects with that 'memory of Marxism', the other which breaks with it. As I argued earlier, even the 'individuation' of creative labour or 'art work' is not a fixed and unchangeable feature. The designers interviewed were actively seeking new ways of association – the problem was that they could not see clearly how this could be achieved and were far too busy trying to stay in business to stand back objectively and look at the whole industry as they were experiencing it. They show few of the signs of rampant individualism or hard competitiveness associated with Thatcher's Britain, suggesting that the ethos of self-reliance is by no means written in stone. None of the designers interviewed were big earners, even the more successful ones. They represent instead a new kind of woman worker, highly qualified (and traditionally this would have made them 'middle class') but subject to great financial insecurity and instability in employment, to the point that most are unable to consider taking time off to have children. The necessity of co-operation and collaboration on a whole range of issues relating to their livelihoods seems inevitable. This is precisely why I have used the term a 'new kind of rag trade'.

Where the word 'proletarianisation' falls well short of the process which I am describing, and while Bourdieu's notion of the cultural intermediaries as 'proletaroid intelligentsia' is even more unwieldy (Bourdieu 1993b), nobody can dispute that this kind of livelihood will and does already imply long hours, unpredictable returns, tough competition from bigger companies and retailers. It means being multi-skilled in hand work, design work, publicity and promotions, management and business and having some idea of manufacture, as well as being in possession of creative vision, imagination and all the other qualities associated with fashion design. These new kinds of workers are posed midway between labour and capital, doing the job of both at the same time. This means that, and this is the second point, the re-socialisation of creative or cultural work including

fashion design, which is not unimaginable, will not and could not mark a return to the organisational forms of 'old labour' but require instead a more imaginative leap, one which has to take into account the fragility of cultural entrepreneurialism and the reality of self-employment. This then is the political challenge, beyond the scope of this book, which is to envisage new forms of collaboration and co-operation (and also social insurance) which reflect the creative, unstable, experimental and fluid patterns of work in fashion.

NOTES

1 FASHION DESIGN AND CULTURAL PRODUCTION

1 The *Guardian* 24 June 1997 reported statistics prepared by the British Fashion Council which indicated a decline in first destination self-employment among fashion graduates from 15 per cent in 1994 to 8 per cent in 1996. There was a corresponding rise in take up of full-time jobs in the fashion industry from 45 per cent in 1994 to 62 per cent in 1996. However, these figures included graduates in fashion marketing and journalism, as well as the whole range of fashion design graduates. In contrast, this current study considers primarily those students trained in what I label 'conceptual fashion'.

3 THE FASHION GIRLS AND THE PAINTING BOYS

1 Course Documentation (1991), available from the offices of the Council for National Academic Awards (CNAA), London.
2 Ibid., (1986).
3 Access was gained to the Association of Heads of Department of Fashion and Textiles through the offices of the CNAA. I attended a number of the association's meetings, undertook preliminary work for a review and the interviews were carried out throughout this period.
4 See note 1, above (1986).
5 Ibid.,(1988).
6 Ibid.
7 Ibid., (1987).
8 English Eccentrics is also, as it happens, the name of a design label which will be considered in chapter 7.
9 Course Documentation (1986), available from the offices of the Council for National Academic Awards (CNAA), London.
10 Ibid., (1989).
11 *House*, winner of the 1993 Turner prize, was a concrete cast of a house erected as a piece of sculpture by Rachel Whiteread in London's East End. It attracted a good deal of publicity, much of it hostile – see N. Couldry (1995) 'Speaking Up in A Public Place: The Strange Case of Rachel Whiteread's House', pp. 96–113.

4 FASHION EDUCATION, TRADE AND INDUSTRY

1 Course documentation available from CNAA (1987).
2 Ibid., (1987).
3 Ibid., (1986).
4 Ibid., (1987).

5 When Stella McCartney (daughter of Paul McCartney) was appointed as designer for the Chloé label in Paris (16 April 1997), one press report quoted a fellow student who remarked on how, despite her enormous personal wealth, Stella McCartney would do all her own sewing.

6 All the quotations above are taken from a range of degree show catalogues which provide brief synopses of the graduating students' work with their own accompanying statements.

5 WHAT KIND OF INDUSTRY? FROM GETTING STARTED TO GOING BUST

1 'The British manufacturing model is unique in the world in that a whacking 70 per cent of British retailing is dominated by multiple chain and variety stores which have exerted the controlling influence over how manufacturing has developed' (Brampton 1994: 41).

2 Pagano and Thomson (1991: 12–13) writing in The Independent on Sunday report that UK fashion and clothing sales count for £265 million per annum in comparison with £1.8 billion in Italy, £1.4 billion in France and £880 million in Germany.

3 Information from interviews with ex-employees of Harvey Nichols, subsequently confirmed by a telephone inquiry with the personnel department.

4 Figures from Yusuf (1994) writing in The Sunday Times, pp. 17–18.

5 British Clothing Association figures quoted by Yusuf, ibid.

6 Phizacklea (1990) makes this point, confirmed in a journalistic piece about home-working for The Independent Weekend (Williams 1996: 5).

7 The Enterprise Allowance Scheme came into being in 1983 as a specific attempt to get people off the dole and into work through supporting their own enterprise. It provided £40 a week which could be claimed in addition to whatever earnings were made through the small businesses set up under the scheme.

8 The concept of 'social entrepreneurialism' appeared, it seems, out of the blue in 1996/7. It referred to new ways of providing a range of social services, in the light of the running down of local authority provision and privatisation of their functions. The new 'social entrepreneurs' tended to be either clerics, or ex-managers from business, made redundant, and looking for a challenge which would require them to combine business skills with a social conscience. So far these initiatives have tended to be based in churches or local community centres. Play groups, crêche facilities and other community services are run on a business footing. The success of the magazine for the homeless The Big Issue has also been hailed as an example of 'social entrepreneurialism' and, following the election of the Labour Government in 1997, a new school for 'social entrepreneurs' has been established by Lord Young. The idea chimes with Tony Blair's comments about creating a more 'decent' society, in this case through fusing business activities, not with the individualist ethos associated with Thatcher, but with some notion of the 'social good'. It remains to be seen whether the arts and culture might be encouraged to develop under this umbrella.

6 A MIXED ECONOMY OF FASHION DESIGN

1 The Jobseeker's Allowance replaced 'dole' in 1996. Claimants are expected to attend for interviews arranged for them at the Job Centres and allowance can be withdrawn if they fail to take up job offers. This makes it difficult, if not impossible, for designers to use the dole as a means of trying to re-establish a place for themselves in fashion while 'officially' unemployed.

2 According to two successful stall-holders the average volume of sales from a weekend stall (Friday, Saturday and Sunday) at Camden Market is approximately £1,000.

7 THE ART AND CRAFT OF FASHION DESIGN

1 The Jigsaw promotional material was supplied by Marysia Woroniecka PR.

8 MANUFACTURE, MONEY AND MARKETS IN FASHION DESIGN

1 For a clear account of all stages in the CMT process, see Phizacklea 1990.
2 Celebrity fashion marks a new stage in the fashion publicity process, comprising a series of trade-offs where well-known actresses, members of the royal family, pop stars and television celebrities 'borrow' an outfit from a designer for a celebrity event which will attract front page news in the press and on TV. The celebrity's own press office will describe the dress in detail as well as crediting the designer. The best known case of this form of 'dual promotion' was when Elizabeth Hurley, attending the premiere of the film Four Weddings and A Funeral (May 1993), starring her boyfriend Hugh Grant, wore a figure hugging Versace evening dress comprising gold safety pins holding the pieces of silk and lycra fabric together at strategic points across her body. The outfit instantly made fashion history as 'that dress'.
3 This information is culled from the press packs accompanying the 1995 seasonal collections of Ally Capellino, Betty Jackson, Whistles, Jigsaw and Sara Sturgeon.

9 A NEW KIND OF RAG TRADE?

1 The company itself reports restructuring as part of an effort to develop its market in a specific, and more limited range of goods.
2 This estimate is arrived at by drawing on a combination of figures from Zeitlin 1988, Phizacklea 1990 and Yusuf 1994.
3 This estimate was arrived at by consulting the business directory for London-based fashion firms, and through inquiries made at the trade magazine Fashion Weekly.
4 The Hackney Fashion centre was a GLC-supported initiative designed to encourage the local fashion industry. It was production focused and did not involve designers in any significant capacity.

10 FASHION AND THE IMAGE INDUSTRIES

1 A good example of this can be found in the following lines of an obituary for the French couturier Madame Gres, which appeared in the Guardian: 'Her range is a deliberately limited one – her piece of ivory honed to perfection – and her appeal was not to the common herd of fashion followers but the connoisseurs who understood the subtleties of the great couturier's art' (McDowell 1994: 26).

REFERENCES

Ashwin, C. (1975) *Art Education: Documents and Policies 1768–1975*, London: Society for Research Into Higher Education.

Barthes, R. (1967, 1983) *The Fashion System*, New York: Hill and Wang.

—— (1977) *Image–Music–Text*, Glasgow: Fontana.

Bates, I. (1993) '"When I Have My Own Studio"; The Making and Shaping of "Designer" Careers' in I. Bates and G. Riseborough (eds), *Youth and Inequality*, pp. 70–84, Buckingham: Open University Press.

Baudrillard, J. (1988) *Selected Writing*, Cambridge: Polity Press.

Beck, U. (1994) 'The Re-Invention of Politics: Towards A Theory of Reflexive Modernization' in U. Beck, A. Giddens and S. Lash, *Reflexive Modernization: Politics, Tradition and Aesthetics in the Modern Social Order*, Cambridge: Polity Press, pp. 1–56.

—— (1997) 'Runaway Worlds', talk delivered at the Runaway Worlds Conference, London: ICA.

Becker, H. (1982) *Art Worlds*, Berkeley: University of California Press.

Bird, E. (1988) 'The Designers' in *Glasgow Girls: Women in the Art School 1880–1920*, Department of Historical and Critical Studies, Glasgow School of Art, Glasgow, Exhibition Catalogue, pp. 24–9.

Bourdieu, P. (1984) *Distinction: A Social Critique of the Judgement of Taste*, London: Routledge and Kegan Paul.

—— (1990) *In Other Words: Essays Towards a Reflexive Sociology*, Cambridge: Polity Press.

—— (1993a) *Sociology in Question*, London: Sage.

—— (1993b) *The Field of Cultural Production*, Cambridge: Polity Press.

Bowles, S. and Gintis, H. (1976) *Schooling in Capitalist America*, London: Routledge and Kegan Paul.

Burkhauser, J. (1988) *Glasgow Girls: Women in the Art School 1880–1920*, Department of Historical and Critical Studies, Glasgow School of Art, Glasgow, Exhibition Catalogue, pp. 8–24.

Butler, J. (1990) *Gender Trouble: Feminism and the Subversion of Identity*, New York: Routledge.

Callaghan, J., The Rt. Hon. Prime Minister (1976) *Ruskin College Speech*: Oxford.

Chambers, I, (1987) *Urban Rhythms: Pop Music and Popular Culture*, Basingstoke: Macmillan.

Cohen, P. (1997) *Re-Thinking the Youth Question: Education, Labour and Cultural Studies*, Basingstoke: Macmillan.

Couldry, N. (1995) 'Speaking up in a Public Space: The Strange Case of Rachel Whiteread's House', *New Formations* 25, Summer, 96–114, London: Routledge.

Donzelot, J. (1991) 'Pleasure in Work' in G. Burchell, C. Gordon and P. Miller (eds), *The Foucault Effect: Studies in Governmentality*, pp. 251–81, London: Harvester Wheatsheaf.

Du Gay, P. (1991) 'Enterprise Culture and the Ideology of Excellence', in *New Formations* 13, Spring, 45–63, London: Routledge.

—— (1996) *Consumption and Identity at Work*, London: Sage.

Elliott, P. (1977) 'Media Organisations and Occupations: An Overview' in J. Curran, M. Gurevitch and J. Woollacottt (eds), *Mass Communication and Society*, pp. 142—74, London: Edward Arnold.

Evans, C. and Thornton, M. (1989) *Women and Fashion: A New Look*, London: Quartet.

Featherstone, M. (1991) *Consumer Culture and Postmodernism*, London: Sage.

Fine, B and Leopold, E. (1993) *The World of Consumption*, London: Routledge.

Forty, A. (1986) *Objects of Desire: Design and Society 1750–1980*, London: Thames and Hudson.

Foucault, M. (1977) *Discipline and Punish: The Birth of the Prison*, Harmondsworth: Allen Lane.

—— (1984) *The Foucault Reader*, P. Rabinow (ed.), London: Penguin.

—— (1988) *Technologies of the Self: A Seminar with Michel Foucault*, L. H. Martin, H. Gutman and P. H. Hutton (eds), London: Tavistock Publications.

Frith, S. and Horne, H. (1987) *Art into Pop*, London: Methuen.

Fuss, D. (1994) 'Fashion and the Homospectatorial Look' in S. Benstock and S. Ferriss (eds), *On Fashion*, Rutgers: Rutgers University Press.

Garland, M. (1957) 'Artifices, Confections and Manufactures, in *The Anatomy of Design: A Series of Inaugural Lectures by Professors of the Royal College of Art*, London: Royal College of Art.

Garnham, N. (1987) 'Concepts of Culture: Public Policy and the Cultural Industries', *Cultural Studies* 1, 1: 23–39, London: Routledge.

Giddens, A. (1991) *Modernity and Self Identity*, Cambridge: Polity Press.

—— (1995) *Beyond Left and Right: The Future of Radical Politics*, Cambridge: Polity Press.

—— (1997) 'Runaway Worlds', talk delivered at the Runaway Worlds Conference, London: ICA.

Gilroy, P. (1987) *There Aint No Black in the Union Jack*, London: Hutchinson.

Griggers, C. (1990) 'A Certain Tension in the Visual/Cultural Field: Helmut Newton, Deborah Turbeville and the Vogue Fashion Layout', *Differences: A Journal of Feminist Cultural Studies* 2, 2: 76–103.

Grossberg, L. (1997) *Bringing it all Back Home: Essays on Cultural Studies*, North Carolina: Duke University Press.

Hall, S. (1988) *The Hard Road to Renewal: Thatcherism and the Crisis of the Left*, London: Verso.

—— (1997) Plenary Lecture delivered at Front Lines, Back Yards Conference, New Ethnicities Unit, University of East London.

Hall, S. et al. (1978) *Policing the Crisis: 'Mugging', the State and Law and Order*, London: Hutchinson.

Hall, S. and Jacques, M. (eds) (1989) *New Times: The Changing Face of Politics in the 1990s*, London: Lawrence and Wishart.

Hall, S. and Jefferson, T. (eds) (1976) *Resistance Through Rituals: Youth Subcultures in Post-War Britain*, London: Hutchinson.

Hartwig, H. (1993) 'Youth Culture-Forever?', *Young: Nordic Journal of Youth Research* 1, 3 (September): 2–16, Stockholm.

Harvey, D. (1989) *The Condition of Postmodernity*, Oxford: Blackwell.

Hebdige, D. (1978) *Subculture: The Meaning of Style*, London: Methuen.

—— (1988) *Hiding in the Light: On Images and Things*, London: Comedia.

Hulanicki, B. (1983) *From A to Biba*, London: Hutchinson.

Huyssen, A. (1986) *After the Great Divide: Modernism, Mass Culture and Postmodernism*, Basingstoke: Macmillan.

Ironside, J. (1973) *Janey, an Autobiography*, London: Michael Joseph.

Jameson, F. (1984) 'Postmodernism or the Cultural Logic of Late Capitalism', *New Left Review* 146: 53–92, London: Verso.

Kumar, K. (1995) *From Post-Industrial to Post-Modern Society: New Theories of the Contemporary World*, Oxford: Blackwell.

Laclau, E. (1990) *New Reflections on the Revolutions of Our Time*, London: Verso.

Laclau, E. and Mouffe, C. (1985) *Hegemony and Socialist Strategy*, London: Verso.

Lash, S. (1993) 'Pierre Bourdieu: Culture, Economy and Social Change' in C. Calhoun et al. (eds), *Pierre Bourdieu: Critical Perspectives*, pp. 193–212, Cambridge: Polity Press.

Lash, S. and Urry, J. (1987) *The End of Organised Capitalism*, Cambridge: Polity Press.

—— (1994) *Economies of Signs and Space*, London: Sage.

Laver, J. (1938, 1983) *Costume and Fashion: A Concise History*, London: Thames and Hudson.

MacCarthy, F. (1972) *A History of British Design 1830–1970*, London: Allen and Unwin.

Macdonald, S. (1970) *The History and Philosophy of Art Education*, London: University of London Press.

McRobbie, A. (ed.) (1989) *Zoot Suits and Second Hand Dresses*, Basingstoke: Macmillan.

—— (1990) *Feminism and Youth Culture*, Basingstoke: Macmillan.

—— (1994) *Postmodernism and Popular Culture*, London: Routledge.

—— (1996a) 'Looking Back at New Times and its Critics' in D. Morley and K-H. Chen (eds), *Stuart Hall: Critical Dialogues in Cultural Studies*, pp. 238–62, London: Routledge.

—— (1996b) 'All the World's a Stage, Screen or Magazine: When Culture is the Logic of Late Capitalism', *Media, Culture and Society* 18 (April): 335–42, London: Sage.

—— (ed.) (1997) *Back To Reality? Social Experience and Cultural Studies*, Manchester: Manchester University Press.

Madge, C. and Weinberger, B (1973) *Art Students Observed*, London: Faber and Faber.

Morley, D. (1997) 'Theoretical Orthodoxies: Textualism, Constructivism and the "New Ethnography" in Cultural Studies' in M. Ferguson and P. Golding (eds), *Cultural Studies in Question*, pp. 138–71, London: Sage.

Mort, F. (1996) *Cultures of Consumption*, London: Routledge.

Murdock, G. (1997a) 'Cultural Studies at the Crossroads' in A. McRobbie (ed.), *Back to Reality? Social Experience and Cultural Studies*, pp. 58–74, Manchester: Manchester University Press.

—— (1997b) 'Base Notes: The Conditions of Cultural Production' in M. Ferguson and P. Golding (eds), *Cultural Studies in Question*, pp. 86–102, London: Sage.

Murray, R. (1989) 'Fordism and Post-Fordism' in S. Hall and M. Jacques (eds), *New Times: The Changing Face of Politics in the 1990s*, pp. 38–54, London: Lawrence and Wishart.

Negus, K. (1992) *Producing Pop: Culture and Conflict in the Popular Music Industry*, London: Edward Arnold.

Nixon, S. (1993) 'Looking For the Holy Grail: Publishing and Advertising Strategies and Contemporary Men's Magazines', *Cultural Studies*, 7, 3: 466–92.

—— (1996) *Hard Looks: Masculinities, the Visual and Practices of Consumption*, London: University of London Press.

—— (1997) 'Designs on Masculinity: Menswear Retailing and the Role of Retail Design' in A. McRobbie (ed.), *Back to Reality? Social Experience and Cultural Studies*, pp. 170–90, Manchester: Manchester University Press.

Parker, R. (1984) *The Subversive Stitch: Embroidery and the Making of the Feminine*, London: The Women's Press.

Pemberton, M. (1993) *Muriel Pemberton, Paintings*, London: Chris Beetles Ltd.

Phizacklea, A. (1990) *Unpacking the Fashion Industry: Gender, Racism and Class in Production*, London: Routledge.

Piore, M. (1997) 'The Return of the Sweatshop' in A. Ross (ed.), *No Sweat: Fashion, Free Trade and the Rights of Garment Workers*, New York: Verso.

Pollert, A. (1988) 'Dismantling Flexibility', *Capital and Class*, 34: 42–75.

Quant, M. (1967) *Quant on Quant*, London: Pan Books Ltd.

Rana, J. (1995) 'Case Study in Fashion Retail', unpublished undergraduate dissertation, Thames Valley University, London.

Ranciere, J. (1981) 'Proletarian Nights', in *Radical Philosophy* no 24: 10–13.

Rose, N. (1990) *Governing the Soul: The Shaping of the Private Self*, London: Routledge.

—— (1997) 'Identity, Genealogy' in P. Du Gay and S. Hall (eds), *The Question of Cultural Identity*, pp. 128–51, London: Sage.

Rose, T. (1994) *Black Noise: Rap Music and Black Culture in Contemporary America*, London: Wesleyan University Press.

Ruskin, J. (1858) 'Mr Ruskin's Inaugural Address', delivered at Cambridge, 29 October, Deighton: Bell.

Salmon, K. (1991) *Survey of the UK Fashion Designer Industry*, London: British Fashion Council.

Schwengell, H. (1991) 'British Enterprise Culture and German Kulturgesellschaft' in R. Keat and N. Abercrombie (eds), *Enterprise Culture*, pp. 136–51, London: Routledge.

Sebba, A. (1990) *Laura Ashley: A Life by Design*, London: Weidenfeld and Nicolson.

Storey, H. (1996) *Fighting Fashion*, London: Faber and Faber.

Stratton, J. and Ang, I. (1996) 'On The Impossibility of a Global Cultural Studies: "British" Cultural Studies in an International Frame' in D. Morley and K-H. Chen (eds), *Stuart Hall: Critical Dialogues in Cultural Studies*, pp. 361–92, London: Routledge.

Stuart, A. (1990) 'Feminism: Dead or Alive?' in J. Rutherford (ed.), *Community, Culture, Difference*, pp. 28–43, London: Lawrence and Wishart.

Tate, J. (1994) 'Homework in West Yorkshire' in S. Mitter and S. Rowbotham (eds), *Dignity and Daily Bread: New Forms of Economic Organisation Among Poor Women in the Third World and the First*, London: Routledge.

Thornton, S. (1996) *Club Culture: Music, Media, and Subcultural Capital*, Cambridge: Polity Press.

Tunstall, J. (1971) *Journalists At Work*, London: Routledge and Kegan Paul.

Westwood, V. (1993) 'Vivian Westwood in Conversation with Brenda Polan', *Addressing Dressing Series*, London: ICA Video.

Williams, R. (1958) *Culture and Society, 1780–1950*, London: Chatto and Windus.

Wilson, E. (1985) *Adorned in Dreams: Fashion and Modernity*, London: Virago.

Wolfe, T. (1969) 'The Noonday Underground' in *The Pump House Gang*, New York: Bantam Books.

Wolff, J. (1981, 1983, 1991) *The Social Production of Art*, London: Macmillan.

Wooton, D. (1993) 'Introduction' to M. Pemberton, *Paintings*, London: Chris Beetles Ltd.

Zeitlin, J. (1988) 'The Clothing Industry in Transition: International Trends and British Response', *Textile History*, 19, 2: 211–38.

ARTICLES CITED IN NEWSPAPERS AND MAGAZINES

Barbieri, A. (1995) 'When a Man Loves a Woman', The *Independent on Sunday*, 17 December: 8–9.

Billen, A. (1996) 'No One Looks at Vogue and Thinks "I Want To Look Like That"', The *Observer* Review, 4 August.

Blair, T., The Rt. Hon., Prime Minister (1997) 'Britain Can Remake It', The *Guardian*, 21 July: 18.

Brampton, S. (1991) 'Style Victim', The Independent on Sunday, 3 December: 9.

—— (1993) 'The Face That Fits', The Guardian Weekend, 4 December: 43–5.

—— (1994) 'The Adoration of St Michael', The Guardian Weekend, 8 October: 40–2.

—— (1996) 'Flight of Fantasy', The Guardian Weekend, 3 February: 12–14.

Chaudhuri, A (1996) 'In Praise of Queen Viv', The Guardian, 10 January: 8–9.

Daniels, C. (1996) 'Falling off the Catwalk', The New Statesman, 2 June: 18–21.

Frankel, S. (1997) 'True Romance', The Guardian Weekend, 5 April: 42–4.

Glancey, J (1997) 'All Dressed up by the Queen of Frock-'n'-Roll', The Guardian, 18 July: 19.

Grant, L (1997) 'The Old Colour of Money', The Guardian, 15 April: 6.

Harlow, J (1995) 'Home is Where the Art is', The Sunday Times, 17 December: 3.

Johnson, B. (1997) 'Was Versace Really a Genius?', The Daily Telegraph, 17 July: 21.

McDowell, C. (1994) 'Couture Out of Time', Obituary – Madame Gres, The Guardian, 17 December: 26.

—— (1996) Obituary – Ossie Clark, The Guardian, 9 August: 16.

McHugh, F. (1993) 'Material Success', The Telegraph Magazine: 37.

Muller, A. (1996) 'Ich Will Nicht Mein Opfer Sein', Die Zeit, 23 February: 57.

Pagano, M. and Thomson, R. (1991) 'How Britain Can Design Rags for Riches', The Independent on Sunday, 10 March: 12–13.

Parsons, T. (1992) The Prince of Ties', The Guardian Weekend, 21 November: 26–8.

Shakespeare, J. (1996) '£45 Buys This Pretty Summer Dress From Next', The Observer Review, 23 June: 7.

Spencer, M. (1997) 'Master of Glitz', The London Evening Standard.

Tuck, A. (1995) 'Hussein Chalayan', Time Out, 11–18 October: 28.

Watson, L. (1994) 'The Hot Bed of Fashion', The London Evening Standard, 15 April: 12–13.

Williams, S. (1996) 'That Designer Jumper You're Wearing: Where Did it Come From?', The Independent Weekend, 24 February: 5.

Wilson, C. (1993) 'Doing Their Own Thing', The Guardian, 22 April: 14–15.

—— (1994) 'Cut and Run', The Guardian Weekend, 21 May: 30–1.

Yusuf, N. (1994) 'Tomorrow, the World,' The Independent on Sunday, 20 April: 17–18.

ARCHIVES

Ethel Cox Collection, London College of Fashion.

St Martin's Archive, Central St Martin's College of Art and Design, London.

INDEX